P9-EKE-126

elisabeth landberger & mita lundin

CERAMICS

A BEGINNER'S GUIDE TO TOOLS AND TECHNIQUES

ALLWORTH PRESS

NEW YORK

Thank You To . . .

The Form Academy in Lidkšping, and especially a huge thank you to Kent Ericson who took us in with open arms and shared his knowledge and provided us with equipment.

Anders Fredholm who was very accommodating and generous with his knowledge of salt firing.

Jan-Åke Andersson for his guidance and support in anagama firing.

© 2012 by Elisabeth Landberger and Mita Lundin

Allworth Press books may be purchased in bulk at special discounts for sales promotion, corporate gifts, fund-raising, or educational purposes. Special editions can also be created to specifications. For details, contact the Special Sales Department, Allworth Press, 307 West 36th Street, 11th Floor, New York, NY 10018 or info@skyhorsepublishing.com.

15 14 13 12 11 5 4 3 2 1

Published by Allworth Press,
an imprint of Skyhorse Publishing, Inc.
307 West 36th Street, 11th Floor, New York, NY 10018.

Allworth Press® is a registered trademark of Skyhorse Publishing, Inc.®, a Delaware corporation.

www.allworth.com

Library of Congress Cataloging-in-Publication Data is available on file.

ISBN: 978-1-58115-896-0

Printed in China

CONTENTS

CLAY

Clay is a natural material that can be found everywhere and is formed through decomposition of igneous rocks, mainly granite. In geology this process is called weathering. The particles that make up clay are called clay particles, and are the most fine-grained weathering and erosion products.

There are two types of weathering: mechanical and chemical. Mechanical weathering occurs primarily by temperature fluctuations. Meltwater flows down into rock crevices, freezes, and expands, exposing the rock to great strain. This process gradually widens the cracks until a piece of the rock finally detaches. In this way the rock is broken down. Plants that manage to take root in the crevices may also be contributing to the detachment of mountainous parts. Chemical weathering is caused by wear and tear from weather and wind. Very small particles break away from the rock due to climate changes.

After millions of years of weathering you get a type of soil with 15 percent of its weight containing particles with a diameter of 0.002 mm. That is clay. The main components of clay are aluminum silicate (kaolinite), quartz and feldspar.

Kaolinite is a hydrous aluminum silicate, a clay mineral that is formed when rocks that contain feldspar crumble. Quartz is a mineral composed of silicon dioxide. It is the Earth's second most common mineral, after feldspar. Many varieties of quartz are popular gemstones. A few examples are: agate, rock crystal, rose and smoky quartz, onyx and amethyst. Feldspar is the generic term for several rock-forming minerals. Chemically, they contain infinite, three-dimensional, negative ions from aluminum, silicon and oxygen, where positive ions of sodium, potassium or calcium are stored.

Primary Clay and Secondary Clay

Clay can be divided into two geological categories: primary clay and secondary clay.

Primary clays are found where they were formed by the parent rock. They contain kaolin, very pure clay that is used to provide strength for porcelain and make it white. It is less plastic than secondary clay and difficult to shape because of its coarse particle size.

Secondary clay is the type of clay that has been transported away from its site of formation. Rivers, glaciers and winds transport it, and grind it up into finer particles in the process. During this process the clay gets contaminated with various pollutants, such as iron and other minerals, and various other types of organic matter. By the time the clay finally settles, often several thousand miles away from its parent rock, it has changed color, texture and thickness. The particle size of secondary clay is much finer than primary clay and therefore it has greater plasticity. It can vary vastly in color, from yellow, red, or gray to almost black.

You could say that china clay is mostly made out of primary clay, while all other clays are secondary.

Moldability—Plasticity

The plasticity of clay has to do with its flat and hexagonal clay particles. Each particle is surrounded by water, and comparable to wet glass plates, they slide around side by side without being parted and let themselves get formed together. When the clay dries, the water disappears and the clay particles stabilize and the object retains its form.

Fat or Lean Clay

We tend to talk about fat and lean clay. Fat clay consists of small clay particles and is easy to shape. But it also has a tendency to shrink a lot, and at times even change its shape or crack during the drying or firing process. Oily clay is suitable for throwing. Lean clay is more coarse-grained and less plastic. It maintains its shape better, shrinks less and has little tendency to

bruise. Therefore it is ideal for building ceramics and tiles.

You can easily change the properties of the clay by adding different substances. If the clay is too oily, you can make it thinner by adding chamotte, sand or quartz. Chamotte is burnt, crushed clay that comes in varying sizes, ranging from powders to coarse grains. If you have lean clay that you want to make more ductile and smooth, you can add ball clay or bentonite.

Different Types of Clay

Earthenware Clay

Earthenware clay is low-fired clay. Firing range varies between 1,652 and 2,192°F. If you fire earthenware at higher temperatures the object will collapse and in a worst case scenario, the object will melt in the oven.

There are large quantities of earthenware clay around the world. The color ranges from gray or white to red, orange, yellow and brown. Red pottery clay is a secondary clay that is high in iron oxide, hence the red or yellow color. Blue clay is another type of clay and it contains high levels of calcium. White earthenware clay is made by mixing clays that are bright, such as ball clay and kaolin.

Earthenware clay is porous, because the clay particles have not melted completely, and the goods still absorb water, or are permeable to water, despite being fired. In order to make the pottery dense, you need to glaze it. Characteristically, pottery acquires clear and bright colors in the glaze due to the low firing temperature. Many oxides and carbonates tend to exhibit their sharpest colors at these temperatures.

Stoneware Clay

Stoneware clay contains more quartz than earthenware, and has a firing range between 2,192 and 2,372°F. Most clays vitrify between these temperatures and become hard and dense. Stoneware clay is denser, because it has a higher density between the particles, and therefore it becomes heavier than earthenware clay, which is more porous. A bowl made out of stoneware is heavier than one made out of pottery clay, even if they are equal in size. The color of stoneware varies from grayish white to gray and

brown. Stoneware glazes have a duller and earthier color scheme, since only a small proportion of all oxides can withstand the high temperatures.

Porcelain Clay

Porcelain clay is white in color and is very hard and dense. It consists largely of kaolin, which makes it less plastic, and the manufactured objects bruise easily during drying or firing. Most porcelain masses tend to shrink a lot, up to 20 percent, so you should take that into account when working with this type of clay. A lot of people find working with porcelain a delight because of its ability to become almost transparent when the pottery items are created out of very thin layers.

Industially, porcelain clay can be fired at temperatures higher than 2,552°F, but usually it is fired at temperatures ranging between 2,282 and 2,552°F. China glazes are usually very beautiful.

Paper Clay / Fiber Clay and Slip Casting Clay

These two types of clay can be purchased as earthenware, stoneware, and porcelain. Paper clay / fiber clay is clay mixed with paper pulp and water. You can buy it ready-mixed, or mix soaked paper into your clay. Its properties are unique. It is incredibly strong, so that you can make very thin objects with fine details. You can add wet clay onto dried clay because the clay is armored. Just dab the dry clay with a wet sponge, so that you can easily repair cracks and such. The paper pulp makes the clay stick together.

Slip casting clay is used for casting objects. You can buy it pre-mixed or in powder format and it can also be obtained as earthenware, stoneware or porcelain. Slip casting clay is very non-plastic, which makes it easy to remove from the mold. It does not shrink significantly.

Obtaining Clay

There are several ways to obtain clay. One is to go out into nature and dig. In order to know where to dig, you can study maps. You can usually find plenty of good mud along riverbanks and the bottom of old

lakes. The deeper down you dig, the more pure the mud will be. It needs to be cleaned from plant parts and other impurities and then filtered. This is best done by leaving it to dry, crushing it, removing debris, and then wetting it again. It is good for the clay to soak in water for some time before you strain it and put it to dry on a gypsum board. When it is dry enough that it does not stick to your fingers, it should be kneaded. Then it is ready to use.

If you want to make it easier on yourself, you should buy ready-to-use clay from a retailer. There are plenty of different clays to choose from. The clay found at retailers tends not to be pure and natural. Most people want the same features no matter what clay they get. You cannot count on that if you go out in nature to dig your own mud, because the clay composition differs even if it is from the same site. You can make clay from different compositions of various constituents like quartz, kaolin, feldspar, ball clay and other components. That way you get clay that is pretty consistent at all times, and you can control its qualities and produce clays for different purposes.

The Many Different Faces of Clay

When you buy clay, it is packaged and enclosed in plastic and ready to use. It is soft and moist and firm in texture. This is ideal when you want to make pottery. Make sure to laminate the clay properly when not in use to maintain its perfect condition.

Once you have made an object out of the clay and let it stand for up to a day, it becomes what is referred to as leather hard. Make sure to let the object dry evenly and turn it upside down to help the drying process. It is common to make the drying process longer by wrapping the object in plastic, because it makes the object dry more evenly. You should laminate the object if you keep working on it over time, especially if a lot of time passes before you get a chance to work on it again. When the object has reached the leather-hard state, you can hold it without deforming it, and it is common to decorate it with patterns at this stage.

Let the object dry once you consider its shape to be done. Whenever the object is large, has thick

walls, or has handles or other shapes attached to it, you should ensure that the drying process is relatively long. This is to prevent breakage. It is best to wrap it in plastic and gradually loosen it as the item dries. While you familiarize yourself with the clay that you are working with, you will also learn about its limitations and easily assess what it can withstand. Once the clay has dried completely, it is very fragile. Store the dry items in a place where they are safe until it is time for the firing.

If you are unsatisfied with your object, you can soak it to reshape it at any stage before the firing. Clay soaked with water is called slip. It is something you should always have on hand. You can use it as glue when you want to put two leather-hard objects together. Sometimes only one of the objects that you want to join will be leather hard, while the other one may be moist, and sometimes the clay that comes straight out of the package but is so thin that it is easier to use slip to attach it.

Reusing Clay

You can reuse all remnants of clay that you do not want to fire, or that have dried in their packages. You can use some of it to create slip, but in a workshop you may end up with quite a bit of dry clay in a very short time. It might come from objects that broke during the drying process or that didn't turn out the way you expected, or any waste material from the creating process.

Put the dry unfired clay in a bucket, pour water over it and let it stand a few days. When the clay has absorbed enough water, pour off any excess water and put the clay on a thick gypsum board, see page 32. Gypsum absorbs moisture, and will therefore draw any excess water out of the clay. Try to spread the clay into an even layer, not too thin, at least 1.5 inches thick. After a while, when the gypsum has sucked up some of the water, turn the clay over for an even and quicker drying process.

Kneading

If you open a new package of clay and it is soft and pliable, you can usually use it without kneading it first.

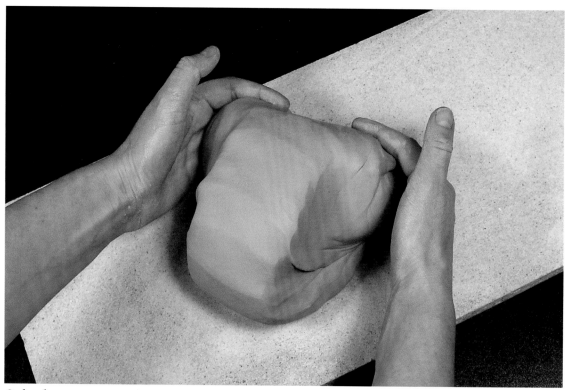

Ox head.

Today, most clays are well prepared when they come from the suppliers. Sometimes the clay can even be a bit too soft, depending on what you want to use it for. Then it is good to let the package stand open for a while, so that some of the moisture evaporates. If the package of clay has been standing for a long time, it can become hard even if it is unopened, and hard clay is difficult to work with. A good tip is to throw the whole package of clay to the floor a number of times. It helps to redistribute the moisture inside the package and softens the clay.

Clay that has been standing in its package tends to be harder on the surface and softer towards the center. By kneading it, you will mix the softer and the harder parts of clay into a more even mass. Clay benefits from being kneaded, but if you knead it for too long you run the risk of making the clay too dry and rough. Make sure that you don't use pieces that are too big. That will make the kneading physically strenuous.

There are several different techniques to use when kneading clay, but in general you knead it the same way as you would knead dough for baking.

More importantly, you need to remove air bubbles from the clay and make sure that new air is not trapped inside. The most important thing to remember is to work the clay so that it is evenly distributed so that it becomes smooth in texture.

One of the kneading techniques is called ox head. You perform it like this: Place your hands on the opposite edges of the clay and press downward and away from you so that the clay forms a spiral in your hands. Repeat until the clay is thoroughly worked. It is important that your hands press the clay down so that it does not get shaped into "handlebars." When the kneading is complete, the lump of clay should resemble an ox head.

Use your entire body weight when kneading. Make sure that you are steady on your feet and that you have a work surface that is of the appropriate height so that you can use your own weight effectively. You can also beat the clay. You do this by taking a large chunk of clay, and using a razor wire, you make a horizontal cut straight through the clay. Lift the top piece of the clay high above the table and

then beat the clay pieces back together with great force. Then flip the clay over and do the same thing from the other direction. This is a great way to get rid of any air bubbles.

You will find a kneading machine in most well-equipped pottery workshops, where you insert used, raw clay. The clay is then pressed through the mill, which uses a screw to make the clay completely homogeneous and ready to use.

If you are kneading recycled or silted clay, it is good to wait until the clay loses its tendency to stick to the fingers. It is beneficial to start kneading the clay on a gypsum board before you move it to a worktable. You can use the clay right away, but silted clay benefits from resting before you use it. Preferably put the clay in a plastic bag and let it mature.

Storing Clay

Clay stays fresh for a very long time if it is well laminated. Heavy-duty plastic bags, barrels or buckets with lids are all great for storing clay. If you notice that a pack of clay starts to harden in its plastic, you can poke a few holes in the plastic and put the entire package in water for a few days, or you can cut the plastic open and add a cup of water before you carefully laminate it again. After a week the clay will be softer.

Clay that has been laminated for a long time can start to rot. No need to worry about it, it is only sign of maturity in the clay. Just knead it the same way you would normally do it.

Shrinkage

It is important to remember that clay tends to shrink a lot. Depending on the kind of clay, it can shrink up to 20 percent. Porcelain clay usually shrinks the most. Stoneware and earthenware clay usually shrink between 10 and 15 percent. The clay does not only shrink during the drying process, but it shrinks the most during firing. To find out how much the clay that you are working with tends to shrink, you can do a shrinkage test. The easiest way to do it is to roll a piece of clay into a flat surface and use a ruler to measure 4 inches and clearly inscribe the distance onto the surface. Then fire the clay the same way you intend to fire the objects that you will create out of the same clay. Once you are done firing the surface, measure the distance of the inscribed line, and do a simple mathematical calculation:

The length of the line made in the raw clay (in this case 4 inches), minus the line in the dry clay, divided by the length of the line in the raw clay, multiplied by 100. The sum is the percentage of the total shrinkage.

Sintering

Another important thing to know is if the clay is waterproof (sintered) or not. Usually the supplier will be able to inform you of that. However, it may be useful to be able to check it yourself, especially if you intend to fire the clay in a lower temperature than is required for it to sinter. If you dig up the clay yourself, you need to be able to get an idea of what kind of clay it is. You can find this out by doing a sintering test. Fire a plate of clay at the correct firing temperature and weigh it. Then put the plate in water and let it boil for several hours. Remove the plate from the water and weigh it again. If it weighs the same as it did before it was boiled, it means that it did not absorb any water, and therefore it is sintered.

GETTING STARTED WITH CLAY

Tools

Depending on what you are going to create, sometimes all you need is your hands and the clay, but if you want to try special techniques you will need some different tools. Most of the tools can be used for a variety of purposes; only your imagination will set the limit. On the following pages are brief descriptions of the most common tools and their main uses. It is common to make your own tools depending on what you intend to create out of the clay, and you will also notice plenty of useful tools in your surroundings that are not necessarily pottery tools, but that work very well in assisting your creative process.

Most potters have their own special uses for their various tools. Likewise, you will probably find unique ways to use your own tools.

Good Tips on How to Make Your Own Tools

You can easily make your own cutting wire. You can use ordinary household wire, fishing line or guitar string and attach the ends to two small wooden pieces or two sticks of fired clay. Twisted wire creates a nice pattern on the bottom of a thrown object. You can twist the wire by using a potter's wheel. Tie the thread to a small piece of wood and attach it to the middle of the potter's wheel with clay. Use wire that is double the length that you want the finished length to be. Spin the potter's wheel. The wire twists while the potter's wheel is spinning. When it is twisted enough, it will fold in the middle and twist itself into a thicker wire. Attach the new thread so that each end is tied to a small piece of wood.

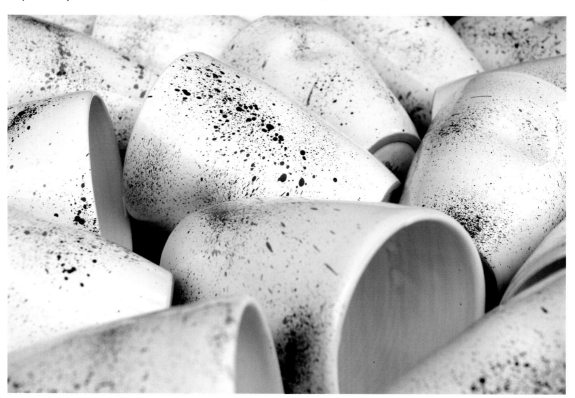

Pottery, thrown, squeezed, faience spatter on top of glaze, oxidation fired, cone 04.

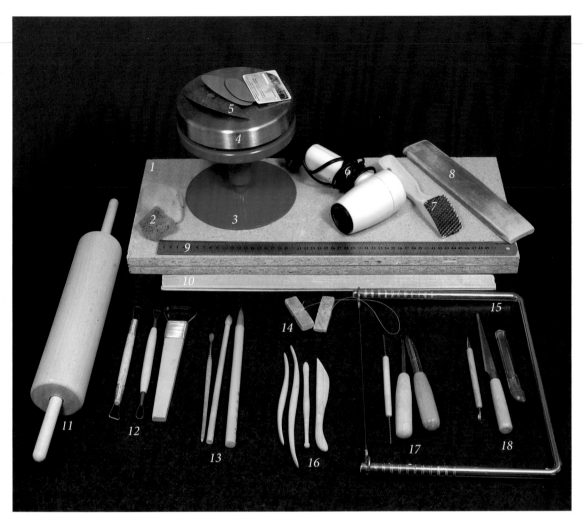

1) Particle boards 2) Sponges 3) Banding Wheel 4) Scale 5) Potter's Ribs 6) Hairdryer 7) Surform 8) Wooden paddle 9) Ruler 10) Wooden strips 11) Rolling Pin 12) Ribbon/Loop Tools 13) Brushes 14) Cutting Wire 15) Clay cutter in frame 16) Wooden Modeling Tools 17) Hole Cutters 18) Knives

Discarded plastic cards, such as credit cards, are perfect to use as ribs. You can cut, file and shape them into desired profile ribs, or use them as they are. Keep in mind that many plastic cards have a thin plastic coating that gradually loosens over time and could scratch your items.

Instead of chamois, you can use a little piece of a plastic bag. If you are using clear plastic, make sure that it does not get mixed into any residual clay that you may have accumulated around the potter's wheel. It can be difficult to notice it in the clay and it might end up in clay that you intend to recycle, where it becomes an unpleasant surprise.

Great Basic Tools

Cutting Wire	This is used for cutting the clay loose from the underlay.
Clay Cutter	Use the clay cutter, which has a cutting wire attached to a frame, to cut clay.
Particle Boards	Great to use as underlay base when working with clay. Makes it easy to move objects without damaging them.
Scale	A good scale will enable you to measure and portion equally large pieces of clay.
Banding Wheel	Banding wheels come in different sizes. They are practical and have many different uses.
Fabric	Fabric is excellent to use underneath clay when you are rolling it.
Rolling Pin	Use it for rolling clay.
Strips	Wooden or metal strips of all kinds are great to use when you roll out the clay, to make sure that the thickness of the clay is even.
Wooden Paddle	A polished piece of wood used for patting the clay lightly to shape it.
Sponges	Use them to wipe the clay and to even it out. You can use natural sponges, or other kinds used for washing.
Plastic Bags	Store the ceramics in plastic bags while you are still working on them to prevent them from drying out.
Hairdryer/ Heat Gun	Great to use when you need to quick-dry an object, or a part of an object. Be cautious not to dry the object too much. Clay dries quickly in the heated air.
Potter's Knife	A sharp knife with a thin blade that is excellent for cutting clay without dragging clay along the cut.
Pin Tool	Use it to pierce holes in the clay.
Hole Cutter	Hole cutters come in varying sizes and are used for punching holes in the clay.
Surform	A coarse rasp blade that is used for creating even edges.
Ribs	Come in different shapes and sizes and are used during trimming, but also to scoop out clay.
Modeling Tools	Used for modeling, but also for smoothing.
Ribbon/Loop Tools	Available in varying sizes and shapes and are used for trimming, but also to scoop out clay.
Ruler	Use it for measuring.
Caliper	Use it when you need to measure the internal or external size of an object.
Brushes	Used for various decorating purposes, but also to fine-polish hard-to-access surfaces.

SHAPE

The word *shape* includes a variety of concepts that together form a result that we can see or feel. It is important to ensure that the various concepts make sense. If you work with sculptural objects you can use any forms of expression freely. If you are making items for practical use you must make sure that they will fill their function. As an example, one must be able to lift a teacup, so it cannot be too heavy, and if you are making plates, you should ensure that they will fit in a cabinet by not making them too wide. These are things you should keep in mind when you sketch a design of an object.

It is helpful to decide the shape and imagine the end result before you begin working on an object. This is when a sketch will come in handy. The advantage of that is that you will think about which method is best to use. The first products seldom turn out the way you expect them to, partially because of unexpected things that happen along the way, and partially due to the fact that it takes time to learn using the different techniques. If you choose to make a bowl and it comes out as a plate, the advantage of that is that you can analyze what went wrong. You are encouraged to try new approaches and develop your skills in the process. In the end you will be able to achieve the bowl shape.

Mass

How much clay should you use? How do you distribute the clay? Should the walls be thick or thin?

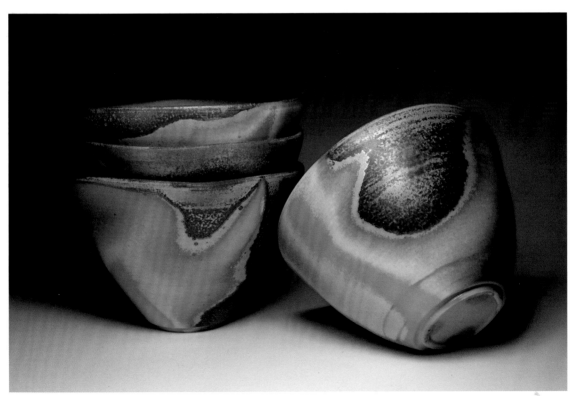

Porcelain, wheel-thrown, anagama fired, cone 8.

Here, you give the object its personal characteristic. Thin walls give a graceful and elegant impression, while thick walls give your creation a robust and stable expression.

Volume

How much space will the object require?

Will the object occupy space on the height or the width? Or perhaps both? This aspect is important for the final result. How will it be used? Will it work the way you expect it to, or will it become too large and unwieldy for the purpose? The object must harmonize with its surroundings; otherwise it will easily become a solitaire item that does not perform its function regardless of whether it is designed to delight the eye, or if it is intended for practical use. Sometimes an object may give a growing impression and may appear larger than it actually is.

Space

How big should the space inside the vessel or sculpture be?

How will it be used? Should it be decorated with paint or with applications? Will the space strive upwards or outwards? How does any color scheme or ornament affect the space? Does it reinforce or restrict the space?

Surface

What does the structure of the object look like? Is the surface smooth or patterned?

Working with the surface does not only mean the outside of an object. It is equally important to consider surprising spaces that are contrasting to the rest of the surface. Some of them are only visible at close range. The surface is also important in relation to the amount of clay and the thickness of the object.

Lines

Are there any boundary lines or external lines? Are there any traces of imprints or ornaments on the object?

The lines limit the eternal shape and create profiles. A line can be a boundary between different expressions. The lines can also interact with the rest of the shape to create an impression of continuation.

Movement

Which way is the subject heading? Is it heading into different directions?

A bowl may give the impression of an upward movement by using a tall foot ring. It lifts the bowl so that it rises above the surface it stands on. This also strengthens an upward-moving pattern. A compact sculpture communicates that there is no motion but that it stands firmly in its place. Even the decoration can enhance the vessel's impression of movement. Even unconscious movements appear in the expression.

Spaces in Shapes

What is the space between a cup and its handle, or the space between an arm and the body of a sculpture? What is the significance of the gaps formed in the decor?

When you attach a handle to your cup, take into account how it feels in your hand. Do you have enough room for your fingers, or should the entire hand be able to grab the handle? Does the space between the handle and the cup call for attention? When sculpting, it is important to take the gaps into consideration, so that the spaces match the rest of the object harmoniously.

Light

How is light distributed over an object?

Lighting can alternate moods and arouse curiosity. With the aid of light, you can attract an audience to the object. Where does light come from? Where does it go? Light enhances shadows and creates depth that can alter the impression of the shape.

These concepts are important guidelines throughout the creative process, but do not let them limit you. Think freely, work with the clay and dare to experiment! The goal of determining the shape before you begin is to be in charge of the creative process instead of vice-versa.

PINCHING

There is a particularly appealing charm to pinch-made bowls and pots. The actual manufacturing process requires a certain kind of caring touch. Closeness, security and warmth are words that are associated with pinching.

Pinching is one of the oldest methods used to shape bowls, plates or whatever dishes you might want to create. It requires no tools other than your hands. This method is best suited for smaller objects that you can easily hold in your hand. However, with practice and a lot of patience it is possible to create larger objects.

First, you decide what the object should look like and determine its size. Use about 7 oz of clay for a 2- to 2.5-inch-high and 3-inch-wide bowl. You will benefit from taking the clay directly out of its packaging. It does not need to be kneaded. In general, it will have a good texture and be free of air. It is fine to use any type of clay for pinching, but if you intend to make larger objects, it is wiser to choose a solid type of clay with chamotte in it.

Begin by shaping the clay into a ball that you can hold in one hand. Stick your finger down the middle of the clay so that you can determine how thick the bottom should be. Widen the bottom to the desired size without stretching out the edges too much. Then begin thinning out the walls by pressing your thumb and index finger against each other with small and light pushes and pulls upward. Move your fingers in small motions around the entire object and try to

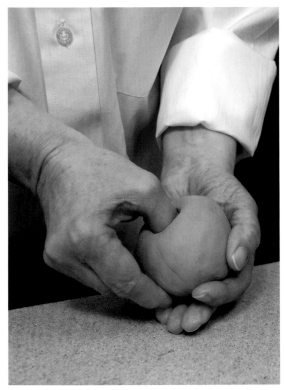

Begin by shaping the clay into a little ball that you can hold in your hand and make a hole in the middle.

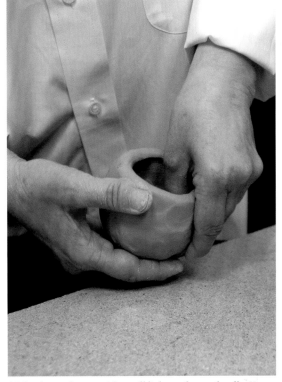

Make the pot larger with small light pushes and pulls. Keep the shape together.

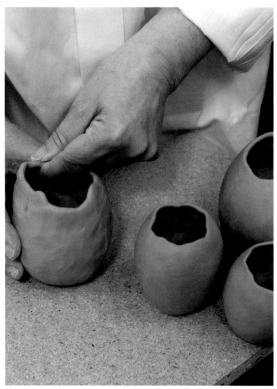

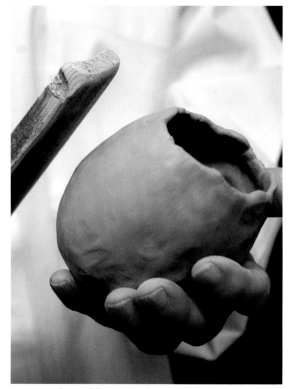

Make the thickness even and smoothen the edge.

Use a wooden paddle to smoothen the surface.

keep the height even. If the clay is thicker at any point you can easily redistribute it.

Pinch the clay straight up into a cylinder-like shape in the beginning, so that the edge does not widen too much. It is much easier to expand the clay into a bowl and end up with a flat plate, than it is to get it into a cylinder shape again. To get a wider shape, gently pinch it all around while pulling up on the height.

When the object becomes too big to keep it in the hand, you can place it on a wooden board and continue working on it. It is difficult to get the thick-

ness even between the bottom and the walls of the clay. The edge easily remains thicker there, which can create problems with tensions if the thickness varies too much. Preferably work with a template to get as close to the intended outcome as possible. How you finish off the work is a matter of taste. By its very nature the object's edge will vary slightly in height and it will be a bit uneven in thickness. When you have reached the final result it will be to your advantage to let the object dry a bit, before you smooth it and possibly pat it with a wooden paddle to make the exterior smoother and more even.

COILING

Coiling is a great method to use when you want to create large and complicated shapes quickly. It is a practical technique to use when working on different irregular and soft shapes.

There are different techniques when you work with coiling and you can either use round or flat coils. When you make small bowls or cups you should use the rounded coils. Whenever you are working on bigger things, such as urns, you will be able to work faster if you flatten the rounded shapes into wide strips. It is good to use a solid clay that contains chamotte, at least if you intend to make large objects.

It is important that you have an idea of what the shape should look like before you start working on an object. It will be beneficial if you make a life-size

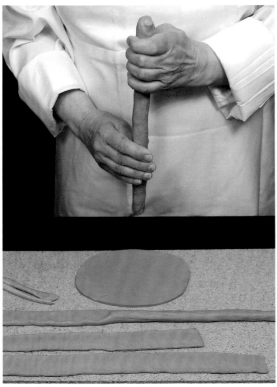

Make rounded or flat clay coils.

sketch of the object. A good way to do this is to fold a paper in half and draw half of the shape. Cut it out. Now you have a shape of what you are going to make and the paper that is left will be an excellent model to use when coiling your creations. You can use the template to measure how big the inclination should be, or to determine if you need to expand or make the shape smaller, and to decide its height. If you work with the template you can avoid any annoying surprises, such as getting the object too wide, or making the waist smaller than you originally intended. You can create freely, but the template is there to assist you in mastering the coiling technique, and learning the strengths and limitations of using such a technique.

When creating small bowls, you begin by rolling out a bottom plate. You can also create the bottom by pressing it out with your hand. It is important that the thickness of the clay does not differ too much between the bottom and the walls so that tensions do not occur, which makes objects crack more easily.

For smaller bowls you can use coils that are between 1/4 and 1/3 inch thick. Begin by pressing the clay with your hands into a thick string, and it will be easier to roll coils that are even in thickness once you transfer your work onto a work surface. Roll the coils with regular and long strokes to prevent them from becoming jagged spirals. Place the finished clay coil onto the bottom plate and cut off both ends obliquely for a longer adhesion surface. Add one coil at a time. As long as the clay has a soft texture, no slip is needed between the coils. Attach one coil at a time, which helps facilitate the whole process and makes it easier to maintain the shape of the object. You attach the coil by using your finger or a modeling tool to carefully squeeze it onto the bottom plate. Smooth the edge with a damp sponge. Sometimes you want to keep the ring.

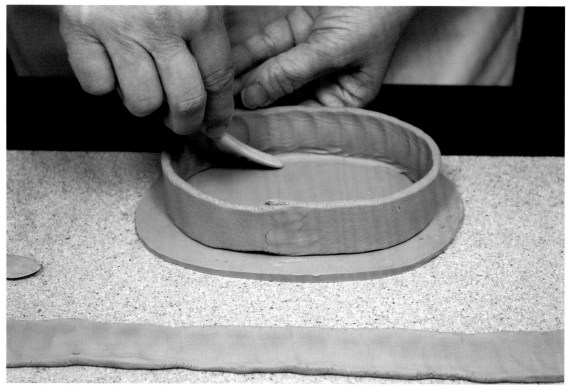

Attach the coil thoroughly onto the bottom plate.

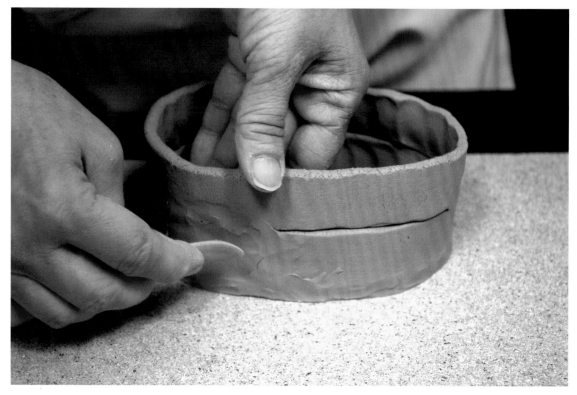

Attach the next coil.

18

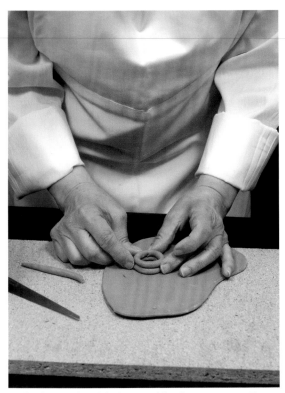

Make the topside, while the rest of the object is resting. The topside is attached securely with slip.

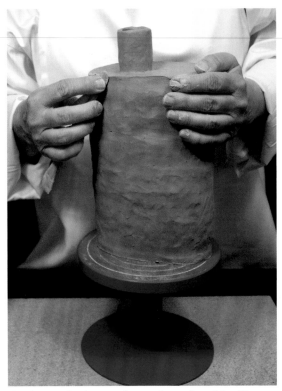

Gently press the shape on the exterior surface of the object and only pull it together on the interior wall.

If you intend to make a bowl that gradually becomes wider it is wise not to increase the length of the coils too much for each row; then you may get a wider bowl than you intended. If the bowl becomes too narrow, just press on the clay lightly to shape it according to the template. Once the bowl reaches your desired height, you will benefit from letting it stand to dry for a little while. Then you can begin to even out the shape and give it a smooth surface if that is what you want. If you let the object dry further to a leather-hard stage, you can use a wooden paddle to shape and reshape the imperfections that exist.

As you use coiling to create large urns or other tall objects, it is faster if you use flat coils. Start by shaping a rounded coil by pressing the clay with both hands. When you have a coil that is about 0.8 inch thick, transfer it to the table and press it out in two steps, first with the thumbs along the coil, and then with the thumb or index finger across. The strips will be between 1 and 1.4 inches wide, depending on how

thick the coils were from the beginning. Remember that clay easily gets stuck to the surface that you are working on. It helps if you put a piece of paper between the clay and the work surface. You use the same approach as when working with the rounded coils. The difference is that with this technique your urns and other objects grow and shape up quicker and you see results faster—great if you are a bit impatient. Here you may want to use a hair dryer or any other quicker drying method because your objects will quickly grow in height and volume. Otherwise the clay might not have the time to dry and settle as you are working on it and the object then easily becomes a bit unstable. As with small bowls you let the object rest before you finish it off and smooth the surface. For that you use a wooden paddle or a rib.

The coiling technique is also used when throwing large pots. Then one ring is added at a time and it is thrown until attached. The result is the same as when building smaller vessels with rounded coils; see page 54.

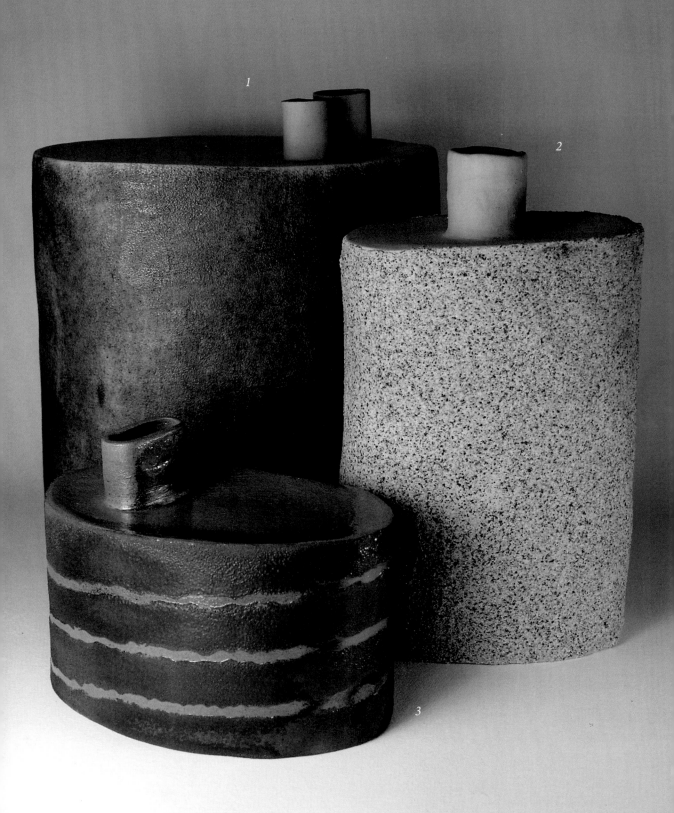

SCULPTING AND MODELING

When you think of pottery and art, it is likely that you visualize sculptures, or terra cotta models. Sculpting and modeling go hand in hand. The category allows a lot of free form, and it is also common practice to combine different creative techniques.

You can use any clay for sculpting, but whenever you are making a large object, it is best to choose a clay with chamotte. The size of the chamotte is less important. When sculpting, it is important not to fire the figures in a temperature that is too high. Usually it is enough only to bisque fire the object if you do not intend to color it. You can also fire it in stoneware temperature, but that can make the clay sinter and move a little bit, which means that protruding parts of the figure may lose their shape and the resilience of the figure may be lost.

When working with clay, modeling sticks, ribbon/loop tools and wooden paddles are usual working tools, in addition to your hands. It is practical to work on a floor banding wheel. Then you can stand and work while rotating the object to see it from different angles and perspectives. Sculpting or modeling is an entirely different way of working with clay than when creating utility goods, although the basic principles are the same. It is important not to work any air into the clay. It may become a bigger problem during sculpting than when working with other techniques.

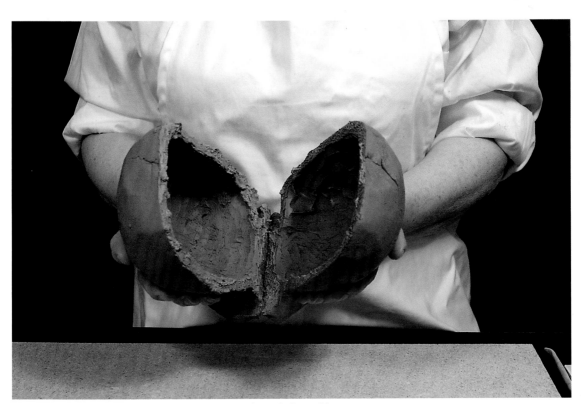

After the halves have been hollowed out, they are joined together with plenty of slip.

Coiled pipes, stoneware. 1) Engobed through stippling, thinly glazed with a transparent glaze, oxidation fired, cone 8. 2) Sand-mixed slip applied with a palette knife, unglazed, oxidation fired, cone 8. 3) Pattern with string, engobed, anagama fired, cone 10.

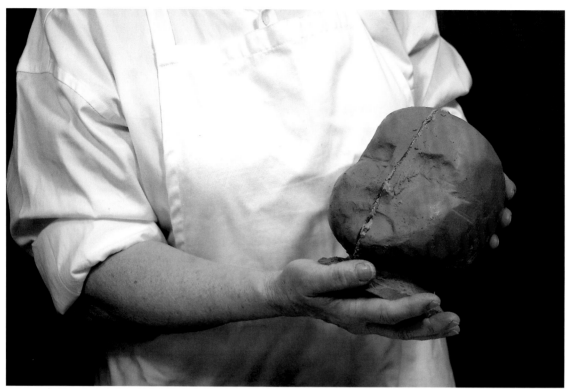

Carefully attach the halves together.

There are several ways to sculpt. One way is to keep building with clay on the object that you are working on. Another is to take a large piece of clay and work away pieces of clay little by little. These techniques are often combined, and if you happen to remove too much clay, you can build it up by making more clay. If you intend to make a big sculpture, it may be wise to create separate parts and then put them together.

When sculpting free forms, it is good to think about it before you begin. Where will the sculpture's center of gravity lie? Will it be able to bear its own weight without losing its shape? Will it need support to retain its shape while you are working on it? Which method is the best to use?

Coiling is an excellent technique to use when sculpting. You build from the bottom up and it allows the object to dry a bit after each layer so that it can bear its own weight. With this technique, you get a hollow sculpture from the beginning and you will be able to notice any weak parts right away.

Sculpting a Face

Take a piece of clay and shape the outer contours with rough features without paying too much attention to the eyes, ears, nose, or mouth. The key is to create the head shape and make it as large as you want it right from the beginning. It is not recommended to increase the head size later on.

Once the basic form is completed, you divide the head vertically in half with a cutting wire to hollow out the two parts. This is done to prevent the head from becoming too compact, as this could lead the clay to crack both during the drying stage as well as during the firing process. Please let the clay dry a bit before hollowing it out, to maintain the shape better while working on it. It is best to use a ribbon or loop tool. Continue scooping out the insides until the walls are about 0.2-0.3 inches thick. It is important not to alter the exterior shape during this process because the two halves will be assembled together again. When it is time for that, you carve precisely at the joints of the two halves and attach with slip. Attach the halves to

Earthenware clay with chamotte, bisque fired, cone 07.

each other properly. Pat with a wooden paddle so that the surfaces press against each other. Add more clay to the exterior and work off the joint seam. Now you have a hollow head shape without any air ducts. This means that there is a volume of air closed inside that creates a resistance as you continue working on the face and shape its characteristics by developing eyes, ears, a nose and mouth.

Now you will need to attach and carve away clay. The clay that you attach should be soft and supple. Make sure that no air is trapped between the object and the clay that you build onto it. Carve and use slip as much as possible. It is disappointing and often impossible to re-attach a nose or an ear if it falls off during firing.

Keep the object moist during the entire time that you are working on it by keeping it under plastic and perhaps also adding wet rags if you will continue working on it the next day. When you have finished the face, it is important to make an air duct into the cavity. The clay will shrink but the trapped air will not diminish and if there are no ducts for it to escape, it will blow up the clay.

Drying

Let your creation dry slowly and preferably loosely wrapped in plastic. A sculpted object can vary greatly in wall thickness, which creates bigger tensions in the goods. This requires a longer and gentler drying process.

SLAB CONSTRUCTION

If you roll out the clay into discs of various sizes and thicknesses you can produce many kinds of objects: tall vases, tiles, boxes and jars, paintings, cups, large plates. Yes, this technique is suitable for many creations.

Slab constructed objects, in particular tiles, are easily bruised during the drying process. Therefore it is appropriate to use a thin clay that contains chamotte. You can add up to 30 percent chamotte or sand into your clay to get it stable and to facilitate the shrinkage during the drying process. Paper and fiber clay is also suitable when using the slab construction technique.

How to Roll the Clay

In the beginning it may be difficult to know how much clay is needed for your creations. Slab construc-tion usually requires more clay than you anticipate. Some work surfaces are excellent to roll out the clay on, depending on the material, while others are not suitable. In a worst-case scenario, the clay gets stuck to the table. To avoid this, you can roll it out on top of a loose surface or a piece of fabric. Then you can easily move your clay disc without making unnecessary marks in it. You can also place wooden strips on each side of the clay disc and roll the rolling pin on top so that the clay disc becomes even in thickness.

It is good to beat the piece of clay a bit before you begin rolling it out. You can use a regular rolling pin; an extra long one can be bought at any good cookware shop. You can also use round rods, iron pipes, or old mangle and pressure rollers.

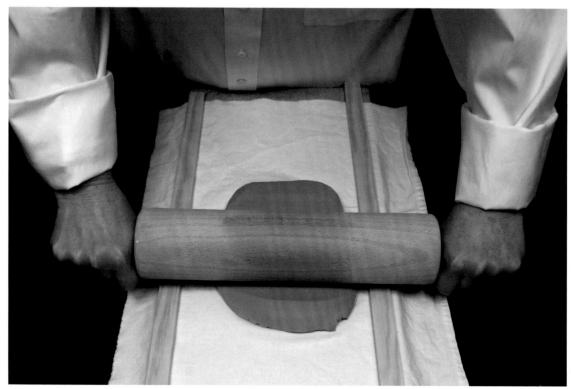

The clay is rolled out between two wooden strips.

Use your entire body weight when you roll out the discs of clay. It is important to move the clay around so that you roll it out from different directions and also turn it at regular intervals so that you roll both sides; otherwise tensions might occur during the drying or the firing process, which leads to cracks. If the clay gets stuck to the rolling pin you can put a cloth on top of the clay when you roll it out. Make sure that the fabric is smooth so that you do not roll folds from the fabric into the clay. If any air bubbles occur in the clay you can easily poke them with a needle.

If you do not want a smooth surface, you have the option to roll the clay out on top of a textured wallpaper or fabric with raised pattern to create the desired embossed effect. You can also put leaves or other objects on top of the rolled smooth surface to create patterns as you roll the clay out with a rolling pin.

Making Tiles

If you are making tiles, you can easily cut out the desired size of the plates with a knife. You can use a ruler and a triangle to cut out perfect angles. Allow the clay to dry a bit before cutting it to make it easier to get sharp angles. Otherwise, the clay tends to stick a bit to the knife when you cut the corners. If you wet the blade it will slide easily. A quick and effective way to cut out tiles is to use a tile cutter. They are available in different sizes. You can also make your own template out of cardboard or wood that you cut out along the lines of the tile in order to get the same shape and size. Remember not to make the tiles too thin and be sure that the tiles have the same thickness.

Once you have cut out the tiles, allow them to dry. Tiles often tend to rise in the corners, but you can prevent this by allowing them to dry very slowly. Place the tiles on particleboards with newspaper in between. Preferably build multiple layers of full chipboards and finish with weights on top. Then cover everything thoroughly in plastic. It is good if the plates lie under the weights during the entire drying process. Also, rotate the tiles as they dry.

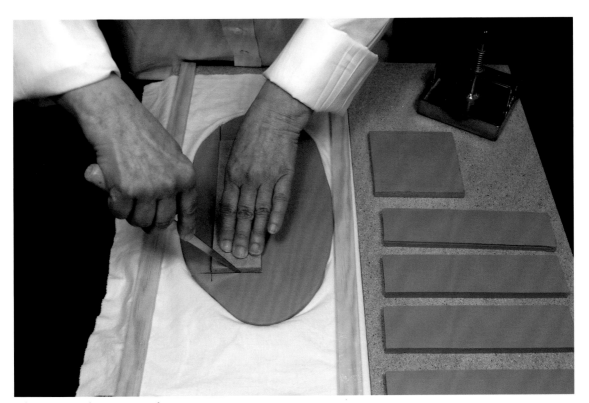

Tiles are cut out by using a template.

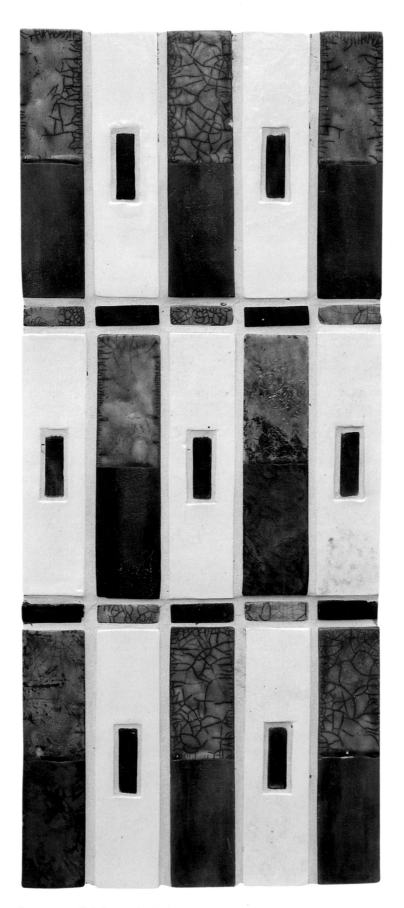

Stoneware, rolled plates, raku fired.

Stoneware, rolled, stamped with writing, colored with stains, unglazed, oxidation fired, cone 8.

Place the rolled clay sheet over the shape.

Slab Building Bowls and Plates

An easy way to make large bowls and plates is by rolling out a large disc of clay and then put it in or over a plaster mold, or any other object with the desired shape. It may be difficult to roll out the 6.5-9 lbs of clay required to make a large plate. Instead, you can roll smaller pieces and then roll them together. Whenever you are rolling a large object, it is especially important that you turn the clay sheet and roll it from every direction. It is easier to move the rolled out clay sheet if you let it sit for a moment. Press lightly with your finger on the clay. When your finger no longer leaves a trace in the clay, you can lift the sheet to the selected shape. Use a damp sponge and a rubber rib to lightly press the clay until it fits snugly against the mold. Once you have it in place and it follows the shape, you cut off any excess clay with cutting wire. If you choose to use a shape other than a plaster mold, it is good if you put newspaper or cloth between the shape and the clay to help absorb moisture. Otherwise it may take a long time before the clay dries. You must

also pay attention to the edge. It tends to dry faster, and that could create tensions in the clay and result in cracks. To avoid this, you can cover the edge with a damp cloth and wrap it in plastic.

If you are going to make really big objects, you may need to use a slab roller. It is like a large mangle with a roller that presses the clay into your desired thickness. Slab rollers come in different maximum widths.

Build and Assemble Rolled Clay Sheets

There are endless possibilities to the objects you can build out of rolled sheets of clay. It helps to have a drawing and perhaps even a model or template. Then you can easily cut out individual parts and assemble them together. Carve with a sharp object on the edges that are to be joined, add slip and gently press the individual parts together. It is important that you make sure that the seams are well joined together, and to further strengthen the seams, you can drizzle a thin string of clay over them and press gently to make it stick. Then you can model the clay string so that it matches the rest of the wall.

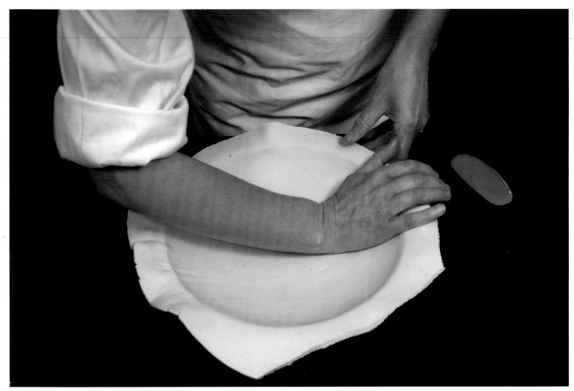

Carefully press the clay into place.

The actual joining of the parts can be made when the clay is leather dry, but some clays, you can join together at an earlier stage. A good way to check whether the clay is ready to be assembled is to let the clay disc stand on its edge. If it does not budge in the corners or collapse, it is perfect to use.

For example, to make a tall vase, it is good to have a supporting shape to wrap in the disc of clay. You can use anything from a paper towel roll, a milk carton, a piece of wood, or anything that provides stability and supports the shape that you desire.

Begin by making the bottom. Then carve scratches into the cylindrical part that is to be fixed. Place the supporting shape on top of the bottom disc and roll the clay disc around the supporting object. Cut the clay on an angle, as shown in the picture, so that the sides can be attached together with slip, and possibly with an extra string of clay. Then you will have to remove the supporting shape as quickly as possible; otherwise the clay may dry and get stuck to the supporting object. If you are using a type of solid clay, you can use a crumpled up newspaper to support it inside. This allows you to set the paper on fire when the clay has dried, or you can let it burn up during the firing process. However, that requires a kiln with a ventilation system that will take care of the smoke. You can also use clay to make supporting pillars as your supporting shape. Make sure to wrap your objects in plastic and allow them to dry slowly, so that they have a lot of time to attach together.

You can also make clay discs by using a clay cutter. It is a tool with a cutting wire attached to a bow frame. It has several different notches so the height of the cutting wire can be adjusted. If you open your clay package on a table, you can cut discs of clay that are of equal size and thickness. It is similar to cutting cheese with a cheese slicer, though on a much larger scale.

If you are working with paper clay, you can roll it out into a really thin disc. To speed up the process of stabilizing it and preparing it for use, you can put it on a piece of newspaper after you have rolled it out with a rolling pin, so that it absorbs the moisture. Sometimes the clay will fringe at the edges when it is cut. In that case you can moisten it with a sponge. Paper clay is

Cut the edge on an angle to create a bigger adhesion surface.

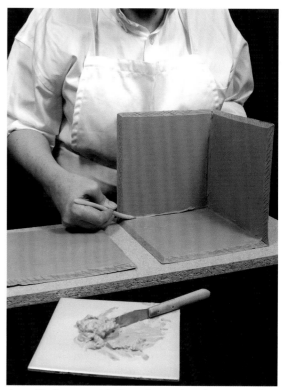

Assemble the parts with slip and strengthen the seams with small clay coils.

more durable than ordinary clay. You can even mix wet paper with dry clay, which is not possible with ordinary clay.

A major advantage of using slab construction is that it is easy to decorate rolled out discs of clay that are lying down on a flat surface. You can easily print, engrave and stamp them before assembling the pieces. With other molding techniques you run the risk of deforming the creations when you print or stamp them.

Closed Shapes

Whether you pinch, coil, roll, sculpt, or throw objects, you can create closed, hollow shapes. Then you can use the air inside to shape the object the way you want it. You can even stick a straw into a newly created object and breathe more air into it. Always make sure to create a hole on one end of the object so that air can escape, or the object will crack during the drying process.

MAKING PLASTER MOLDS

The word gypsum is derived from the Greek word *gupsos*, and it means "the boiled stone." The chemical name for plaster is potassium sulfate and it is a very common mineral. Gypsum has been used as building material for decades. There is evidence that indicates that plaster was already in use during the construction of the Great Pyramids in Egypt. The raw material gypsum was analyzed during the 1700s and received its chemical formula: $CaSO_{42}H_2O$. It was also given its English term, "Plaster of Paris," as there were major discoveries nearby the city. Stucco was widely popular in Europe during this time and plaster was used to make it, and is so even to this day. Today, gypsum boards are more commonly used in the construction industry.

Plaster is a cheap and easily available material. Plaster powder can be purchased in various packages, ranging from 2.2 to 55 lbs. Store it in a dry place.

Plaster molds are widely used in ceramics. Many are simple to manufacture and require no special tools, while others are more elaborate and require more advanced equipment and a lot of knowledge. Plaster molds are practical when you want to mass-produce things. Many artisans and industries use this method. You can make plaster molds with elaborate details, but in this book we will stick to the simplest forms. If you are interested in more detailed plaster mold techniques, there are many books available that describe various plaster casting techniques in detail. In order to cast a plaster mold, you need plaster, water, and a

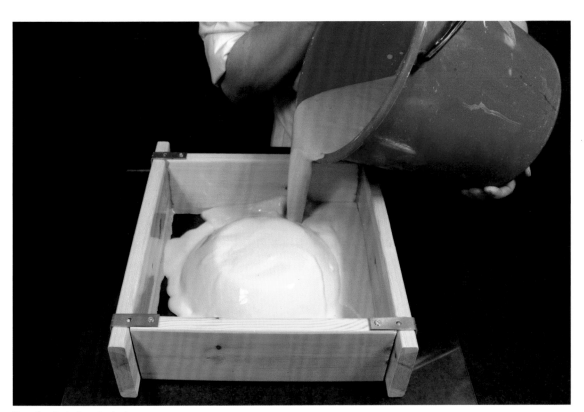

Pour the plaster in a steady stream.

bucket, something to build a frame from, and a glass board or another suitable disc that is completely smooth that you can use as a bottom plate. You also need an object—it could be a bowl or a pot—that you want to use for casting. Remember to choose a form that does not have any bulges or other details that the plaster might get caught in, or you will not be able to dislodge the object from the cast. The object that you want to use as the cast shape can be of any solid material: plastic, glass, wood or clay. You will need to lubricate the shape with cooking oil, Vaseline or dish liquid to prevent the plaster from getting stuck to the object.

Ensure that your work surface is flat and straight. Preferably use a spirit level to do so. Grease the bottom plate with your lubricant of choice. Place the object that you want to cast with the top-side down onto the bottom plate. If the object is made out of clay, it does not need to be lubricated; the plaster will easily release from it. But if the shape is made out of any other material, you will need to lubricate it. Build a wall all around the shape. Try to keep the walls around the final plaster mold about 1.2 inches thick. That will ensure that the clay in the plaster mold dries evenly. The wall that you build around the shape can consist of wooden boards, clay, a bucket without a bottom, or anything else that forms walls around the shape. Make sure that the walls are stable so that they will be able to withstand the weight of the wet plaster that will be poured into the space between the wall and the shape.

Next, mix the plaster according to the directions on the packaging. As a rule, the more water is added to the plaster mix, the weaker the end result will be. If you want a really strong plaster mold, you should mix about one part water with two parts of plaster.

Begin by measuring the water. Then sprinkle the plaster into the water. Eventually you will have a saturated mixture. You will know that it is saturated when the dry plaster starts to form small islands on the water surface, and the water layer is extremely thin. Carefully stir the plaster with a spoon or with your hand and squeeze or remove any lumps that may have formed. Mix as close to the bottom as possible. Do it carefully to release any air bubbles that may have formed. The air bubbles may appear as holes in the plaster shape and can be difficult to repair. Do not add

any more plaster or water once you have stirred the mixture. It worsens the quality of the plaster.

When the mixture has the texture of a smooth cream, it is time to pour it into the shape. Pour it slowly and carefully in a steady stream. Once the shape is filled with plaster, shake the bottom plate gently to remove any air bubbles and to create a smooth surface. The surface will become the bottom once you turn it, so make sure that it is horizontal.

Clean all the pots and ladles before the plaster hardens. Be careful not to pour any large amounts of plaster down the drain, because it will set in the pipe and cause blockage! Plaster even hardens in water.

Plaster hardens immediately. The process is called burning. After a while, it has solidified enough for you to remove the supporting walls and lift out the casted object. Now is a good time to polish your plaster mold, remove any residue clay and fill in any air holes. You can do this by using a metal rib to scrape away a little bit of damp clay and cover the hole with the same tool. You will achieve better results if the surface of the plaster mold is smooth and even. It takes several hours for the plaster to solidify, and a few days for the plaster mold to dry completely. You can dry the molds in the oven at a low heat, about 122°F. If you wait to use the plaster mold until it is completely dry you will achieve better results.

Gypsum boards are great to use underneath wet clay. You make these in the same way you would make any plaster object. However, you may want to armor them. A good gypsum board is relatively thick, at least 2 inches. If you want them a little bit larger so that they can hold a lot of clay, they will last longer if they are armored. You can use chicken wire or fabric to cover your boards. Begin by pouring plaster into the mold, add the armor material and finish off with more plaster. Allow it to dry as usual.

It is a good idea to cast round gypsum boards that you can throw objects on top of. Clay objects loosen easily from plaster surfaces because they absorb water from the clay so that it dries faster.

Be careful not to get plaster flakes into the objects. While clay will shrink, plaster will not, so when clay dries, it can crack and at worst explode if there is any plaster mixed in.

USING SLIP CASTING CLAY

You can use a plaster mold in many different ways. One is to use it with clay that has a liquid consistency. Many people believe that there are several benefits to casting in clay. First off, you can make very thin objects, and you can create many items that are exactly alike. Slip casting clay is available as earthenware, stoneware and porcelain. You can buy it already mixed, in powder form, or you can make your own from scratch. The ready-mix is ready to use immediately. If you decide to make your own from scratch, you will have a little bit of work to do.

When you buy slip casting clay from the supplier, it comes with directions on how to mix it—just follow them. Mix in a bucket with tight-fitting lid. It may seem that the amount of water is small compared to the amount of clay used, but additives can keep the clay liquid despite the low water content. Always begin by measuring the water, then add the dry ingredients. Rainwater is good, because it is soft. Allow the mixture to stand one day before you stir it. The clay is a bit tough to stir. You will benefit from using a drill with a whisk attachment. Then the clay mass is sieved to remove any lumps.

Check the mass density with a hydrometer once the mass is completely smooth. A hydrometer looks like a thermometer. It will bob a little when you carefully lower it down into the mass, but will eventually stop with a portion above the surface and some below. The figure that ends up exactly at the surface line is your reading scale.

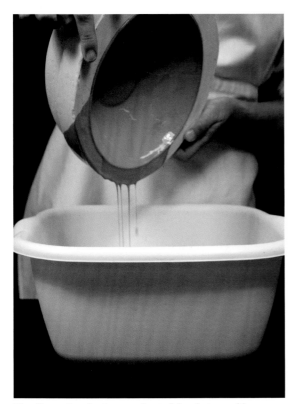

The slip casting clay is poured out of the plaster mold.

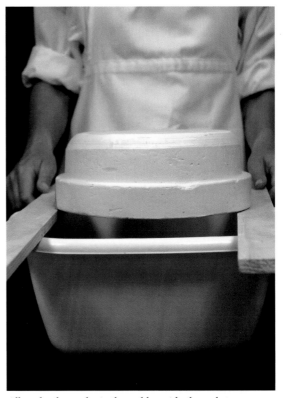

Allow the clay to dry in the mold, upside-down, between wooden strips.

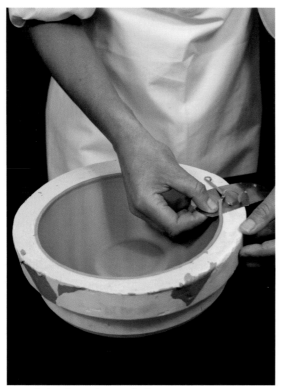

Smooth the edge with a metal rib.

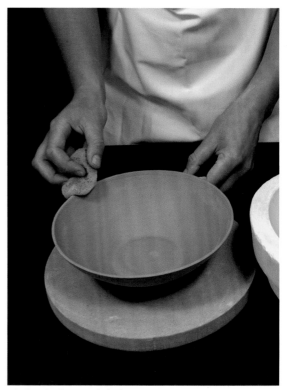

The bowl is being polished.

Before you pour the clay into the plaster mold it is good to moisten the interior. It will make it easier to release the clay out of the mold. Make sure that the mold is standing on an even surface before you pour the clay inside. Pour slowly in an unbroken stream to avoid the clay from sloshing around. Pour it to the brim but without overflowing the clay. The plaster mold will absorb the water, which means that the surface will sink after a while. When that happens, gently fill it up again. Wait until the object you are casting has the desired thickness, it can take anywhere between 15 and 45 minutes.

If you are using an open mold, you will see how the clay gradually solidifies from the edge and inward, and you can determine when the walls have a suitable thickness. A good way is to time it, to ensure that objects become evenly thick. Slip casting clay is easily bruised and therefore it is good to try out different thicknesses on the objects. Some shapes handle thin walls better than others.

When you have achieved your desired thickness on the clay walls, it is time to pour out the clay.

Again, it is important that you pour the clay carefully, otherwise it might leave marks on the side that you pour from. If you pour it gradually and continuously increase the angle of inclination, it will not spill on the edge and leave any marks. Then place the plaster mold upside down, between two wooden strips over a tub, so that all the wet clay flows out of the mold.

When the clay has hardened a bit, flip the mold and use a metal rib to cut off any excess clay that might have gathered on the sides to get a smooth edge. Then you will have to wait a bit longer before it is possible to loosen the object from the mold. It can be anything from leather hard to almost dry. Keep in mind that at this stage the clay is extremely fragile, so treat it with caution. At this point you can also use a damp sponge to smooth the edges. Then, you can move on to the next one.

When you are finished molding, seal the lid on the bucket tightly until it is time to use it again. Slip casting clay settles easily and forms hard sediment at the bottom. If this happens, you whisk it, and sieve

Stoneware, slab constructed, decorated with screen printing, glaze fired in an oxidation kiln, cone 8.

the clay mass to remove any lumps. You may want to re-check the mass density with a hydrometer. If it has been standing for a while, liquid may have evaporated. In that case, you add water to achive the same density number as before.

You can also make your own slip casting clay. Here is a recipe that you can use:

135 oz water

22 lbs clay powder

0.044-0.066 lb of soda ash

1 oz water glass

Use this recipe as your starting point and experiment until you find what works with the type of clay that you are working with. Various clays have different content and you may need to adjust the individual quantities in this recipe.

Other Ways to Cast Clay

Another way to use plaster molds, as earlier mentioned, is to roll clay and put it inside or on top of the shape, but you can also use your fingers to press the clay into the mold, or cover it with rounded coils. The various techniques each offer an interesting outcome when used with a plaster mold. It is also common to use plaster molding to create little decorative details. Make a plaster mold out of a decorative shape that you wish to decorate your creations with and press a bit of clay into it and you will have a beautiful application.

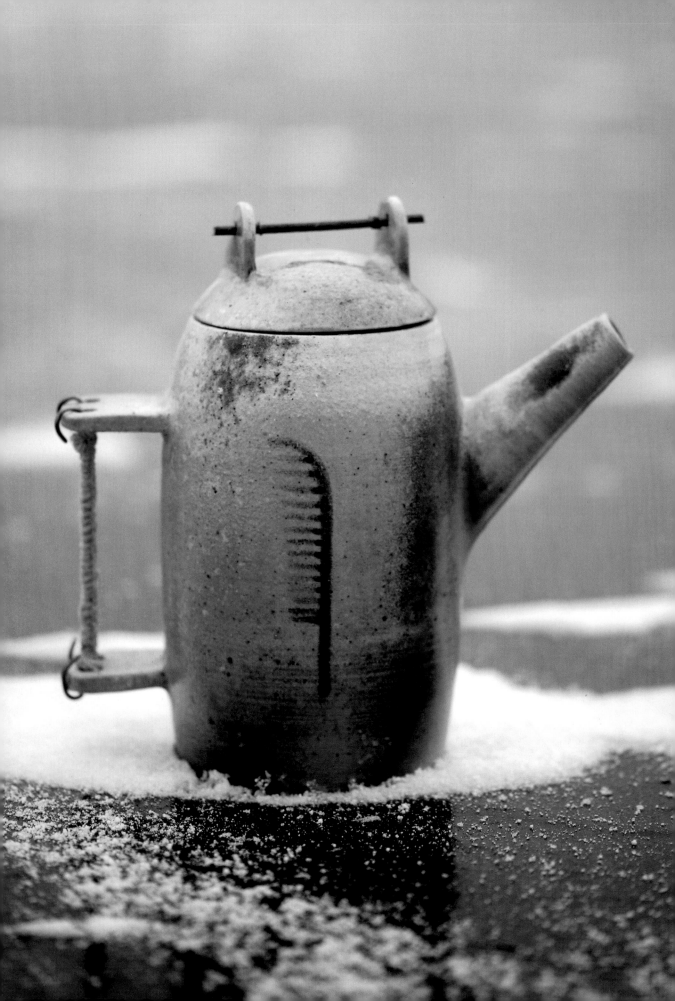

THROWING

It is easy to be in awe when you watch someone throwing an object on a potter's wheel. It looks like such an easy and quick task. Suddenly the lump of clay has turned into a tall vase or a large bowl. How did it happen? Well, it required some training. If you study ten different people who have mastered the craft, you will notice that there are many different approaches.

Pottery is an ancient technique. Representations of potter's wheels have been found in Egypt from about 5000 BC. The technique has spread from that region since and today banding wheels come in all sorts of shapes and sizes. The throwing wheel used to be very large at the beginning of its time, and a long stick was used to spin it. Later, kick boards were used for the same purpose.

Manual potter's wheels are still being used today, but electrically driven banding wheels are more common. There are plenty of different options to choose from. If you are looking to throw large objects, there are machines that are a bit more expensive that can hold up to 220 lbs. If you wish to start on a smaller scale, there are simpler options that are less expensive. You can also choose a throwing wheel that you can use sitting down or standing up. It is a great advantage to be able to change positions.

Tool preference differs from person to person, and you will discover your own favorites over time. Always keep the tools at your workstation so that they come in handy when you need them. Throwing objects in front of a mirror may be of a great advantage. It will prevent you from keeping a crooked and rounded spine while you are trying to view the object from the sides, because you will be able to see the how the entire object grows and takes shape in the mirror.

It is wise to weigh the pieces of clay before you begin. A good weight to start out with is 17.6 oz. If you weigh up several pieces of clay of the same size, you can easily track your development by continuously measuring the objects that you create. With 17.6 oz you can create a 5.1-inch-high cylinder that is 3.9 inches wide, or a bowl that is 2.8 inches high and 5.9 inches wide.

Approximate measurements, all in untrimmed condition:

Item	Weight in lbs	Height in inches	Diameter in inches
Cylinder	4	11.8	4.7
Bowl	1.1	2.8	5.9
Bowl	1.8	3.9	7
Cup	0.7	4.7	3.5
Pitcher	3.3	9.8	4.7
Plate	3.7	1	11.4

The most important thing, other than your tools and the clay, is to have a collected mind and a good mood. If you feel stressed out, you might as well do something else, because this process requires calm and focus. Feel like you will be able to pull it off, and you will!

Centering

Once you have positioned yourself comfortably in front of your potter's wheel, it is time to place the piece of clay on it. Place it in the middle of the throwing plate with power! It is important not to get any air in between the clay and the throwing plate because then you may encounter problems with the centering, and you will have problems with creating a nice foundation for your object. Shape the clay into an egg shape to prevent air from getting trapped in between the clay and the potter's wheel. The egg shape will make it easier to distribute the clay over the throwing plate.

Then, start the potter's wheel. The centrifugal force will tend to move everything on the throwing plate away from the center. Use focused and calm movements to guide the clay where you want it.

Stoneware, thrown, amagama fired, cone 10 (opposite).

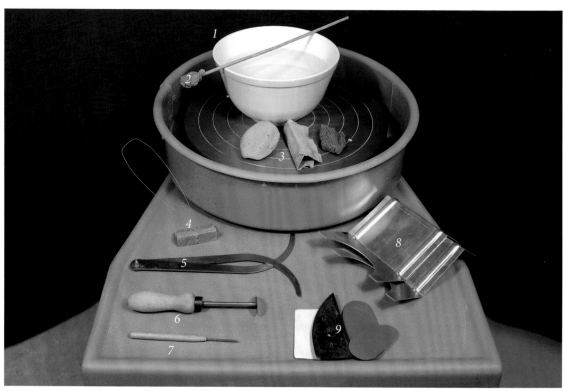

1)Water Bowl 2) Sponge on a stick 3) Sponges and chamois 4) Cutting wire 5) Caliper 6) Trimming tool 7) Pin tool 8) Lifters 9) Potter's ribs

What You Need to Get Started

Bowl with water	
Cutting wire	Use cutting wire to cut the clay off the underlay.
Sponges	Use sponges to even the clay out, or to wipe it off.
Sponge on a stick	Use it to wipe the interior of tall and thin objects. You can easily make your own by attaching a sponge to a stick with a rubber band.
Pin tool	Use it to measure the thickness of a thrown object's bottom, or to cut off uneven edges.
Rib	Potter's ribs come in many different shapes and forms, and are made out of various materials.
Trimming tool	Use it when throwing and polishing objects.
Ruler	To measure objects.
Caliper	Use it to measure the exterior and the interior of objects.
Lifters	Assists you in removing objects from the potter's wheel.
Particle boards / Tiles	Place newly thrown objects on top.
Bats	Plates out of various materials that attach to the potter's wheel.

Moisten the clay with water while the potter's wheel is spinning, and make sure that your hands are wet enough to prevent the clay from sticking to your fingers. Unexpected friction is a guaranteed disappointment no matter how far along you are in your work. However, you have to be cautious not to pour too much water, because it will soften the clay too much, and make it difficult to handle. Clay collapses easily once it is saturated with water.

Now it is time to begin the centering itself. That is, to place the clay right in the middle of the potter's wheel. It is a very important step. Use both your hands, and ensure that the arms have proper support against the throwing tub or your body. Approach the clay carefully, and do not apply all your strength at once, but gradually. If you imagine that the potter's wheel is a dial that spins counterclockwise, add the pressure at 8 o'clock. Then press the clay toward the center evenly with one hand, while you hold the clay with the opposite hand for solid support. If you push the clay from both sides, it will wobble and get off-

center. Always keep the potter's wheel spinning, both when you gently put your hands on it and when you remove them. Any jerky and fast movements will easily push the clay off-center.

It is now time for you to shape the clay into a rising cone. Be careful to avoid a hole forming at the top of the cone. You can tilt your thumb over the top to prevent this from happening. Make sure that you do not make the cone too tall in the beginning. The important thing is to create a peak shape, to which you can guide unevenly distributed clay. Bend the cone carefully forward with one hand and press it down to flatten it, kind of like a grapefruit that has been cut in half. This process is usually done three times, and each time you make the cone a little bit higher. This cone building process has two important functions: It homogenizes the clay and makes the centering easier. Every time you raise the cone, make sure that the clay closest to the potter's wheel (the bottom of the cone) is evenly centered. If that part becomes uneven and wobbly, the clay will not stay

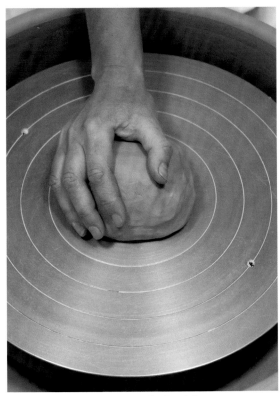

Place the clay onto the potter's wheel with force.

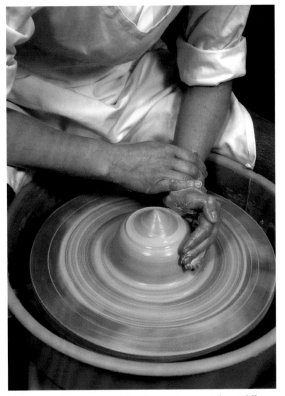

Gather up the clay by pressing the wrist against the middle.

centered. Work through that part of the clay with your wrist until the clay spins smooth and even.

Take your time with this process in the beginning. Discover your own way by playing with the clay; feel it and pay attention to it. The important thing is that you get an idea of what happens to the clay when you treat it differently.

Remember always to use both hands for increased stability, and be sure to handle the clay with care. It may be difficult to keep the hands still at first. It will seem as if the clay is the one leading, and your hands are just following along. You are the one who should take charge over the situation. No need to use force or big muscles to achieve this, just stay focused and have plenty of patience. If you have been working on centering your piece of clay for a while without any success, you can deliberately push it off center a little, before you slowly and gently try to get it in the middle. Sometimes it works better if you close your eyes. Rest your arms on your legs or on the throwing tub, or fold the elbow into the stomach to find support. Through practice and experience you will discover the technique that suits you best.

Making a Hole and Opening Up

Once the piece of clay appears to be completely still while the potter's wheel is spinning at full speed, the clay is centered. It is now time for the next step, hole piercing. This step may be done in several ways. Make sure that the potter's wheel is spinning at a high speed. Use one or more fingers to pierce a hole in the middle of the piece of clay. Remember to moisten the clay and make sure that the hands are connected the entire time. You need to be determined when you make the hole so that it pierces straight down the middle of the clay. If you pierce it off center, or make it wobbly, the clay will move off center again.

Make the hole about as deep as the bottom, which will be about 0.4 inches thick. This measure allows for different options when you want to finish off and trim the bottom; see page 57. You can keep track of the thickness by sticking a pin tool through the bottom, straight down into the bat, when the potter's wheel is completely still. It is better to start out by making a

shallow hole, as it makes it easier to adjust than if you make a hole that is too deep. However, if you make the hole too shallow, the bottom will turn out very thick, and the object becomes heavy and clumsy.

When you are satisfied with the thickness of the bottom, you should finish it. Squeeze the clay with your fingers straight outwards to the sides a few inches, until the bottom has the width that you desire. The clay that you push away will form the walls of the object. Level off the bottom by sliding your fingers back and forth over it to smooth it out, but also to prevent tensions. It is important that you are thorough with this process because it will prevent the bottom from cracking during the drying stage.

Now it is time for you to determine the angle of the bottom in relation to the wall, whether you want a sharp angle or a rounded one. A sharp angle is characteristic of a cylinder, where the wall of cylinder remains vertical. But you can also make a sharp angle in any other degree, depending on whether you want a wall that is slanted inwards or outwards. A rounded angle is a characteristic feature for a bowl shape, where the inner line of the bowl does not have a beginning or an end.

Once you have decided how to connect the bottom with the walls, it is time to pull up the walls. Once you have practiced a bit, the piercing, the process of pressing out the bottom, and the first pulling up of the walls will only take a few seconds, and you will be able to do everything in one single sweep. But before you become used to this process, it will take a little bit longer. There are different ways in which you can pull up the walls, and it is common to use different techniques depending on the amount of clay that you are working with and what end result you are envisioning. Simply put, you use the clay contained in the walls and draw it upwards and distribute it evenly. It is important that you take it slowly and keep the same pressure with the fingers so that the walls form a uniform thickness. It is also important to have plenty of water, both on the interior and exterior walls; otherwise you risk getting the fingers stuck in the clay. In the first sweep you can lift the clay with one hand, just like a claw that grabs the clay and lifts it straight up. However, it is more

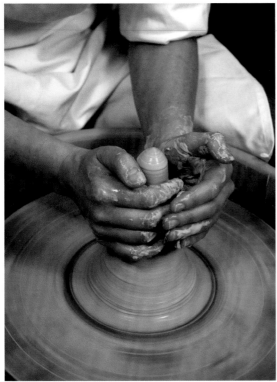

Squeeze the clay into a cone.

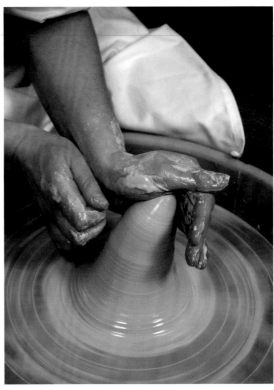

Press the cone down by bending it forward.

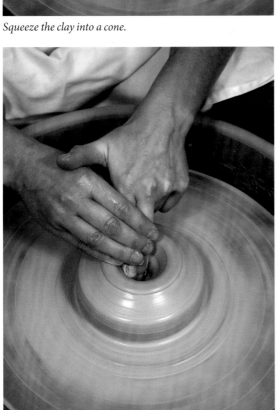

Press one or more fingers down into the clay to make a hole.

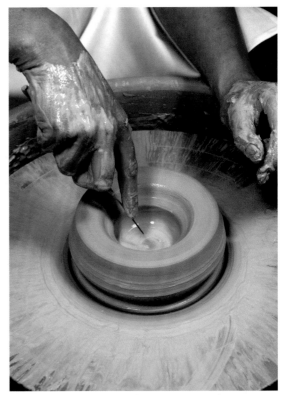

Check the thickness of the bottom with a pin tool.

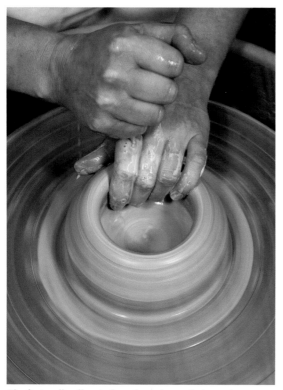

The first wall pull up is done through a crab claw grip.

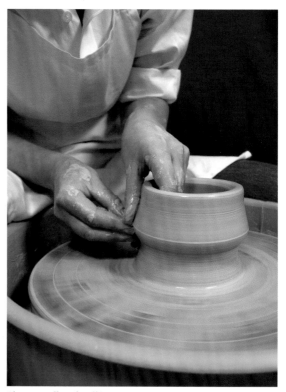

Shape a roll and pull it up.

common to use both hands to pull up the walls, either with your fingertips on the inside and outside, or with the left hand's fingertips on the inside and right knuckle on the outside. The knuckle gives extra support when you are throwing bigger objects. Some people like to use a sponge or a rib against the exterior wall, while the wall is being pulled up. Try it out, since it is a highly personalized process. When you pull up the walls, you should ideally also squeeze a little bit inwards because the centrifugal force will expand the object's edges outward.

You can use a sponge to remove water that has collected inside. Little lakes that form on the bottom will eventually weaken the object. It is better to regularly remove the water, and add more when you need to. Remember to replace the water in the water dish whenever you are throwing objects for a longer time, otherwise you may get a bowl with a slip.

How to Throw a Cylinder

When you come this far, it is time for you to lift up the walls to their final height. Begin by making a

cylinder. Slow down the potter's wheel a notch. Use the left middle finger to press out a roll on the interior, right above the bottom where the wall begins. Use your right hand for resistance on the exterior wall, but let the pocket be about 0.5 inch. The exterior will be bulging out unless the walls are very thick. Wet the interior and the exterior of the clay walls with water. Place your left middle finger in the bulge that you have made, and use the right fingertips on the outside just below the bulge, but about 0.5 inch in front of your finger on the interior wall. Envision a clock and imagine that the grip should be performed somewhere between 3 and 4 o'clock. Keep a steady grip without applying too much pressure to lift the clay. Do it all in one constant motion, using the same speed the entire time. The clay will be thinned out as the walls begin to grow. Remember to lift straight up. When you come close to the edge you reduce the pressure completely from the inside and keep only the left fingers for support, while you continue with a little pressure from the outside to keep the cylinder from becoming wider and wider. Be thorough with

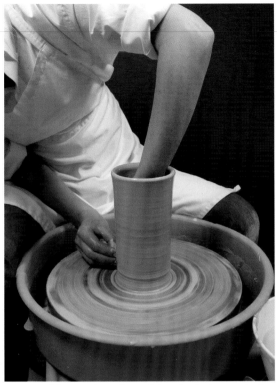

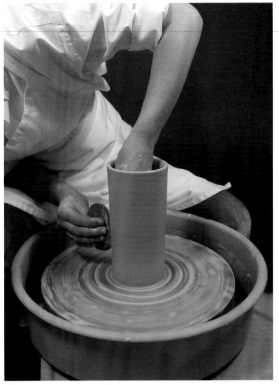

Continue lifting up the walls until the cylinder has reached its final height.

Use a rib to smoothen the exterior.

the edge. If you have a solid edge, it will increase the stability of the entire object. To strengthen the edge, place the left hand thumb and forefinger on either side of it and put the right index finger on top of your fingers and press gently. This process will ensure that you get a collected and compressed edge. You can also use a sponge or a chamois.

Repeat this pulling up procedure several times and complete the lift all the way up to the edge. Make sure to incorporate all the clay from the outer edge of the bottom so that it does not form a skirt on the cylinder. When you have reached your desired height on the cylinder, it is time to polish it before lifting it off the potter's wheel. Many people consider the stripes that are formed on the exterior during the throwing process to be highly decorative, and if you decide to keep them, leave them alone, but perhaps take a sponge and remove any water or slips. If you want a completely smooth surface, use a rib on the cylinder's outside while holding a supporting finger with the left hand on the interior. You may also need to check the

edge of the cylinder. If you want a rounded edge, you can place a chamois over the edge, and keep it in place with one hand on each side of the cylinder, and the edge will be nice and rounded. You can shape the edge flat with by using a finger. It is worth spending a little work on completing the edge. It is a big part of the overall impression of the cylinder. Do not forget about the outer edge of the bottom. Cut away any excess clay with a trimming tool.

Once you are done with the final details, remove the water from the bat and use cutting wire to cut the cylinder off of it. Make sure to dry your hands before you take a firm grip around the cylinder and lift it off. Place the cylinder on top of a particleboard covered with newspaper. The paper prevents the object from getting stuck to the particleboard.

Once you have some practice and experience you will be able to lift the cylinder up to its final height in about three rounds, but in the beginning you will usually need to lift it more times than that. Remember not to grab too much clay each time.

It is a matter of taste how high and how thick you want your cylinder, but there is a limit to how much the clay can handle. It varies from clay to clay, so you can try your way, but it is important to remember that the more times you pull up the clay, the more water is added. That combined with the fact that the walls get thinner will weaken the clay.

In most cases, you begin all the moves from the bottom, because that is usually where most clay is collected, and you complete the lifts all the way up to the edge. In the beginning it may be difficult to keep an even pressure the entire lift, which ensures that the wall will be even. Move your fingers gently along the interior and exterior walls to feel if there is any roughness to the surface. The clay may vary in thickness in different places on the cylinder. If this is the case, you can drag some clay from the thicker part where there is more clay.

The edge of the cylinder may begin to move outwards. To be able to continue working on it, it is good

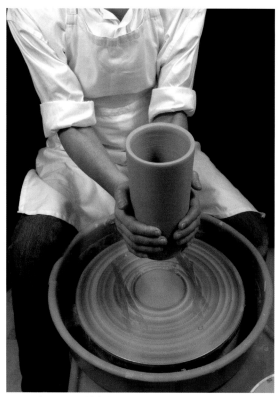

Cut with wire, and lift the cylinder with dry hands.

to tighten up the edge, and pull it together to regain control over the object. You can do this by grabbing the cylinder around the edge with both hands on either side and very slowly squeeze it together. When you perfom this strangling pressure on the clay, it is of great importance that the movement is done slowly. If the edge is thin and you work too quickly, small ruffles may form in the clay that can be difficult to get rid of. Ruffles can also be a sign of the clay being too wet.

Another thing that could happen is that the edge becomes uneven, that it is higher on one side. This happens if you grab the clay with different pressure on the various sides when you lift the clay up. To rectify it, just cut the edge where it is higher so that it becomes even on all sides. This is easily done by using a pin tool. Use a lower speed on the throwing wheel when performing this task. Keep the pin tool in your right hand. Let the left hand rest against the right hand for support, as it holds the edge. Then you slowly and carefully press the pin tool against the clay walls and make a notch. As the notch becomes deeper the clay above the pin tool begins to loosen. When it does, lift it off and clean up the freshly cut edge with a sponge or a chamois.

Another problem that may occur is the formation of air bubbles. You feel the air bubbles right away when you throw an object, and the faster you get rid of them, the better. The easiest way to do so is to take a pin tool and stick it straight through the bubble, so that it becomes a hole straight through the wall. If you are lucky, the air will be removed when you throw the object and lift up the walls. If that does not work, you will have to pierce new holes and try to fill the void from the air bubbles with clay. If you do not find the air bubbles disturbing while you are throwing the object, you can wait until the clay is leather hard before you pierce them and smooth them out.

The cylinder is an excellent practice item, and cutting your newly thrown objects in half with a cutting wire will help you evolve quickly. It will give you a chance to observe how you are throwing the objects. It will enable you to observe the thickness of the bottom, and determine if you were able to lift the clay up into the walls or if too much of it remains on the

bottom. You can also see the thickness of the walls, and how evenly thrown they are. A good tip is also to throw the object for so long that it becomes so tall that the clay collapses. This way you familiarize yourself with the clay and become aware of its limitations. After analyzing your creation, you can place it onto a gypsum board and start working on a new piece of clay. Practicing in this way will help you develop fast, and once you have mastered a good cylinder, you will easily move on to more complex shapes.

Other Shapes

The cylinder is a starting point for a variety of shapes. Using it as a basic structure you can decide whether you want a bulging shape, or an inward structure, or both. The process is very logical. If you want an object with a swelling shape, you create it by pressing a little extra with your fingers from the inside. If you desire a waist for your object, press with your fingers from the outside, or use a strangle grip, which was described earlier. Using these

techniques you can make round ball shapes, bottles, jugs and all sorts of other objects.

Throwing a Bowl

The process of throwing a bowl is very similar to that of throwing a cylinder, and it is also easier. Thanks to the centrifugal force your potter's wheel will naturally create a bowl shape.

You begin the same way as with the cylinder, by centering it and making a hole. When piercing the hole, consider what kind of foot ring you want for your bowl. If you are going to do a high foot ring, you will need extra clay in the bottom to work with in order to eventually achieve this, and you shouldn't make the hole too deep. A bottom that is 0.5 inch thick is suitable for many different design options.

You create a rounded bottom with your fingers. When you pull out the bottom of the bowl, you do so in a sweeping motion where the thumb continues up the wall so that there is an unbroken line. You might need to work a little bit on this unbroken line to make

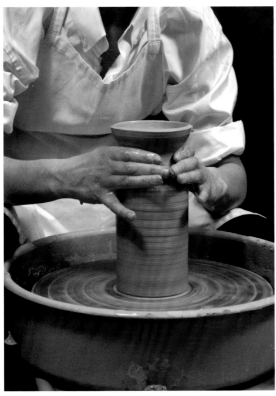

Strangling.

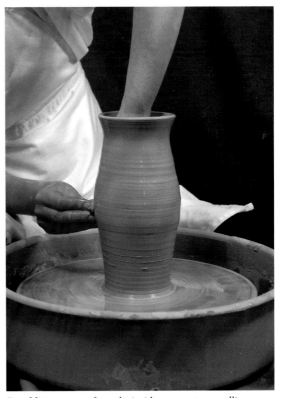

By adding pressure from the inside you create a swelling shape.

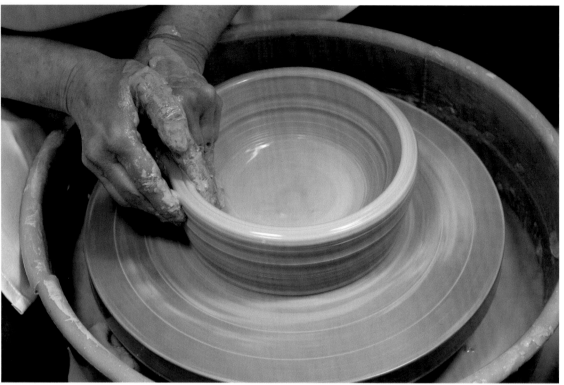
The bottom is constructed.

it pretty. If you are careful and cautious you will be fine. When you lift the walls up, you begin the same way as when you are making a cylinder, but you pull the walls slightly outward. Then you proceed gradually by slowly pulling the walls up and out by grabbing clay from the bottom. You will benefit from not pulling the walls too much outward, rather try to keep them tighter together. It is much easier to widen a too narrow bowl than to try to tighten one that has become too broad. Remember to lower the speed on the potter's wheel. The larger and wider the bowl is, the more you need to slow the speed down.

When you are throwing bowls, make sure not to make the walls too thin at the bottom, especially if you are making bowls that are low and wide. The clay at the bottom helps to carry the entire shape.

When you are working with a bowl shape, the inner line is especially important because it gives character to the entire dish. If you want a bowl that is perfectly round inside, make sure to get a smooth unbroken curve from edge to edge. You can use a rib to help create this shape.

Another very crucial factor for the entire expression of the bowl is the edge. Keep it in mind when you are throwing so that it does not look as if you suddenly ran out of clay. You are in a good place if you make sure that the edge is a little bit thicker than the wall, so that there are plenty of design options when you are about to finish off the border. It can have many different finishes, and depending on how you choose to make the edge, it will convey different things. You can make it rounded, perfectly straight, you can tilt it in different directions and create angles, or bend it in different ways. Experiment to find out what kind of edge suits your particular bowl the best. A good way to check this is to walk away from the potter's wheel and observe it from a distance. This will give you a much better perspective than if you sit right in front of it. What do the different finishes mean to you, and which one suits you?

It can be difficult to remove a bowl from the potter's wheel, especially if it is wide, and the wider the bottom, the more impossible the task seems. Therefore you should keep in mind to keep the bottom fairly

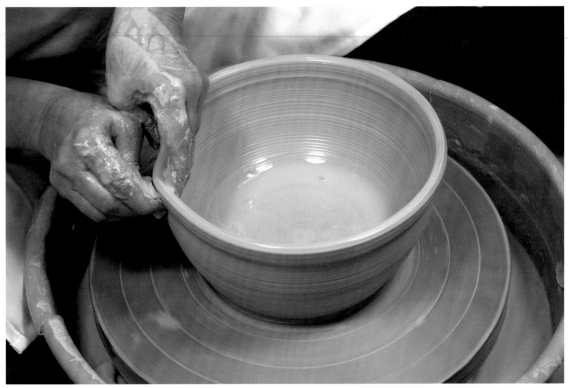

Save clay for the edge.

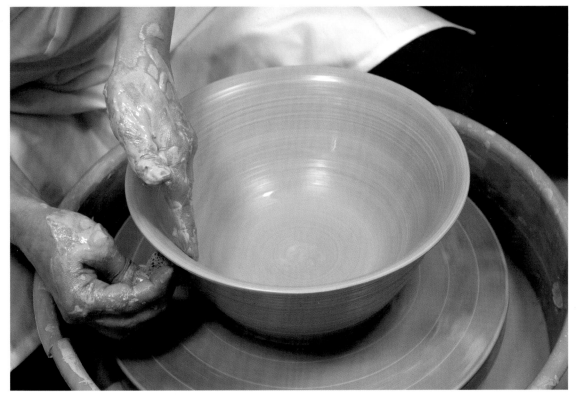

The characteristic of the edge is completed.

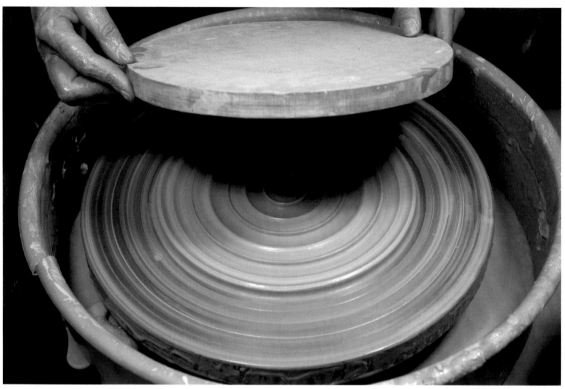

Press the plate into place.

small if you want to throw the bowl on the potter's wheel. You can put a piece of newspaper on top of the bowl edge to prevent the bowl from deforming when you lift it off. Wait until the edge forms a damp ring through the paper. You can assist this process by spinning the potter's wheel slowly while you hold your finger carefully on top of the edge. This little maneuver captures air in the cavity, which helps to maintain the shape of the bowl when you lift it off.

You can also let the bowl slip off on a coat of water by squeezing some clean water from a sponge onto the bat and using a cutting wire to slide water underneath the bowl. The water will move the bowl slowly towards you, and when it is right by the edge, you can push it over the edge slightly so that you can get a couple of fingers underneath the bowl and lift it off.

You can also use lifters. You stick them underneath the object from opposite sides after you have cut it off with cutting wire. Then you lift. A spatula or any similar object will usually work as well, especially if you add a little extra water on top.

If you prefer not to lift it at all, you can use a tile with a little bit of water and allow the bowl to glide over the edge of the potter's wheel and onto the tile.

That will reduce the risk of the bowl getting deformed. It is important that the tile, or whatever type of plate that you choose to use is quite wet, otherwise it will halt the process.

Throwing on a Plate

To avoid the soft and newly thrown object deforming when you remove it from the bat, you can throw it on a plate instead. Then you can lift off the entire plate with the object when it is completed. Today, most of the new potter's wheels that are sold have special holes to which you can attach various types of tiles with the use of nuts. You can buy these special plates and they are made out of plastic most of the time. They are relatively expensive, and if you wish to throw several different objects you will need a few of them. However, there are simpler and cheaper methods.

We begin with the plates. They need to be made out of some type of absorbent material such as wood,

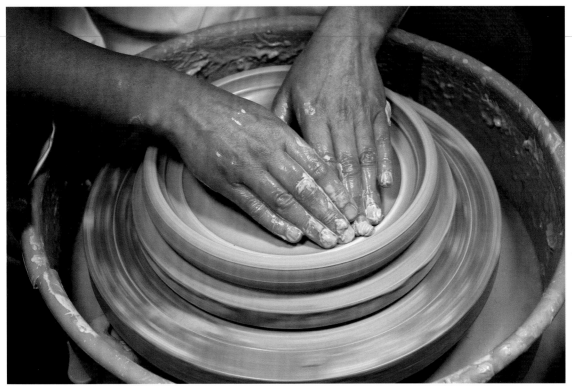

Broaden the base by pushing the clay to the edge.

plaster or bisque fired clay. If you choose to use wood, a particleboard is an excellent choice. You can easily cut them into circular plates. It is wise not to choose particleboards that are too thin because then the plates will easily wear down with time and might give your objects a slightly rounded bottom. Plaster boards are a great choice if you want to remove your objects easily, because they absorb the moisture from the bottom. You can easily make your own plaster boards; see page 32.

There are different ways in which you can attach your plates to the potter's wheel. The easiest way is if you get it as centered as possible onto the potter's wheel. Most potter's wheels are marked with lines that you can use to guide you when centering the plate. You can use pieces of clay to attach your plate. Attach the plate by placing it directly onto the potter's wheel and press three pieces of clay around it at 12, 4 and 8 o'clock. Make sure to push them down thoroughly to secure the plate. When you have finished throwing the object, just twist the plate and lift it off and attach a new one. The pieces of clay will hold about six plate

changes before you need to replace them. They soak up water while you are throwing objects and when they become too wet, they can no longer keep the plate in place. Then it is time to replace them with new ones. Therefore, it is good to use clay that is relatively solid to attach the plate with.

It is also common to throw a clay base to which you attach your plate. You can keep the clay base for several days if you cover it with plastic and add more water to it. When you do not want to use the clay base anymore, collect the clay and knead it again.

The amount of clay that you need will depend on the size of the potter's wheel. Generally, you will need a piece that is between 17.6 ounces and 28.2 ounces. It provides a clay base that is close to the size of the potter's wheel, and a little less than 0.4 inches high. Customize it to the size of the plate that you attach to it.

Begin by centering the clay as usual, but instead of making a hole, make a wide cut in the clay from the center outwards. Use the wrist to press the clay down and outwards. Try to keep the pressure as even as possible so that you create a flat surface. Press from the

49

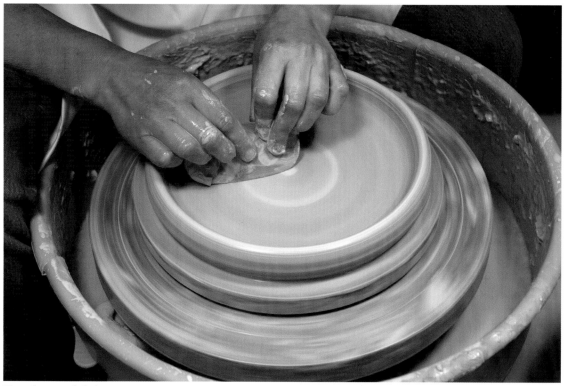

Use a rib to smooth the bottom.

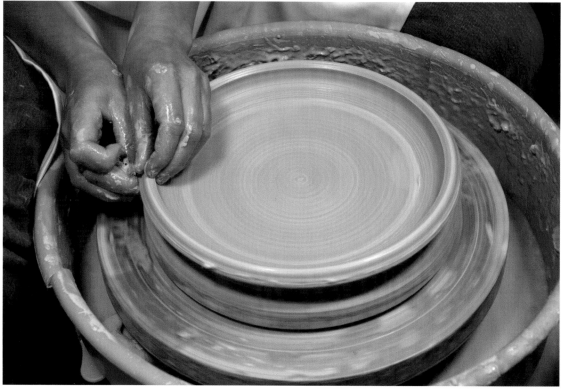

Constructing the brim.

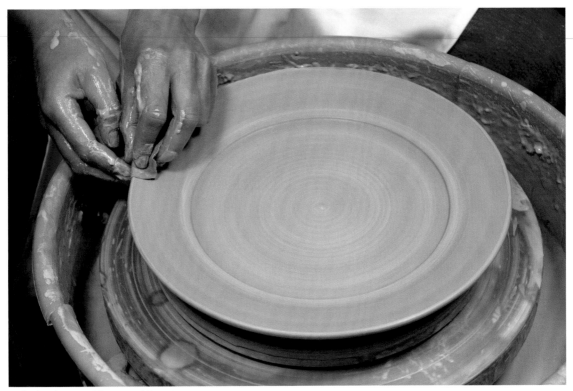

Make the edge even with a piece of chamois.

inside out the entire time and be careful not to trap any air between the outer edge and the potter's wheel. Use your fingers or a rib to create a flat surface. Once it is smooth and even and the size that you want, take a finger and create furrows in the clay base while the potter's wheel is spinning. These grooves leave room for air that will help suck the plate down to the clay so that it stays in place securely. Every time you wish to change the plate and replace it with a new one, you should add water to the clay base for a firm hold. Use your body weight to press the plate down. Once you have attached a plate this way it is secured so tightly that it might be difficult to remove it. Stick a screwdriver or a similar object underneath the plate to loosen it more easily.

If you are throwing on the plate, you will be able to create broad and large objects, and easily remove them from the potter's wheel without deforming them. This way you can make objects that have a wider bottom than the potter's wheel that you are using. When you are using plates, especially gypsum boards, you will not need to cut the object off with

cutting wire. The bottom of the object will dry rapidly so that the object can be removed easily.

Throwing Plates and Saucers with Brims

It is almost necessary to use a plate when throwing plates and saucers. You can make small saucers directly on the potter's wheel, but if you intend to make an object with a wider bottom you will need to place a plate underneath to be able to remove it from the potter's wheel. Throwing a plate is much like throwing a cylinder except that you fold the walls down.

Begin by placing a base plate any way you like it, and center the clay on top. Then, make a plate the same way you would make a clay base, but instead of shaping it completely flat, you leave a little wall along the outer edge. The bottom is particularly important when making a plate. You want it to be absolutely smooth and without any marks that silverware can get stuck to while you eat. Use one of your wrists to work the clay inside the plate. Keeping the elbow high while you press down will give you extra power and stability. Support the outer edge of the plate with the

opposite hand. The wall along the outer edge will grow as you press the clay with your wrist. Remember not to make the bottom too thin. Keep it about 0.5 inch thick. You can do all this while the potter's wheel is spinning pretty fast.

Unlike the process when you are making a clay base, you need to be especially meticulous when creating the bottom of your plate. Constantly pressing the clay towards the edge will create enormous tensions in the clay, and therefore you must make sure to work the clay back towards the middle. You do so by dragging your fingers over the clay from the edge and towards the center with a fairly light touch. This will also even out the surface. It is good to do this a few times back and forth until you get a very smooth and plane bottom. You can use a rib to help you create an extra smooth surface. When you are finished with the bottom, and the plate has a nice clay wall around the perimeter, it is time to make the brim. It can be done in different ways. Start by gathering any excess clay onto the potter's wheel, because you will not be able to access it at a later stage. You should also reduce the speed at this point.

One way is to pull up the wall like on a cylinder. Then slowly fold the wall down by pressing your hand against it from the inside. Keep the other hand on the outside as support. It is important that the potter's wheel is not spinning too fast, to prevent the wall from collapsing. You can use a rib instead of using your hand. The rib will also collect any clay slips or unnecessary moisture, which can weaken the clay. You can press the wall pretty far down, sometimes completely horizontally, depending on what type of clay you are using. Try things out to get a feel for how much the clay that you are working with can handle.

The width of the brim will affect its outcome. A shorter brim withstands a much sharper angle than a wider one. The edge tends to rise as the clay dries so take that into account and make sure that you do not create a brim that is angled too steeply.

You can also create a brim right from the start, much like when you pull up the walls on a bowl. Spin the potter's wheel fairly slowly during this process. Instead of pulling the wall upwards, drag it away from the center right away. This is usually done in a single stroke. It is important that you work with a lot of composure as the potter's wheel is spinning much slower. If you work too fast, the edge will easily become uneven. If you are going to pull the brim out in several strokes, you need to make sure that you do not make them too horizontal, as this will make it difficult to get the hand underneath the brim before the next tug. You can finish off the brim by dragging a rib over it. You will benefit from supporting the edge from underneath the edge with one hand while you are doing it.

If you're going to cut the plate off with cutting wire once you have thrown it, you need to tighten the wire firmly and press it hard against the potter's wheel. If the bottom is very wide it will not matter how hard you press the cutting wire down as you cut, it will still move slightly up and cut into the bottom of the plate. If you are unlucky it might even cut a hole in the center of the plate. You need to take this into account before you determine how thick you want the bottom. A much better option is to throw plates on top of gypsum boards as they will detach on their own once the gypsum has soaked up the moisture. It is a slightly longer process as you allow the plate to dry slowly, covered in plastic, until the plate finally loosens from the potter's wheel.

Thrown plates. 1)Earthenware, glazed, faience painted, oxidation fired, cone 5. 2) Stoneware, sgrafitto decoration, glazed, oxidation fired, cone 8. 3) Stoneware, sgrafitto decoration, glazed, oxidation fired, cone 8. 4) Stoneware, decorated with colored wax, glazed, oxidation fired, cone 8. 5) Stoneware, brim decorated with engobe, oxidation fired, cone 8. 6) Stoneware, glazed, oxidation fired, cone 8.

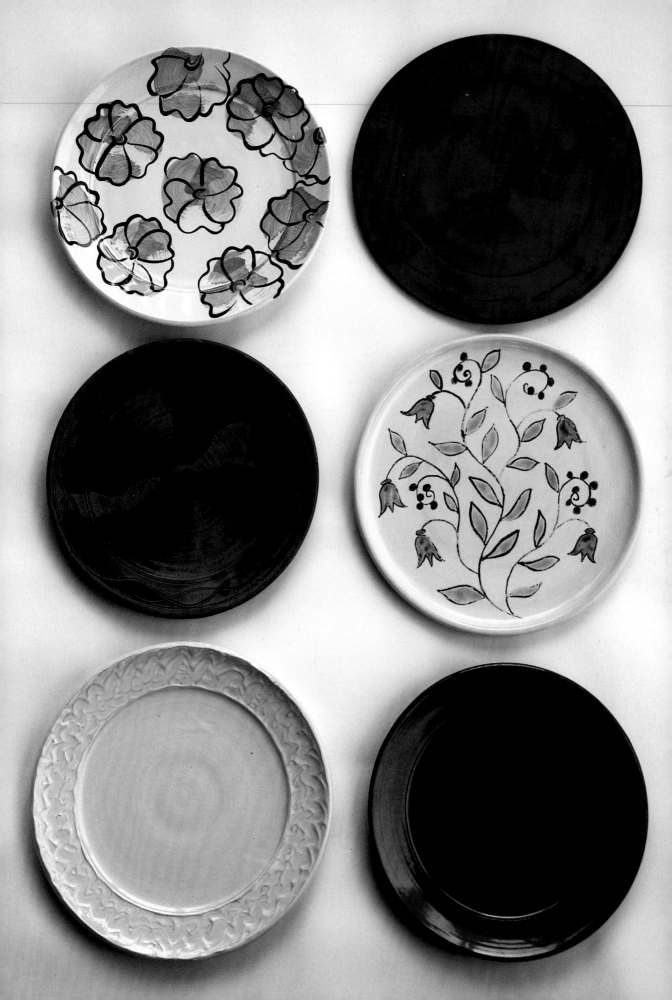

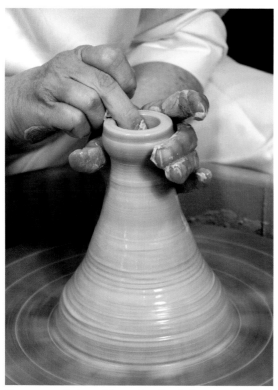

Center a small piece of clay and make a hole.

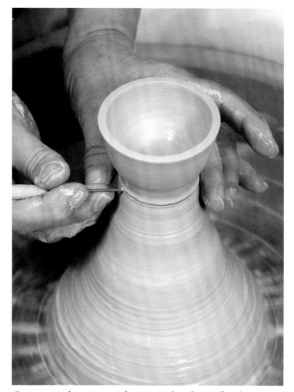

Carve an indentation with a pin tool and cut off with cutting wire.

Throwing on a Piece of Clay

If you are going to make many small and identical objects, you will benefit from using a technique that is called throwing on a piece of clay. Instead of weighing each little individual piece of clay, you take a rather big piece and attach it to the potter's wheel. You do not need to be meticulous when you center it. You will create the individual pieces of clay as you work on it. You collect clay on top of the piece of clay while the potter's wheel is spinning. You can use your hand as a measuring tool to make sure that each piece of clay is approximately the same size. Then center the small piece on top of the large piece and throw the object as usual. When you are finished, you cut off the small object with cutting wire or a knife and lift it aside with dry hands, before you start working on the next piece. This is a fast and effective way to create smaller items such as eggcups, lids or small bowls. They tiny objects are easier to throw on a piece of clay because you get closer to them as the big piece of clay forms a hill. Otherwise, small things can be tricky to work on when you throw them directly on the potter's wheel.

When the object comes up a bit in the air you are able to place your hands around it better.

Throwing Large Objects

The more you master the art of throwing, the more clay you will be able to handle. There are really no limits except that you should have a potter's wheel that can handle the pounds of clay you decide to use, and access to a large oven where you can fit the objects when it is time to fire them.

It takes some strong will, strength and technique to center a very large piece of clay. Instead of centering the entire piece at once, you can gradually increase it in size by adding more clay to it.

Let's say that you begin with a piece of clay that weighs about 4.5 pounds, and when you are finished centering it, you add another piece of clay to it. You can keep building it up with more pieces until the piece is the size that you want it. Your work position will alter some now. You may need to stand up during the centering and hole cutting process. You might need to use your wrist or elbow to pierce the hole. When you lift

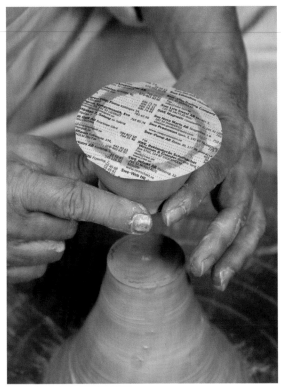

The paper helps to maintain the shape of the bowl while you are lifting it off.

the walls up, you may use the knuckles on the inside and the entire side of your hand on the outside to be able to pull the wall up. The technique used when throwing large objects differs from person to person.

Another common way to make large objects is by using thick coils of clay. Begin by rolling or pressing even coils. Then you will need to throw a base plate. When you are done with that, you will place a coil in a circle on top of the base plate, and cut the ends on an angle so that they can be joined. You will not need to use a slip. Instead, you will attach the coil by throwing it, simultaneously as you begin lifting up a wall. Make sure that you do not make the wall too thin, because then it will not be able to bear the weight of several clay coils. Cut of the top layer of the coil so that it is even all around before you add another layer. Then you continue to add several coils and throw each of them so they attach. Spin the potter's wheel slowly the entire time. Remember not to use too much water when you work with this technique. Once you have added several layers, you will benefit from taking a break and allowing the clay to

dry a little bit. A wall that is too high will not bear its own weight for too long.

If you take a long break during your work, the top edge might get a bit dry. Then you can carve it and add a little bit of moisture so that its consistency agrees with the consistency of the next clay coil. If you continue working on the same object for several days, it is important that you leave it covered in plastic while you are not working on it.

If you are eager to finish the pot, you can use a hot-air gun or a hair dryer to speed up the process. Place the coils as usual and throw them on. Then blow hot air on them. Make sure that you do not direct the warm air towards the top edge where a new coil is to be placed, but against the walls of the object. Continue to spin the potter's wheel so that the heat is evenly distributed. The walls will quickly dry, thus increasing their ability to bear weight. You can follow the following pattern: add a coil, throw it, add heat, etc. Watch the exterior of the pot the entire time and make sure that it is even. If you want a smooth surface, you can use a rib. For this purpose, you will benefit from using an extra large rib. You can also use a straight plank. You must keep track of the shape the entire time; the walls of the pot will easily start to bulge if you are not paying attention. With a little bit of practice you will be able to shape the pot's outline so that it is both convex and concave, like a classical amphora.

One thing to keep in mind is that you need to be able to lift your pot. This technique, combined with a lot of enthusiasm quickly packs on the pounds onto the pot.

You can also throw the biggest pot possible, and when you have reached the maximum height, you continue building it up with additional coils.

Handling Newly Manufactured Items

Once you are finished throwing an object, leave it to dry. Ideally, you should leave it to stand for a while in order to stabilize and get rid of the worst of the moisture. Otherwise, the plastic bag easily gets stuck to the object when you wrap it and deforms it. It is also good to turn the object from time to time; then it will dry more evenly. Take into account any drafts from windows, radiators or warm sunlight, which might accelerate the drying process. Then it is extra

A clay coil is applied.

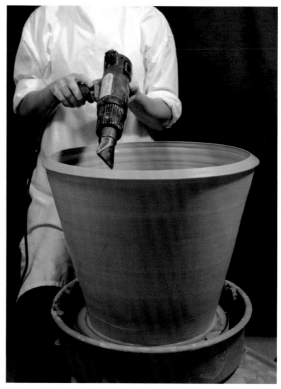

The pot is blown with a hot air gun.

important to turn the object from time to time; otherwise it may dry so much on one side that the object becomes askew. Finally, you can cover it in plastic.

When the object has been standing in plastic for so long that the edge is stable enough to carry its own weight, it is good to turn it upside down. It will help the object get dry all around.

The drying process varies from clay to clay, and eventually you will learn how far you can stretch its boundaries. You must take your own time into account. When will you be able to continue working on your creation? If you have the time to check in with it daily, you may not even need to cover it in plastic, but if your schedule does not allow for you to work on it as frequently, you will have to do it. Otherwise, the object might get so dry that you will not be able to continue working on it the way you intended.

It is best to proceed working on the clay when it is leather hard. Then the object is hard enough to keep its shape when you hold it, but still soft enough for you to to press a nail into it to and leave a mark. Many potters consider clay to be the most beautiful at its leather hard stage.

Tips

- Remember not to lift the walls of the object too quickly. If you pull them up faster than the potter's wheel is spinning, you might end up with an uneven edge.

- Always throw objects with wide bottoms on top of a plate. Otherwise the object will get deformed when you lift it off the potter's wheel.

- The plates that you use for throwing do not need to be round, they may have corners, just be careful so that you do not get hurt. Sometimes angular plates, especially if they are not centered, can cause confusion in the beginning but you will learn to focus on the clay eventually.

- Bisque fired clay, such as a tile, is a good option if you want to do a large amount of cups or small bowls. Tiles that are 6 x 6 inches do not take up a lot of space.

- Avoid MDF panels that are made out of ground and pressed sawmill chips. If they are exposed to moisture repeatedly, which happens when you throw objects, they tend to form layers and become uneven. In addition, particles might start coming off the panel and get stuck to the bottom of the object.

TRIMMING AND OTHER THROWING TECHNIQUES

The process where you finish off the underside of the thrown object on the potter's wheel is called trimming. You could say that trimming is the part of the throwing process where you complete the shape of the object. Not all objects require trimming. Depending on the object, it can often be enough just to smooth the bottom with a wet sponge. However, if you are throwing a big bowl, you have to have more clay in the lower part than in the top, or the walls will not be able to stay upright. When the bowl has dried a little bit, you trim away any excess clay and make the walls evenly thick to create harmony and balance to the entire expression of the bowl. If you chose not to go through with the trimming process in this case, you would get a bowl with a very heavy and bulky bottom.

You usually trim clay when it is leather hard. You need water, a sponge, something to carve with, or a trimming tool.

You should examine the object before centering it on the potter's wheel so that you know where any excess clay needs to be removed. It will also give you an idea of how thick the bottom and the walls are, which is essential to prevent you from trimming too much and creating a hole.

Once you have an idea of where and how much needs to be trimmed, it is time to attach the object upside down on the potter's wheel. This is best done with water. Lightly moisten the potter's wheel and place the object as close to the center as possible. It is important to place the object exactly in the middle of the potter's wheel, or you risk trimming one side more than the other, a visible mistake you want to avoid. You can use a pointed tool to ensure that the object is in the middle. Hold it against the bottom of the object while the potter's wheel is spinning. A stick or a knitting needle works fine. Spin the potter's wheel quite slowly. Hold the stick gently against the spinning bottom so that a ring is engraved. This way you will be

able to tell if the object is centered, or if you need to move it in any direction. If you need to adjust it, just push it gently and redo the test. Keep repeating this procedure until the object is centered in the middle. Then you press the object down firmly with your hand so that it is stabilized. The water on the potter's wheel will latch on to the clay and keep the object in place throughout the trimming process.

You can also attach the object that is to be trimmed with little pieces of clay that you press firmly against the potter's wheel. If you do that, it entails the risk that the object becomes deformed, if only a little. Attach the pieces of clay at 12, 4 and 8 o'clock and gently press them down against the object.

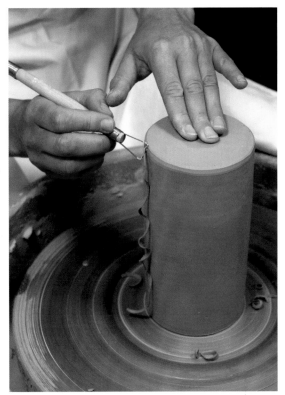

Cylinder, attached with water, being trimmed.

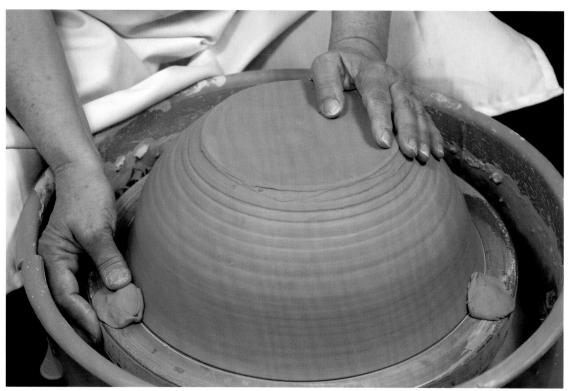

Attaching with clay.

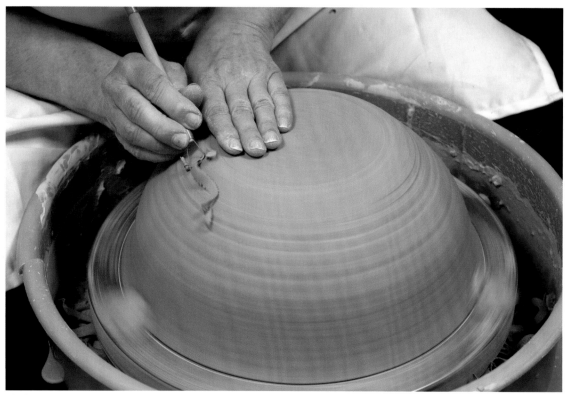

The bottom size is determined.

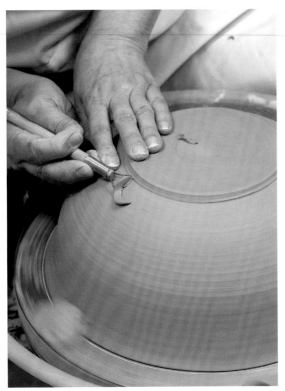

The outer edge of the foot ring is completed.

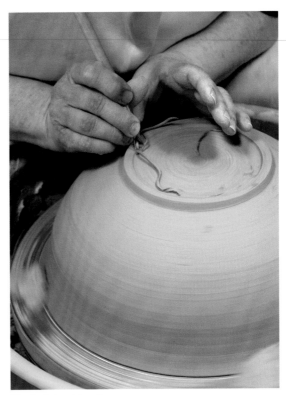

The foot ring takes shape.

Trimming is a technique where you use a pottery tool to strip away clay while the potter's wheel is spinning fast. This will remove the clay in long coils. One hand holds the pottery tool, while the fingers of the other hand provide resistance against the object, partially to provide stability, but also to ensure that the object does not suddenly detach from the potter's wheel. Make sure to support your hands against each other for increased stability. If your hand is unsteady you run the risk of creating unwanted, deep cuts in the clay with the pottery tool. It is common to start trimming the bottom and then, if necessary, move on to the walls. Then you work on the walls and the bottom in parallels, so that the object's exterior line gets a nice finish around the foot ring and so that it is consistent with the interior line.

The actual foot ring can have many different looks, but aim to shape it so that it forms a unity coupled with the other elements of the object. The foot should look like it belongs with the rest of the object.

To remove the completed object from the potter's wheel, give it a very slight nudge while the wheel is spinning. That will detach the object so that you can lift it off.

Sometimes an object has dried so much that you will not be able to trim it. You can easily fix that by placing the object on a water-saturated plaster surface and cover it in plastic. After two days the object will be like newly thrown.

Using Chucks

You cannot trim all objects directly on the potter's wheel. A big plate, for example, is nearly impossible to detach if you attach it with water upside down on the potter's wheel, a bottle with a long neck will not stay balanced, and even a bowl may be too wide to fit upside down on the potter's wheel. Then it is practical to use a chuck. A chuck is a supporting shape that you either place your object on top of, or inside. You can easily throw your own chucks.

A chuck for a plate can be a wide, flat, thrown plate that is about 1.2 inches thick. A chuck used for a bottle looks more like a tall and thick cone. Thrown chucks are very practical. If you throw them the same

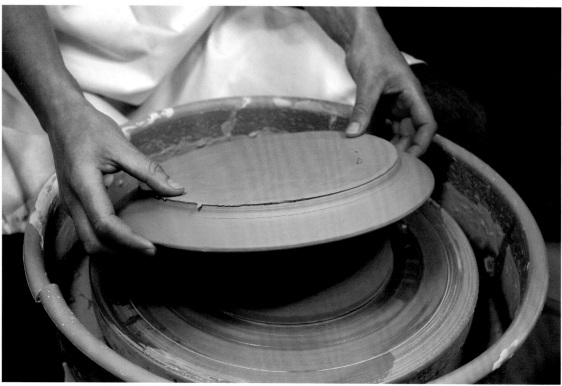
Place the plate on top of a chuck.

day that you plan on using them, and let them stand uncovered to dry, they will be dry enough to utilize when the time comes to trim the object you intended them for. You can leave the chuck on the potter's wheel so that it is centered and ready to use.

A thrown chuck can be used repeatedly until it breaks. When that happens, you can macerate the clay and reuse it. If you want to attach a dry, unfired piece of clay, quickly dip its bottom in water and center it on the potter's wheel. It will quickly latch on. Give it a nudge when you want to detach it.

To prevent the chuck from attaching itself to the object that is to be trimmed, or to prevent it from collapsing, cover it in fabric. It is good to wait for a little while to let the chuck dry and stabilize a bit before you cover it in fabric.

If you do not want to make your own clay chucks, our surroundings are usually full of them. Flowerpots, vases, buckets, and plates, just to name a few. Make sure that you are thorough when you attach them with soft pieces of clay. Even the brim of whatever object you choose to use as a chuck might need

to be examined. If it is sharp or uneven, you can place fabric or a coil of clay to support the piece of clay that you want to throw.

Other Throwing Techniques

An object is not always finished just because you have thrown one thing. Many objects are compounds of several elements. A teapot, for example, has at least four parts. We will now take a closer look at some additional turning techniques and how to make various details when you throw objects.

Folds and Lids

Jars, teapots and jugs are examples of items that often have lids. There are many different ways to make a cover. To figure out how to make the lid, you should have a clear picture of what it should look like. What is the object with the lid going to be used for? Do you need to be able to stack things on top of the lid? Should the cap be completely tight? If you are making a lid for a teapot, you must make sure that it will not fall off when you start pouring tea. The fit is very important,

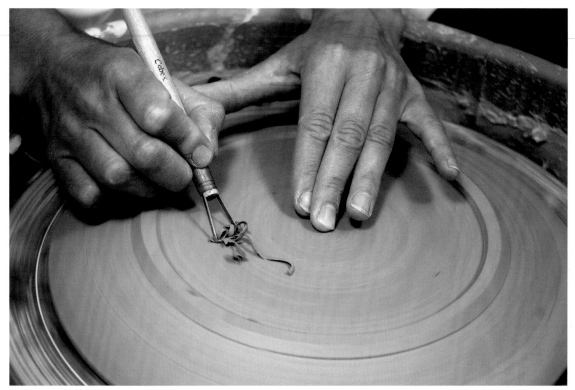

The bottom of the plate is trimmed.

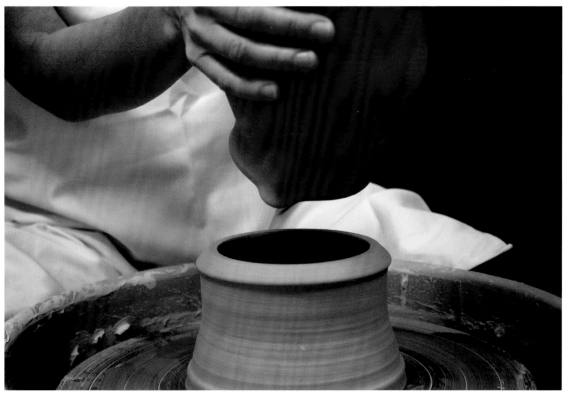

A pitcher is being trimmed in a chuck.

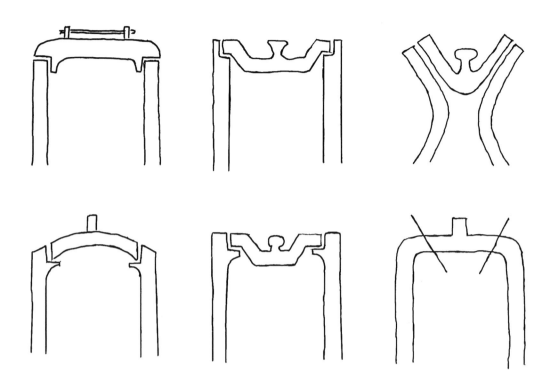

A few types of folds and lids.

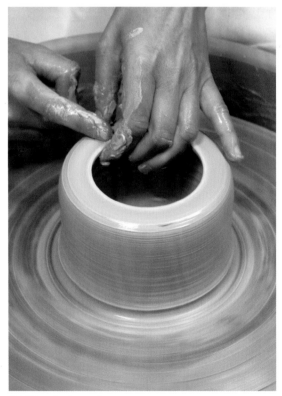

Fold the edge inwards.

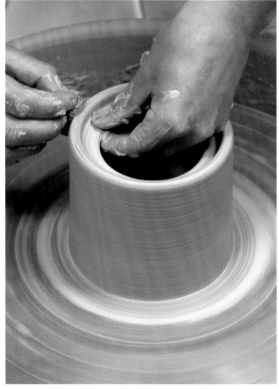

Push the edge down to create a fold.

but so is the aesthetic shape—you want it to fit organically with the object's shape. Many lids have a little knob on top to lift the lid, which in itself provides an exciting opportunity for individual expression.

If you are going to make a jar with a lid, or a teapot, you may need to create a fold for the lid to rest on. Many lids do not require a fold, but it may be helpful to know how to make one. There are mainly two techniques when it comes to creating folds or supporting edges. Begin by throwing a straight cylinder. One way is to fold about 0.6–0.8 inch of the top edge of the cylinder inwards, into a 90-degree angle. Use the fingers of one hand as support underneath the folded edge, while you press the entire fold down with one of the fingers on the other hand, or with a stick, to form a shelf.

The other way is to make the top edge thicker than the rest of the wall. When it is time to make the fold, insert a finger or a stick in the middle of the thick edge and then slowly press down, so that the edge is divided, and the half that is pressed down forms a

shelf. Then you can place one hand underneath the fold while the potter's wheel is spinning slowly to smooth the fold and give it nice angles both above and below the little shelf.

With both techniques it is common to make a fold before you complete the shape completely. For example, if you want to make a round teapot, you give it the rounded shape after the supporting shelf is made.

To get a well-fitting lid, you must measure and determine the size accurately. It is important that you take the measurements when the object is newly thrown. This will give you the exact size. Then make the lid, so that the parts dry at the same time. The quicker you can put the lid on the object, the better the two parts will fit together. You can use a regular ruler for measuring, but to be able to access both the inside and outside, it is good to use a caliper.

How do you throw the lid? If you want a lid that is flat on top, you do it exactly the same way you would make a cylinder. If you want a dome-shaped lid, make

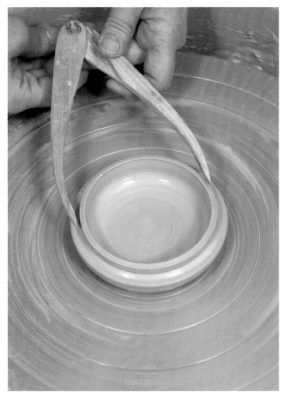

Measure accurately.

Make sure that the lid fits.

it the way you would a small bowl. See the outlines on page 62. If you did not create a fold on the lid, you may need to make one on the lid. Again, you need to be meticulous when taking the measurements to make sure that the lid will fit.

Trim the lid once it is leather hard. You will benefit from doing it when it is joined with the body of the object, so that you can create the exterior line that you want on the object as a whole.

Another way to throw an object with a lid is to throw a cylinder at the top, so you get a completely closed shape. Cover the object in plastic and allow it to dry for a little bit before you cut off the top part with a thin knife so that you get a lid. If you make a straight cut in the clay, it may be difficult to keep the lid in place. Then you can create a thin seam and attach it on the inside of the lid with a slip. However, if you cut the clay on a diagonal, the lid will remain securely in place.

If you want a knob on the lid, there are a variety of choices. You can model a knob, and when the lid is trimmed, attach the knob, with a slip if necessary. You can also throw the lid in such a way that you create a knob at the same time. Another option is to throw a lid that is thick enough for you to trim a knob out of it later. You can also throw the knob itself, on a piece of clay, and later attach it to the lid. Or, you can take the finished cover, once it is trimmed and leather dry, center it on the potter's wheel, and carve it a bit on the top with a pin tool and moisten it a bit so that you can attach a piece of clay on top and throw the knob right on top of the lid. You need only a very small amount of clay to throw a knob, and it is good practice for throwing smaller things. You will be working almost exclusively with your fingertips.

Tips

- Save the dimensions of the lids that you throw. Then you can create a new lid that fits perfectly at any time if your lid happens to break.

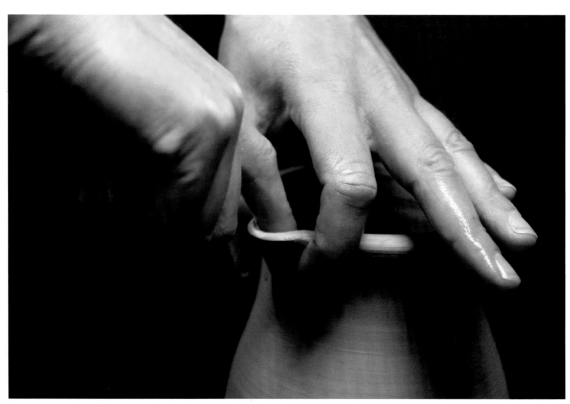

Create a spout by pulling it out with wet fingertips.

Spouts, Nozzles and Handles

You may need additional parts to complete your object: handles for mugs or dishes, or spouts for your pitchers.

You will need to create spouts and nozzles on vessels that will use to pour liquids out of. You can easily make a spout on newly thrown objects. Decide where on the object to place the spout. Then you flatten that part of the brim with your thumb and index finger, just an inch or two. Then you place a thumb and index finger on either side of the outside of the flattened edge. Moisten your other index finger and use it to pull out the spout as shown in the picture. It is easier to pour liquids out of a thin spout than a thick one.

You throw spouts that you would use for teapots separately. You can do it with a cylinder as the starting point, but instead you throw it more together at the top so it looks more like a cone. You can also throw a little bowl. It should be tall and not too wide. Lift the bowl off the potter's wheel, and let it dry for a little bit before you squeeze it so that it is flat in the middle and looks like it has two bent chimneys on either side. You will use one of these "chimneys" as a spout for your object.

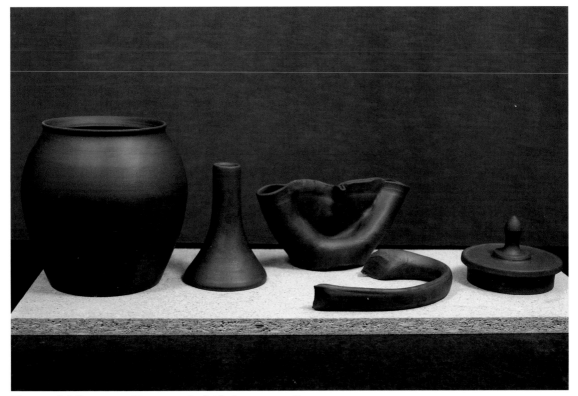

The teapot's different parts. You can see the finished pot on page 68.

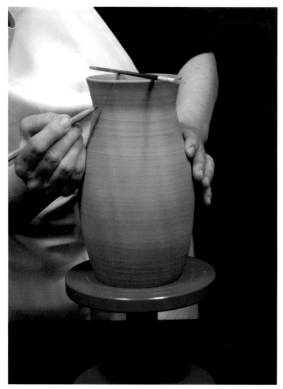

Make a mark where you intend to cut the pitcher.

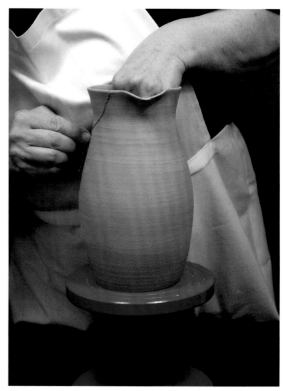

Cut the pitcher's shape with cutting wire.

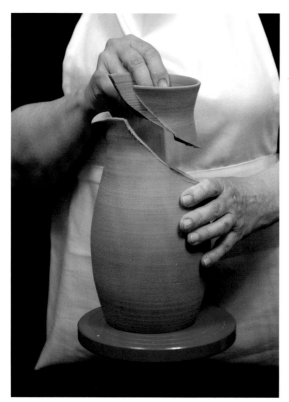

A cut pitcher.

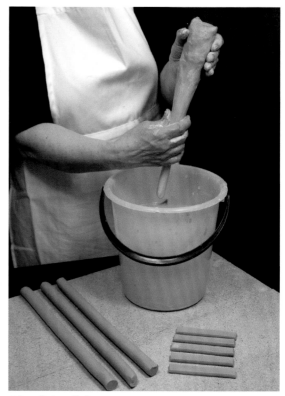

A handle is pulled.

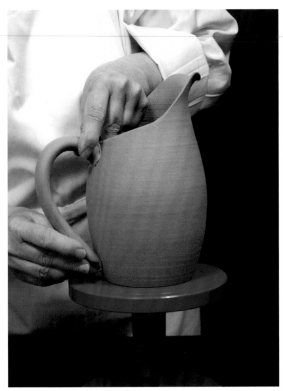

Attach the handle thoroughly.

from pulling off pieces of clay. The moist hand will determine the shape of the handle. If you hold it hard, you will get a skinny and rounded handle. If you release your grip around it a bit, and change the squeeze around it, you will get a wider and flatter handle. Once you are satisfied with the length of it, you snip it off with your fingers, bend it and leave it to dry.

It is common to attach the handle once the object itself is leather hard, so the handle itself should have dried a little bit as well. Once you have cut the handle to fit the object the way you want it, you carve each end of the handle where it is to attach to the object, and you add a little slip to each end. Then you gently press the handle into place. Once you have secured it, and polished the handle around the seams, you should cover the entire object in plastic to prevent the clay from cracking around the seams during the drying process.

Another way to pull out the handle is to attach the clay cone directly onto the leather hard object and pull it out from there. This way makes it difficult to pull out a handle that is long and skinny, because it will tend to collapse.

Keep in mind that if you are going to make a teapot that consists of a body, a lid, a handle and a spout, or if you are going to make any other object that comprises several parts, it is best to make all the parts the same day and leave them to dry simultaneously before you assemble them.

There is an additional way to create a spout. Cut off one side of the pitcher's brim and shape a spout out of the remaining edge. You have to allow the pitcher to dry a little bit before you start cutting. Mark the clay with a pen where you intend to cut it. Use cutting wire or a thin clay knife. Even out the newly cut edge with a moist sponge.

There are different ways you can create a handle; you can roll out a clay plate and cut out a handle, or make handles out of coils, or press one using a handle machine, or you can simply pull one out. It may be useful to have a few different handles ready to see which one fits your object the best. A pulled handle usually goes well together with a thrown object.

Apart from clay, you will need a lot of water when pulling a handle. Begin by shaping a piece of clay into an oblong cone. Use one hand to hold the thickest part of the cone. Moisten the other hand and grab the opposite part of the cone and pull it so that it becomes longer and skinnier. It reminds me a little bit of milking a cow. You have to keep your hand moist to prevent you

Compound Shapes

By assembling different parts you can build very wide and very tall objects. It is a great method to use when making large pots. You throw several parts, measure each one meticulously, and once the pieces are leather hard you can assemble them with slips. Usually, all the work is done on a potter's wheel and finished off by throwing the seams together so that they are not visible. Other common compound shapes are goblets, cake plates, and other footed dishes. If you are going to make a footed bowl, you trim the bowl so that it gets a rounded bottom and then you attach the foot that you made for it. You can also throw a foot directly

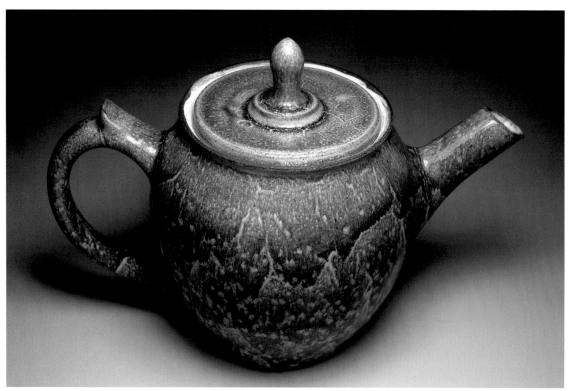

Stoneware clay, thrown, ash glazed, oxidation fired, cone 8.

onto the trimmed bowl. If you choose the latter, you will benefit from using a chuck underneath the bowl. It is to prevent the bowl from collapsing from the weight of the foot when you throw it. Keep in mind to not use too much water, which could deform the bowl.

Transform Thrown Shapes

Many people strive for perfection when they create with clay, and sometimes the objects even look factory made. This is common especially in the beginning when you are first starting out, and you want nothing more than to create a perfect rounded brim with smooth and beautiful walls. The more you work with clay, the more you will appreciate and welcome other shapes that surprise and excite. Breaking a perfect line will provoke the eye. It will welcome curiosity. What is happening here? It will also give you the opportunity to find your very own expression when creating your objects.

Square and Oval Thrown Objects

You can make square and oval shapes out of the objects that you throw. Let us imagine that you are going to make a square mug, starting out with a basic cylinder shape. Once you have thrown the cylinder and it is still attached to the potter's wheel while it is standing still, you make it square by swiping your index finger along the interior wall of the cylinder as you use follow along with your other index finger and thumb on the exterior wall, all the way from the bottom to the top edge of the mug. This maneuver will create a corner. Make the other corners the same way. Cut the mug loose from the potter's wheel once you are satisfied with the shape, and let it stand to dry. When the mug is leather hard you can beat its sides with a paddle to enhance the corners.

You can create an oval shape the following way. You begin by throwing a bowl with a relatively wide bottom. Cut the bowl loose and place it on a slippery surface, like a moist particleboard. Now you cut out a

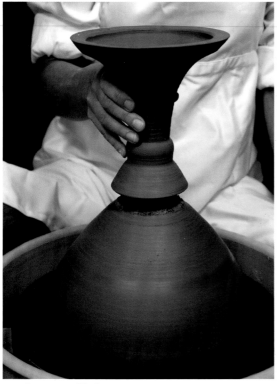

Use slip to assemble the parts.

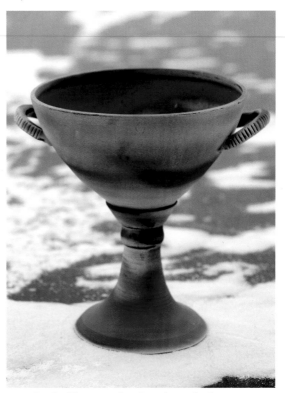

Completed goblet, spray glazed, oxidation fired, cone 8.

long, narrow slit in the shape of a leaf in the middle of the bottom. Remove the narrow slit and squeeze the bottom of the bowl together by pressing the exterior walls towards the center. Now you have an oval shaped bottom, and the walls follow the same oval shape. You can use the leaf shape that you cut out to seal the glitch in the bottom.

You can also throw an oval object by throwing a cylinder without a bottom. Since the bottom provides stability, you should allow the cylinder to stand to dry a little bit on top of the potter's wheel. Meanwhile, you can roll a clay plate that will be the bottom. Once the cylinder is a little bit steady, you cut it loose and squeeze it into any desired oval shape. Place the cylinder on top of the clay plate and leave yourself some margin when you mark it on the bottom plate. Carve the bottom, add slip and then press the cylinder on top. You may need to strengthen the inside seam by adding a thin string of clay that you press to the seam with a modeling stick. Finish off by cutting

the outside seam and refine it. Also polish the seam on the interior bottom so that it becomes smooth.

You can make other shapes the same way as above, i. e. S or U shapes.

With this technique as starting point you can create a lot of exciting shapes by bending the objects in regular and irregular ways to create different angles. You can use your hands, ribs, or paddles to alter the shape. Use your imagination and try out different ideas!

Faceting

Faceting is another exciting technique to use to alter the shape of a thrown object. You throw an object with relatively thick walls and then you cut away pieces of the walls with cutting wire. This is done directly after you have thrown the object, while it is still standing on the potter's wheel. You can cut all the way from the top edge to the bottom or just cut away pieces of the walls. Make sure not to cut away too much so that the walls get so skinny that they cannot

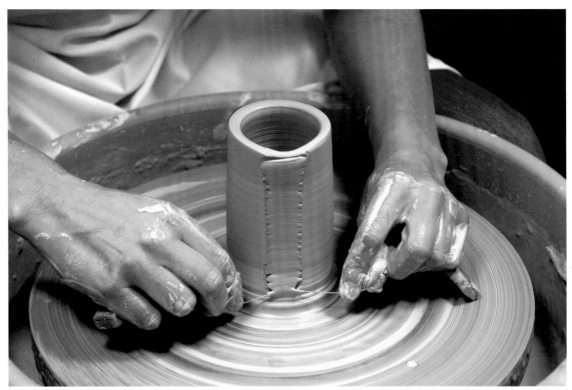

Cut away pieces with cutting wire.

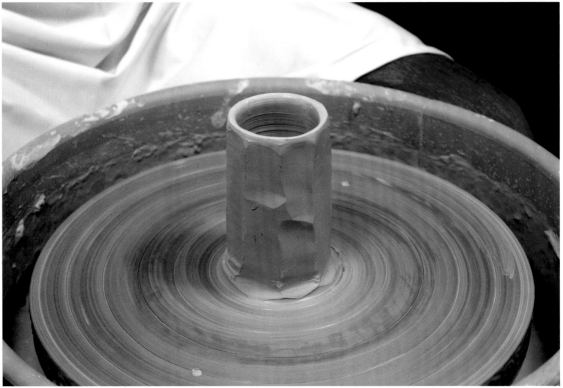

Mug with cut exterior.

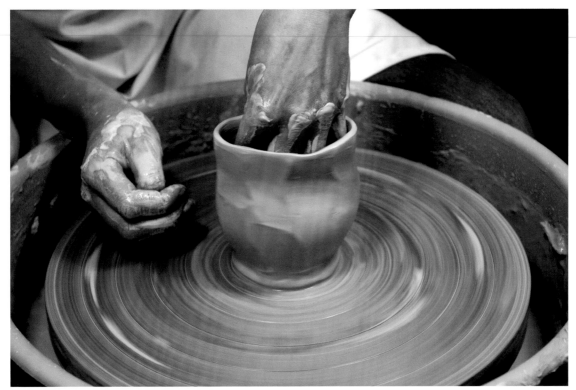

Throw the mug from the inside to widen it.

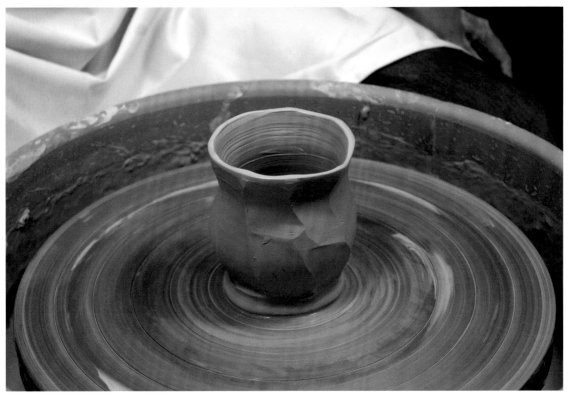

Faceted mug.

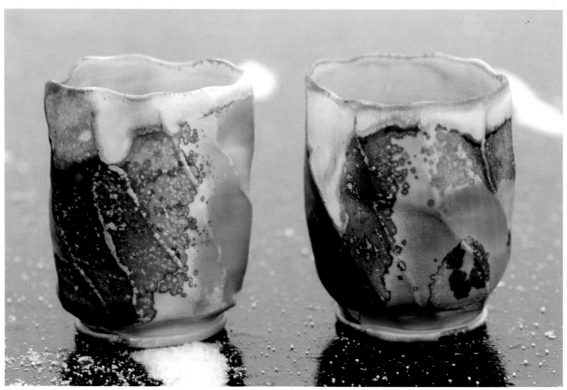

Porcelain clay, faceted, interior glazed, anagama fired, cone 10.

hold up their own weight. Faceting will result in a rounded shape with an angular exterior. Once you are done with cutting the exterior, you can polish the object with a damp sponge and remove it from the potter's wheel, or you can keep on throwing. If you choose the latter option, make sure that you only work on the interior of the object so that you do not remove the lines and angles that you created on the exterior surface.

Lightly moisten the object's interior, and slowly work your way up with one hand on the inside to get the object to swell. If you are spinning the potter's wheel fast while you are doing this, the exterior pattern will turn into a spiral, and you can try different spinning speeds to see which pattern each of them creates.

Cut and Paste

Just like the title suggests, the point of this technique is to cut and paste, or more like cut and assemble clay. Just like with faceting, the intention is to create exciting interruptions in the thrown cylinder shape to give the rounded shape an interesting expression. You can easily create triangular, oval or square objects using this method and it allows you to work on both moist and leather hard clay.

You create a cut in the clay and then you patch it up again, but by overlapping the pieces with slip. You can also use this technique with pinched, rolled or coiled objects.

After you have made cuts in the clay you patch it up with slip.

Porcelain clay, thrown, cut and pasted parts, glazed, oxidation fired, cone 8.

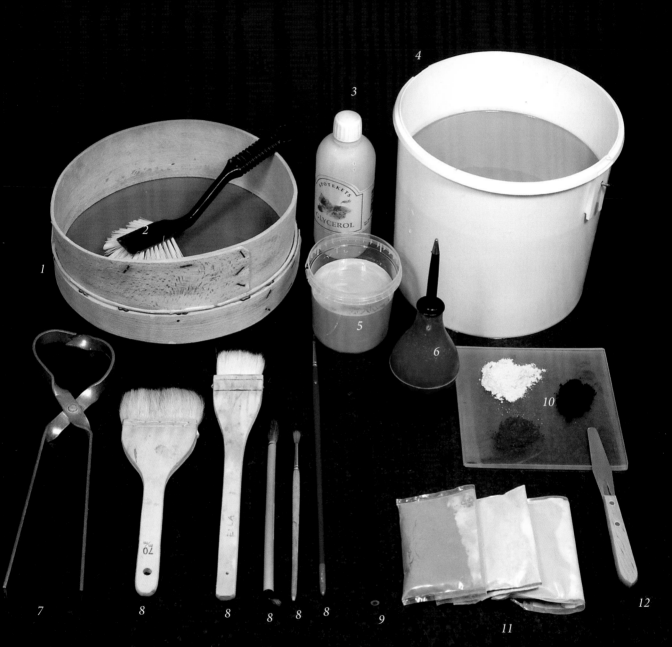

DECORATING WET CLAY

Decoration is a form of communication. Decoration can convey a certain message, or exist just for aesthetic pleasure. It should enhance the object's character and improve the final outcome. Position, size and color are very important factors should be thought out before you begin.

You will benefit from having an idea of what the end result should look like, before you begin decorating your clay object. It will help you choose the appropriate technique. Imagining the end result right from the start will help you incorporate the decoration technique at an early stage and make it part of a natural process as a whole. Trying out different techniques is the best approach to decide which method suits the particular object that you are working on. If you are working with patterns, try them out on different places on your samples to find out where the decoration looks best.

Carving

Carving a pattern is one of the easiest ways to decorate clay. It does not require any advanced equipment. Try it with different tools, such as forks, knives, sticks, or other things in your surroundings. Also try turning and twisting the tools, or use their opposite side to see how it affects the pattern. You can carve décor into the clay when the clay is soft, or when it is dry. You will avoid unwanted imprints if you work with leather hard clay.

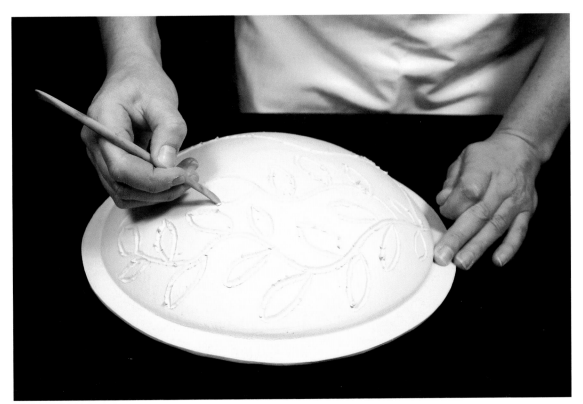

Carving leather hard clay.

Stamping

Stamping, pressing or rolling patterns into clay is another way to decorate your creations. Here too, you can use things around you for tools, such as seedpods, seashells, wires or screw heads.

If you have your own patterns or figures, you can often make your own stamps. If you make them out of clay, you only need to bisque fire them before they are ready to be utilized. Carve your pattern into leather hard clay, allow it to dry, and press soft clay into the carved pattern. This way you will get two stamps, one that creates a bulging pattern, and another that produces a hollow design. Remember that writing will be inverted if you stamp it on.

You can also produce stamps out of plaster. You can create roller stamps by casting a plaster plate that is about 1.2 inches thick, or as thick as you wish the pattern to be. Carve the pattern all around it without any seams showing. Punch a hole straight through the plaster so that you can thread a thick steel thread or something similar through it and bend the thread into a handle. Then you roll the pattern over the object that you are decorating.

You can also make a roller stamp by throwing a cylinder without a bottom. Make sure to create really straight walls. Once the cylinder is leather dry, you can carve a pattern into it. Let it dry and bisque fire it. Insert a round rod through it and roll your pattern onto a rolled clay surface.

There are roller stamps ready to buy with different patterns and letters if you do not want to make your own.

Perforating

You can also decorate clay by creating holes in it. Holes will let in light and reflect it in a decorative way. It is best to perforate clay when it is leather hard. If you are working with clay while it is still very soft, it may collapse when you cut big holes in it. However, if it is too dry, it can crack. Use a sharp knife when you cut out a pattern, and if you want nice round holes, you can use a hole cutter. A drill works well too, if you use it manually.

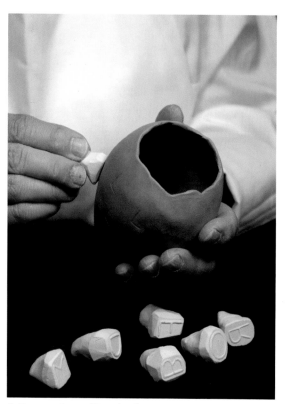

Letters are stamped into the clay.

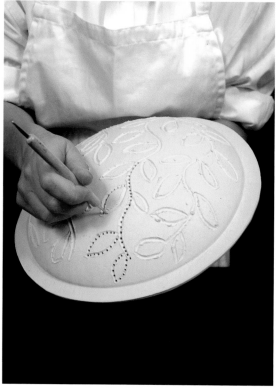

Perforating clay.

The important part is that you do not just press a hole into the clay, but that you remove the clay in the hole. The clay is easily deformed if you just press it out.

Application

Applications are made out of clay and are attached to the object to decorate it. It can be anything from a seal, or a flower, to a decorative border. You can emphasize the application by using clay of a different color and structure than the object itself, but you will benefit from using clay that has the same shrinkage allowance. Attach the application when it is leather hard onto the leather hard object. Carve the spots on the clay where the application will attach, as well as the entire backside of the application. Then you add slip and press the two clays firmly against each other. The applications will fall off when they dry if they are not attached properly.

Burnishing

Burnishing is a technique that you use to polish the clay, and the process presses the clay particles together. Before potters started using glazes, this was the most common way to treat utility goods to make them somewhat waterproof. Sometimes they would be greased after the firing process to make them more water-resistant.

Burnishing is a simple technique, but it requires a lot of patience. You need a hard, smooth and preferably rounded tool, such as a spoon or a polishing stone. Once the clay is leather hard, polish it with the backside of the spoon, bit by bit, until the surface is smooth and shiny. You can polish the surface with a piece of soft chamois or a piece of soft plastic in addition to the spoon. The clay will be as shiny as a mirror. Burnished clay will produce a beautiful contrast on matte clay. The glossy surface will turn matte when you moisten it. You can paint a pattern on the shiny surface with a wet brush. The pattern will appear matte and a tone more gray than the polished surface. You can also apply an engobe, see page 82, and burnish it. If you add fine quartz sand to the clay and burnish it, you will not need to glaze it before the glaze firing. The

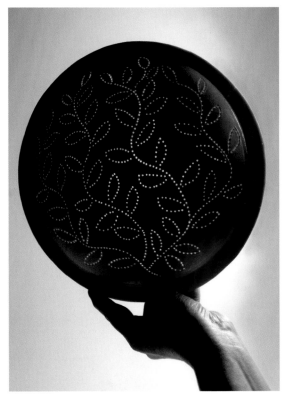

Porcelain paper clay, slab constructed and put into a mold, carved and perforated, glazed, oxidation fired, cone 8.

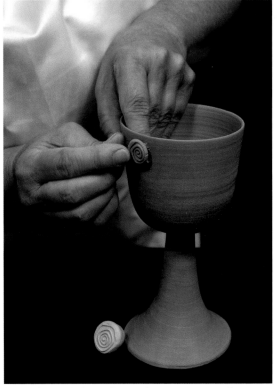

Carefully attach the application by pressing it into place.

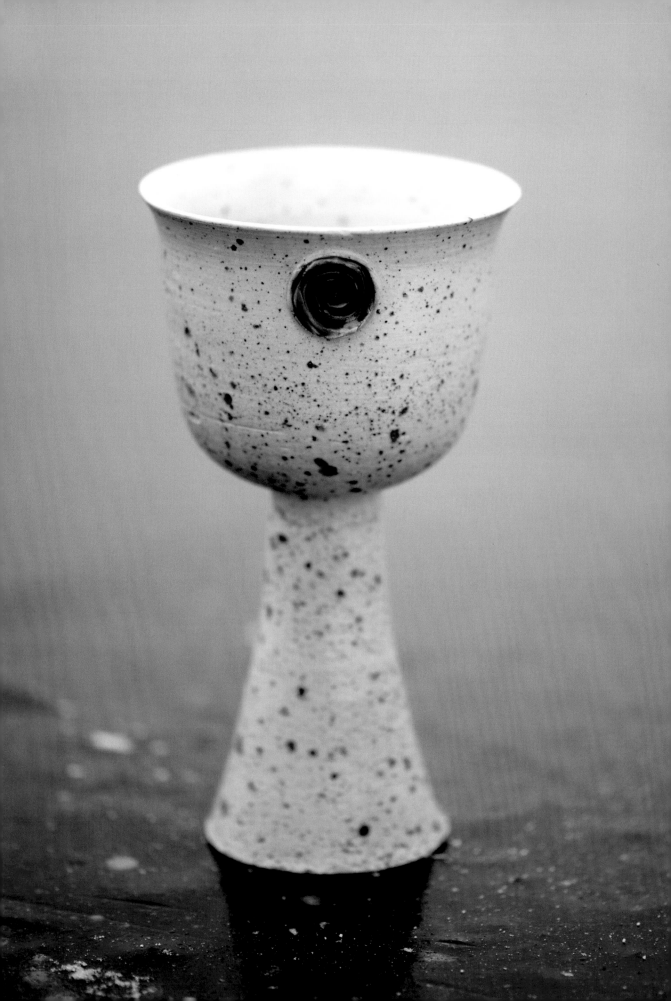

quartz in the sand will partially melt and add beautiful nuances to the clay. You often use this technique during the black firing process; see page 129.

Any clays can be burnished, but you will be better off not using any chamotte clay. When burnishing chamotte, a piece of it might come loose and leave a hole in the clay, and in some cases even leave a big cut in the object.

The shiniest of the glossy surface is burned off at about 1,922°F, but the object still retains a clear shine even though it is burned at a high temperature.

Transform the Structure of the Surface

Another way to change the surface structure is to add engobes or slips based on a completely different type of clay, or by adding chamotte or sand to the engobe or slip; see page 82. You can create decorative expressions by varying the surface texture on one object. Contrasting textures, such as: glazed–matte, or smooth surface–rough surface, will add a nice creative expression.

The clay is polished with the backside of a spoon.

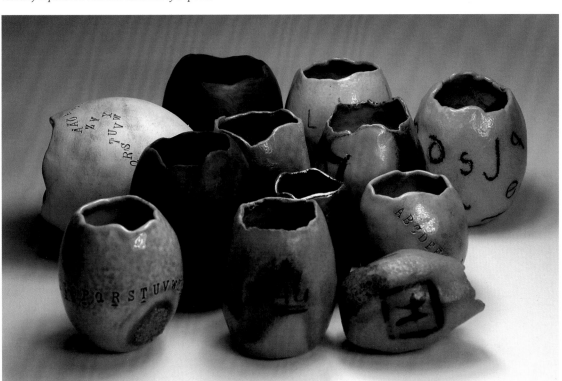

Pinched stoneware clay. 1) Burnished, unglazed, raku fired. 2) Stamped, engobed letters, salt fired, cone 10 . 3) Stamped with letters, salt fired, cone 10. 4) Stamped with letters that have been colored with stains, oxidation fired, cone 8. 5) Burnished, anagama fired, cone 10. 6) Burnished, anagama fired, cone 10. 7) unglazed, raku fired. 8) Sparingly glazed, raku fired. 9) Stamped with letters that have been painted with paint body, salt fired, cone 10. 10) Stamped with letters, painted with stains, salt fired, cone 10. 11) Burnished, decorated with black stain, anagama fired, cone 10. 12) Burnished, decorated with black stain, salt fired, cone 10.

Stoneware clay with lava patches, thrown and assembled parts, application painted with copper oxide, glazed, oxidation fired, cone 8 (opposite).

Sand-mixed slip is applied.

Stoneware clay, thrown, engobe print on the bottom, lid decorated with sand-mixed slip, painted with stain, oxidation fired, cone 8.

Relief Decoration

Another way to decorate your creations is to make reliefs. Reliefs are motifs made out of clay and attached to the clay surface. It can be done either by adding on, or scraping away clay around a motif. The relief can be made out of the same clay as the basic clay or with another type of clay, perhaps in a different color or texture. If the clay is soft where you are about to add a relief, you can just press it into place with a modeling stick. If the clay is leather hard, you need to carve the surface and attach it with slip.

You can also create a relief by carving out a motif in the clay. Use a trimming tool or a ceramic knife.

Wax Relief

You can use wax or shellac to create raised letters or tactile drawings in the clay. If you are building up a relief, you will inevitably get seams, and cracks may appear during the drying process. You can avoid this if you make the relief directly from the existing clay by washing away clay around your object.

For this you need leather hard clay, wax or shellac, a sponge, brushes and plenty of water. Wax is more viscous and easier to handle. Shellac, which is thinner, is more pliable with a brush and covers larger areas smoothly. Whichever you choose, the procedure is the same.

Paint the motif with wax or shellac. Make sure the entire ornament is covered. Allow it to dry properly. Use a damp sponge to remove the clay around the pattern. The more you remove, the more the relief will rise. You can also use a hard brush to enhance the contours.

With this technique, you can get pretty thin streaks. If you also want your subject to appear even more, you can engobe clay all around it, and leave the relief colorless.

Clay is removed around the waxed letters with a sponge.

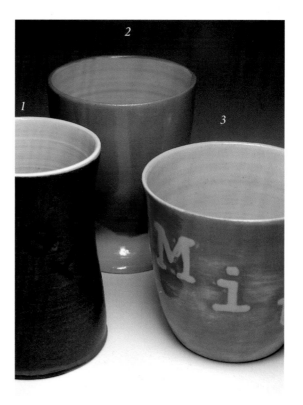

Stoneware, wheel-thrown. 1) Perfusion by pouring, oxidation fired, cone 8. 2) Perfused by dipping, decorated with underglaze paint, glazed, oxidation fired, cone 8. 3) Decorated with wax resist and clay trimmed with sponge, engobed, glazed, oxidation fired, cone 8.

ENGOBES

If you want to add some color to your items, you can use engobes.

It is clay mixed with water and colored with oxides or stains. Before glaze was invented, engobes were primarily used to decorate pottery. Engobing offers a wide variety of ways to create a personal creative expression.

The texture of the engobe should be similar to that of soured milk, but you can modify it by removing or adding water so that it fits the purpose that you will use it for. It is usually applied to leather hard clay.

Different clays have varying shrinkage allowance, and it is important to ensure that the enbobe you are going to use matches the clay. A good way to test it out is to make an engobe out of the clay that you are working with. Then you know that the engobe shrinks as much as the clay and that it will not crack or peel off during the drying or firing process. It is also common to mix engobes with the clay in powder form, such as ball clay and kaolin, mixing about half of each. You can also buy engobes in powder form, or already mixed.

Use oxides or color cells to color engobes. If you choose oxides, keep in mind that they are very potent. For 22 lbs of dry clay, you can expect to use between 0.0088 and 0.35 ounce of oxide for a nice result.

When you have bisque fired an engobed object, it will have a dull, matte finish, and it will get a clear color only after you glaze fire it. Usually, a transparent glaze is applied. If you use a colored glaze, it will reduce the colortone of the engobe.

How to Mix Engobes

Weigh the desired amount of dry clay and coloring agent. Pour it into a bucket of water. Start with 3.4 cups of water for every 2.2 lbs of dry matter. Let the mixture stand for a while. Use a hand blender to get a smooth mixture. If the engobe is too thick, you can add more water, little by little. Then sieve the engobe through a 60-80 mesh to remove any lumps. If you find that the engobe becomes too watery, let it stand for a few days. Then the clay will sink, and the water will settle on the surface so that it is easy to remove excess fluid.

Some Coloring Examples:

The examples are based on 22 lbs of dry, white clay.

Cobalt oxide	0.25–0.0088 ounce	Light blue to dark blue
Copper oxide	0.07–0.18 ounce	Various shades of green
Manganese oxide	0.07–0.3 ounce	Brown or purple
Iron oxide	0.07–0.35 ounce	Yellow to brown
Rutile	0.07–0.3 ounce	Cream color

It is fine to mix the different oxides, and you can mix them with stains. Ultimately, the composition of the glaze will affect the color of the engobe.

Whenever you work with engobes, you should have a fairly clear picture of what the final product will look like before you begin. It will make it easier to choose the appropriate decorating technique and to determine when the work should be performed.

Various Ways of Using Engobes

Applying Engobes

Engobes can be applied with a brush. You can paint the clay when it is leather hard or soft. Use a soft brush that is not too dense. Applying engobes with a brush is much like painting with watercolor. You see the brush strokes. To get an opaque result, you need to apply several coats of paint. You can consciously work with a creative expression where you choose to treat it as watercolors.

Another way to apply engobes is to use a damp sponge. With this method you get a better surface

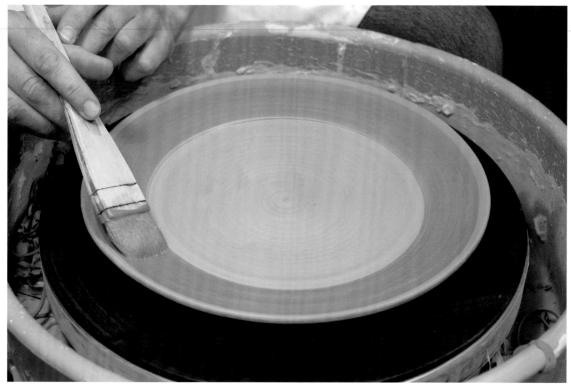

The engobe is applied with a broad brush.

coverage at once. However, the surface will become a bit lumpy and have a special surface structure. To achieve a thick, even and covering paint result, work with both a brush and a sponge.

You can also dip the object in engobe, or pour the engobe over the object. This is called dipping. When you dip the object in engobe, it is important to do it at the appropriate drying stage. It is best when the object is leather hard, or almost dry. Then it will not absorb as much water and can easily be handled without deforming. You have to be quite quick, as clay absorbs water very fast. Let the item dry thoroughly so that you can touch it without changing its shape.

Yet another way to work with engobes is to first pour it over the item and immediately wipe the engobe off with a sponge or a cloth in definite patterns. The key is to work quickly because engobes dry very fast.

Stencils

An easy way to create patterns with engobes is to use stencils out of newspaper. All you need is newspaper, scissors, water and engobes. Cut strips or patterns out of the paper. Let us say that you want to make a flower. Draw the flower on the newspaper and cut it out. Now, you can choose to either use the cut out flower as a template, or the rest of the newspaper with the hole in the shape of a flower. Wet the paper and attach it to the leather-hard surface. Sponge or brush on the engobe. If you want the engobe to cover the clay, you should apply several layers before the paper is removed. Once you peel the newspaper off, the pattern will appear. By adding a new stencil onto the engobe and covering it with a new color, you can achieve complicated patterns and colors. Allow the newly painted engobe to dry a little bit before you apply a new one.

An item's exterior is dipped in engobe, step 1.

An item's exterior is dipped in engobe, step 2.

An item's exterior is dipped in engobe, step 3.

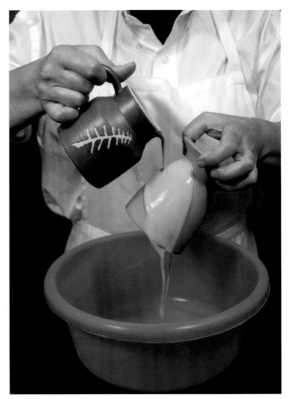

The engobe is poured over the item.

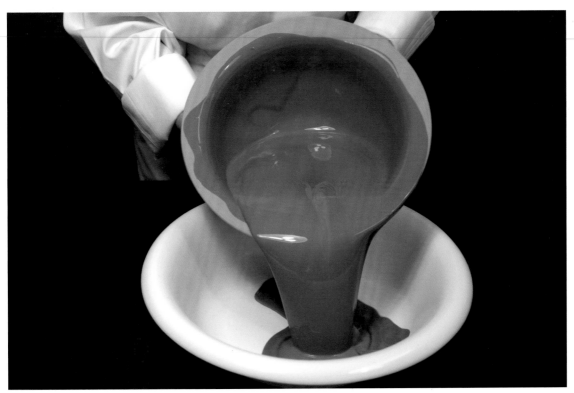

The item's interior is infused with engobe.

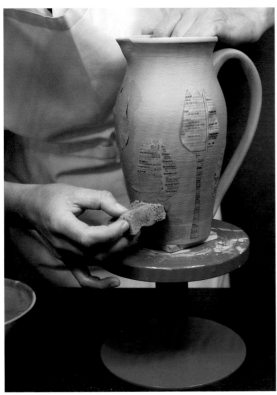

Engobe stippled onto stencils with a sponge.

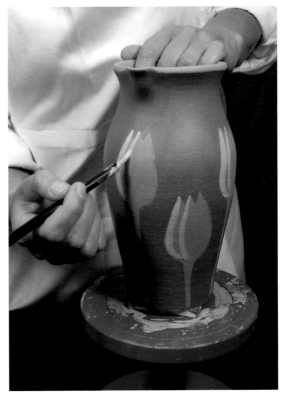

Detail painting with engobe.

Marbling

You can marble your creation with two or more engobes in different colors. It is a technique that allows you to create random, undulating forms. Marbling can be done to the interior or exterior of the object. The object should be leather hard when you marble it.

If you are going to marble a bowl, you pour two or more engobes into the bowl simultaneously and ripple the paint gently to let the colors flow into each other. Then quickly pour out any excess paint. Now you have a marbled pattern and if you wiggle the bowl gently, the pattern will change. You can also begin by pouring a primer into the bowl and then add smaller doses of other colors. Angle and rock the bowl until you are satisfied with the result.

There is also another way to marble, which produces a batik-like pattern. This technique is best applied onto flat objects, such as plates and tiles. The engobe should also be relatively thin. Place the leather hard plate onto the potter's wheel and pour engobes in different colors over it. Then run the potter's wheel at a slow to moderate speed until the colors are hurled into different directions. At this stage, it may be advantageous to use a ball syringe to distribute the colors more evenly and also check where the paint ends up.

Ball Syringe

Painting with a ball syringe is a classic decoration method. A ball syringe is a rubber ball with a small spout. With it, you can create fine, even lines and dots. Previously, cow horns were used with a tip from a feather, but today most ball syringes are made out of rubber or plastic. You can also use small plastic bottles with long spouts, or cake frosting decorating tips. You can buy nozzles in different sizes for your ball syringe to vary the width of the lines. When you paint with a ball syringe, the engobe should be quite thick; otherwise it will leak out of the ball syringe.

Fill the ball syringe completely with engobe. Pinch it lightly so that the first drop comes out. This will also get rid of air inside the ball syringe. If any air is left inside the ball syringe, it can squirt the engobe onto

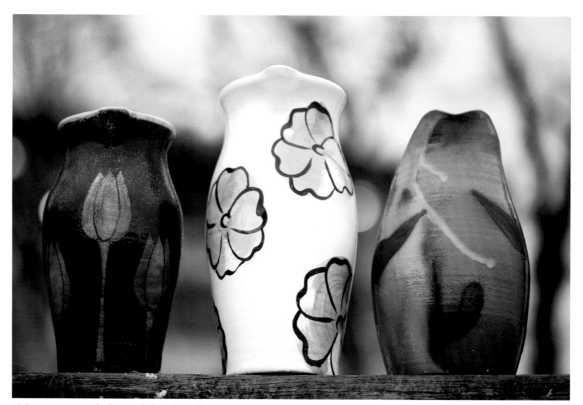

1) Stoneware, engobed, stenciled, outlines drawn with oxide pen, salt fired, cone 10. 2), Earthenware, tin-glazed, faience, oxidation fired, cone 05. 3) Stoneware, decorated with engobes, anagama fired, cone 10.

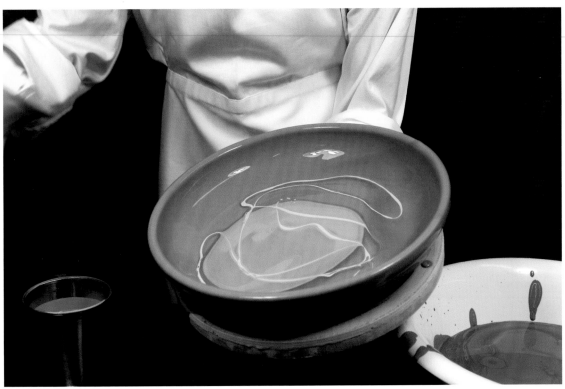

Engobes in different colors are poured into the bowl.

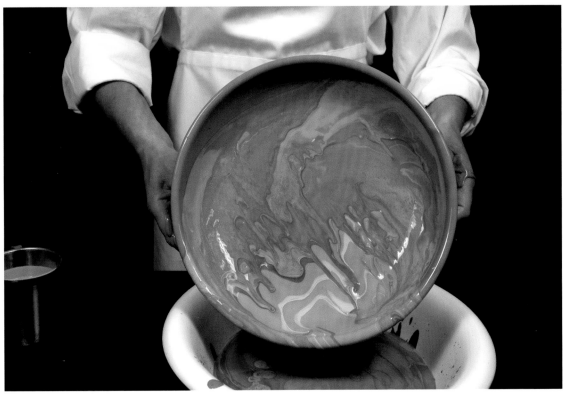

The engobe is poured out.

The ball syringe creates dots.

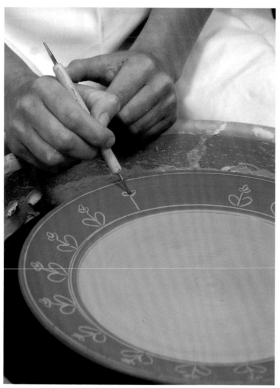

The pattern is carved into the brim.

the object and ruin the pattern. If the engobe is a bit thicker, it creates thick, embossed lines, while a thinner engobe will match with the underlying clay. Sieve the engobe thoroughly so there are no lumps in it. A smooth engobe produces fine results and you can draw intricate patterns with it. However, it may require some practice to squeeze out an even flow of paint.

Sgrafitto

Sgrafitto means "carve deep" in Italian. You draw thin or thick lines in a layer of engobe to uncover the underlying clay. This way, you can create very fine details. You can carve a pattern with just about anything. A pen will produce sharp lines, while a needle can create really fine, thin lines. The technique works best on leather hard surfaces. If the clay is too soft when you carve, clay shavings may occur along the lines you create and get stuck to your object and ruin the result.

To get sgrafitto in different colors and shades, layer engobes in varying colors and then scrape

patterns with a rib. Use a rib that is made out of bendable metal and slightly curved. When you drag the rounded rib over the clay, the colors from the various engobes will appear in different layers.

Inlay

Inlay is a technique that produces fine, continuous lines in clay without any disruption on the surface. Patterns are carved or hollowed out in leather hard clay. Then the hollows are filled with engobe or colored clay. When the inlays have dried, the excess paint is scraped away. The result is razor sharp.

Begin by drawing the pattern you have in mind loosely with a pencil on leather hard clay. Then use a needle or the tip of a knife to form V-shaped gouges. Try to get the indentations equally deep. Do not make the surfaces that are to be filled with engobe too large, because it will make it difficult to fill them to a smooth surface. Fill them with engobe until the grooves are covered and let them dry a bit. The engobe should have the consistency of soured milk. You need to

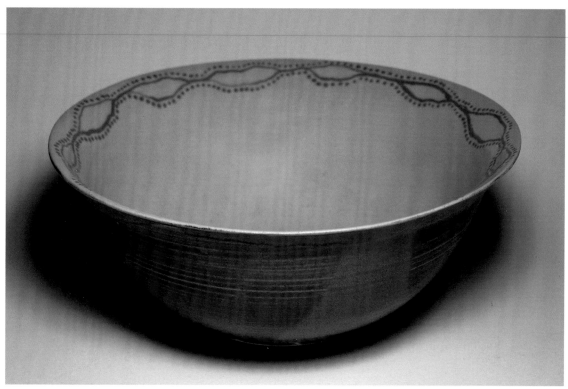

Stoneware, wheel thrown, decorated with ball syringe, glazed, oxidation fired, cone 8.

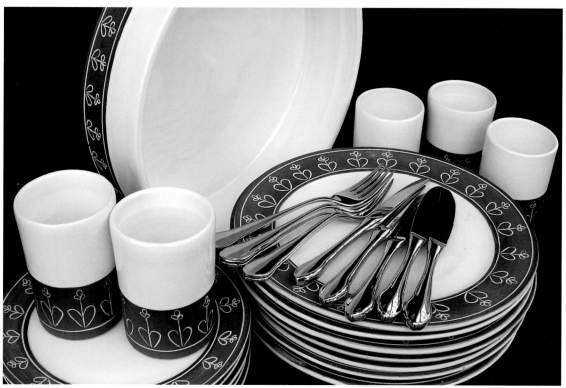

Dinner set out of stoneware clay, wheel thrown, brush painted with engobe, sgrafitto decoration, waxed before glazed, oxidation fired, cone 8.

repeat this a few times to fill the hollow completely, and to get a smooth surface. If the pattern is composed of multiple colors it is best to work with one color at a time. Once the engobe is dry, scrape away any excess engobe with a bendable metal rib. Even very thin lines will appear well-defined with this technique. It is important to remove any excess engobe, because it may not be so visible after the bisque firing. However, any excess will stand out clearly after the glaze firing.

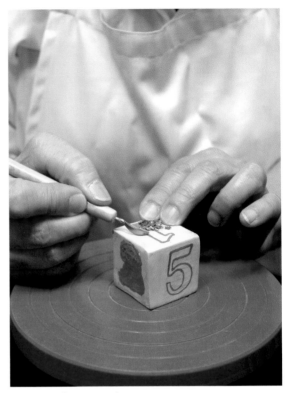

Excess engobe is scraped away.

Slab constructed and assembled, unglazed, oxidation fired, cone 8. 1) Stoneware clay, screen print, transferred and stained letters. 2) Stoneware, screen print. 3) Porcelain clay, transferred and stained letters. 4) Stoneware, engobed, screen print with tin oxide. 5) Porcelain clay, stain inlay. 6) Stoneware, screen print.

Stamps made out of various materials.

Stamping with Engobes

Stamps can be used at any time during the production process, even with engobes. It is a simple way to create a repeating pattern. You can make your own engobe stamps. Preferably choose a soft material. One way is to cut out a shape from a piece of foam rubber and glue it onto a piece of wood. Another way is to make a stamp out of a sponge. Saturate the sponge with water and freeze it. Once it is frozen, you can cut a pattern in it with a sharp knife.

If you are using a foam rubber stamp, it should be dry when you begin. However, if you have a sponge stamp, it must be damp before you dip it in engobe.

Engobes should be quite liquid. If the engobe is too thick, it is difficult to get a covering print.

Engobe with Coarser Structure

You can also alter the roughness of engobes and create different surfaces on an object. To do so, you can use chamotte or sand. Fine sand can be purchased from a pet store, but you can also use sand from the nearest sandbox that you find. Then you may incorporate other particles of varying sizes, which can produce interesting results. Sand contains silicon, which is an important constituent in glaze and you can get a particular glaze when using sand, with various structures. Different structures in the same color give the surface an interesting appearance.

Wax Resist

You can use wax to create patterns on the clay. The engobe will not stick to the waxed surfaces so you can wax the parts you want uncolored and create a pattern.

Tips

- Engobes are used on leather hard clay most of the time. However, there are recipes for engobes that can be used on dry clay, as well as bisque fired clay.
- If you are using engobes that are suitable for completely dry clay, do not cover the entire object with it. The dry clay absorbs the water from the engobe, which will make the object collapse.
- When you decorate with engobes, you can combine several of these techniques. Just make sure that you do not overwork the object so that you do not lose the effect of the decoration.

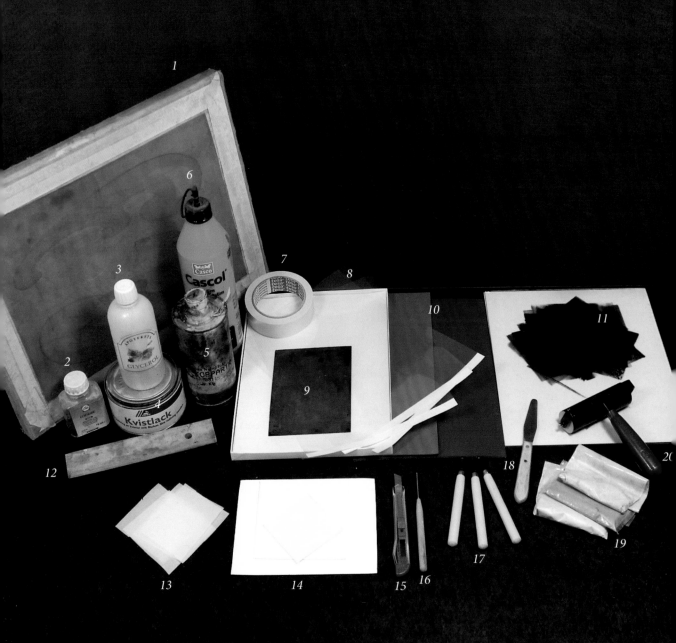

PRINTING TECHNIQUES

Transferring images to ceramics by using different printing techniques is another way to decorate your pottery. By transferring images, you can easily create repeating patterns or text. Ceramics are primarily three-dimensional, while prints are two-dimensional. However, ceramics can be categorized into both categories because of flat surfaces that can be decorated or carry a message regardless of whether it is an item intended to be used every day, or a sculptural object.

Stepping over boundaries and applying printing techniques onto clay is an interesting work that involves new challenges. It offers many ways to create a highly personal style on your creations. There are various printing techniques, and we will go over some of them here.

Decorating pottery can sometimes be a bit tricky depending on the shape of the object, and sometimes it may be difficult to access all surfaces, or to be steady on the hand when decorating with writing. Many of these printing techniques offer satisfactory alternative ways to achieve good results when tackling these challenges.

The choice of clay is not significant when it comes to printing; you can use prints on any type of clays. Paper clay that can be rolled very thin is a fun choice. It can also run through a printing press instead of paper.

Printing on Leather Hard or Bisque Fired Clay

For best results, print onto leather hard clay because it attaches to that type of surface, but also because it is not as rigid as a bisque fired surface. You can also print motifs and texts onto relatively newly rolled clay and then transfer the clay to a plaster mold and gently press it down without ruining the print. Most of the techniques also work on bisque fired pottery.

Transferring Patterns

One way to transfer images from sketches to printing sheets is to cover the entire back of the image sketch with pencil. Then place the template onto the clay or print sheet and fill in the image from the right side. The graphite will stick to the places where you draw.

Making Sheets

Some of the techniques require printing sheets. You can make these yourself, out of a copper plate, cardboard, or plexiglass. In addition, you need a sharp instrument to carve with, an awl or a needle, and wood glue and chalk.

You engrave the pattern directly onto the copper sheet. Use tools that have a steel tip, awl, nail or graphic dry point. Try to make the carvings deep so that they hold the paint. This applies to all types of metal sheets. An awl or needle is used for plexiglass as well.

Making printing sheets out of cardboard works well. The cardboard should be about 0.08–0.12 inch thick and have a blank layer. You can paint the surface a few times with shellac to amplify this. If you want a matte finish so that the paint sticks more easily, you can tear off the top layer, that is, the shiny surface. You can also carve the box with thin lines.

On a cardboard plate, you can build a motif and create a relief. You can use cardboard pieces and glue or paint the motif with wood glue, mixed with a little bit of chalk to thicken it. Also try to stick other materials to the sheet to see what kind of patterns they create.

Look around you for other things that can be used for sheets. Rulers, for example, are pre-embossed plates, which can produce interesting ornaments on your ceramics.

Preparing the Ink

You can prepare the ink yourself. You need a glass sheet or a tile to mix the color on, a palette knife, ball clay, a painting medium in the form of glycerol, copper plate oil or linseed oil, and oxides or stains.

If you are using stains, make sure that the color withstands the temperature you plan on firing it in. Use

1) Screen frame 2) Gum arabic 3) Glycerol 4) Shellac 5) Copper plate oil 6) Wood glue 7) Masking tape 8) Overhead film 9) Copper sheet 10) Linoleum mat 11) Glass plate to roll out the ink on 12) Squeegee 13) Potter's tissue 14) Cardboard 15) Knife 16) Needle 17) Linoleum knives 18) Palette knife 19) Stains 20) Rubber roller

about 40 percent of color and 60 percent of ball clay and put it on the plate. Add a few drops of some sort of painting medium and grate the color, see page 103, with a palette knife to a spreadable paste that attaches well to the object. Work the paint thoroughly with the knife and make sure that all lumps disappear. By adding ball clay, the mixture becomes smooth and will easily adhere to the object. Dilute the mixture as little as possible, but enough so that you are able to paint it on with a brush. Some of the techniques require you to use copper plate oil or linseed oil as a painting medium. Examples are when it is important that the ink does not dissolve in the water, or when there is a risk that the image will bleed, meaning that the paint leaks when it comes in contact with the glaze. Instructions will follow in cases where the oil is needed.

Planning the Print

It can be difficult to figure out which printing technique will produce the best result for the image you want, or which method is appropriate for the item that is to be decorated. Make testers to see how the various prints turn out on the clay. This will make it easier to choose the technique that will be the most suitable for the object you are working on. Make sure you have all the necessary materials in handy so that the printing process runs smoothly. All techniques require the use of paint.

Collography on Clay

Collography is sometimes referred to as glue print or cardboard print and it is a print-making technique that uses cardboard amongst other materials. This method requires clay, cardboard sheets, viscous ink, a glass plate and a rubber roller. In the picture below left, a cardboard sheet is used in which the motif is painted on with wood glue mixed with chalk.

Begin by rolling out the clay to the thickness you want it and let it dry enough so that it does not get marked when you lift it. Roll out the ink onto the glass plate with the roller. You can proceed in two different ways.

The cardboard sheet is lifted from the clay.

Rolled paperclay, collography print, colored with black stain, unglazed, oxidation fired, cone 8.

One way is to use only one color that you roll onto the entire sheet. Wipe the entire sheet with a smooth newspaper. There will be leftover paint along the outline of the motif. Be careful not to create any fingerprints. Place the sheet on top of the rolled out clay and use the rolling pin to roll it into place. Keep in mind that the image will be inverted.

The other way is to use a brush to paint the sheet in different colors. It is important not to layer on too thick with paint because the color layer will will be pressed onto the clay. The thinner the layer, the better the result will turn out.

Transferring Images with Potter's Tissue

Potter's tissue is a thin tissue paper that you can use to transfer images. The motifs can either be painted directly onto the paper or be pressed on by using sheets. Because the paper is formable, the print can be transferred to different types of clay and not only onto clay that has been rolled out on a flat surface. You can use this technique on leather hard and bisque fired

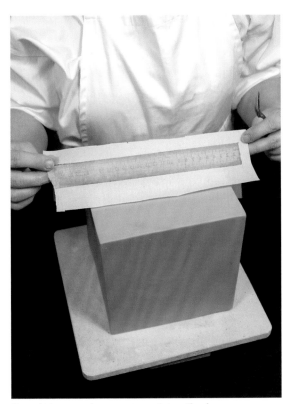

Potter's tissue ready to create a print on the clay.

clay. Remember that the image will be inverted if you use potter's tissue.

In addition to potter's tissue, you will need printing ink as described above, a sheet, newspaper, and a spoon. Moisten the clay a little before you make the print. In the picture a ruler was used as plate. The ruler was colored in with black ink. Any excess dye was wiped off with a newspaper so that there was only paint in the grooves. Then, the ruler was pressed hard against a potter's tissue and a spoon was used to rub the motif onto the paper. The paper was then pressed onto the clay, and the spoon was used to transfer the motif from paper to clay.

If you do it this way, make sure to remove the paper slowly after you are done transferring the image. Then you can check if the print turned out clearly. If not, you can put the paper back and rub it some more with the spoon.

Another way is to draw the motif directly onto the potter's tissue. This can be done in several ways. In addition to the materials that are specified in the paragraph above, you need a glass sheet, a rubber roller and a pen.

Begin by rolling out the paint evenly over the glass sheet and let it dry. Then place the potter's tissue on top and draw your design with a pen either freehand, or add an image that you want to trace on top of the paper and draw around it. You can use this technique to create thin, precise lines, but keep in mind that each time you apply pressure to the paper, it will leave a color print so do not rest your hands on the object. When you have finished drawing your design, it is ready to be printed. Use a damp sponge to press the motif into place.

You can also screen pictures onto potter's tissue and then transfer them to your items. The advantage of this is that you can repeat the same image on different shapes where you cannot apply pressure directly onto the clay. You can also fold the paper over edges and create an image that continues from interior to exterior, i.e. on a mug.

Screen Printing

Another way to apply images onto pottery is through screen printing. With this method, you can draw

The overhead film blocks the color so that only the stencil will appear.

your own designs for printing or decorate with your photos. To create a screenprint, use a wooden or aluminum frame with a stretched fabric, a so-called screen frame. The fabric lets through color and the image is created when part of the fabric is blocked so that no color leaks through. In addition, you need ink that is like mayonnaise in the consistency, a squeegee, masking tape and overhead film.

To be able to print the images on the ceramics, they need to be transferred to the screen frame first. There are two ways of doing this, and the way you choose depends on what kind of image you want to print.

The easiest way is to draw your pattern on overhead film and cut it out. This works well if the pattern is not too complicated or does not require great precision. Then you attach the cut-out image to the bottom of the frame with masking tape so that the color only penetrates the fabric where it is intended; see picture above.

Transferring photographs to a screen frame is a lot more advanced and requires more equipment than is usually found in a pottery workshop. It is recommended to go to a ceramic specialty store and have an expert help you make a screen frame with the photos that you want. They can also provide advice on necessary preparations, and the cost of this tends to be moderate compared to what the equipment itself would cost. In addition, more pictures can be placed onto the same frame, so your print can vary. The printing technique remains the same no matter how you get your pictures onto the frame.

Once the images are in place in on the screen frame, it is time to transfer them onto the pottery. You can press them directly onto rolled out clay. Moisten it a little so that it absorbs the image better. For vases, cups and other round objects you transfer the images to potter's tissue before you transfer them onto the objects. Remember that the picture needs to be reversed so that the end result will produce the image with the right side up. This is especially important with text prints.

Place the screen onto the rolled clay or potter's tissue. Spread the ink above the image in a long string

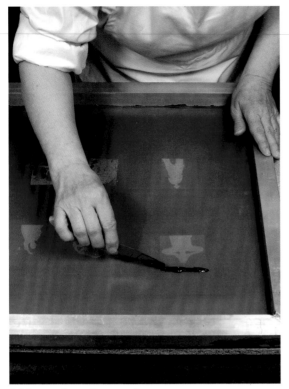

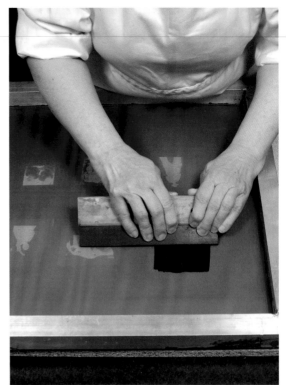

Ink is spread over the screenframe.

The paint is distributed over the image with a squeegee.

that covers the width of the image. Use a squeegee to drag a solid and firm grip over the paint so that you distribute it over the image in one go. Gently lift the frame.

You have time to print three images in succession before it is time to clean the frame so that the paint does not dry into the canvas and make it unusable. Dish soap or regular soap is fine to use.

Since the screen frame usually contains several images it is important to mask them off so that no images are printed by mistake. Do this with paper or tape.

Linoleum Print

For this technique, you will need clay, a linoleum mat, linoleum knives, ink, a glass sheet, a rubber roller, and a rolling pin.

Roll out the clay and let it dry. Make a linoleum sheet by cutting an image out of the linoleum mat with a linoleum knife. Keep in mind that the image will be reversed. Roll the ink onto the glass with a rubber roller. The paint should be spread as thickly as possible, but still be workable. Once the roller is

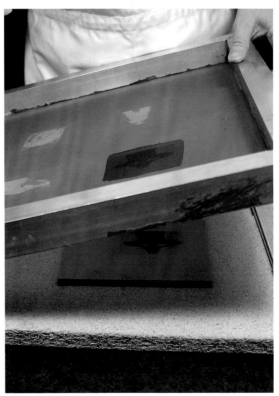

The screen frame is lifted.

The linoleum sheet is pressed onto white engobe.

Engobed pieces of paper with text are pressed onto the clay.

thoroughly covered in paint, roll the color onto your linoleum sheet. Try to get a uniform layer of paint. The actual motif will remain colorless. You can also make the sheet the opposite way, by cutting away everything except for the image.

Then you press the linoleum sheet against the clay and use a rolling pin to press the image onto the clay; just make sure not to press too hard. Lift the sheet away. You can also press the image onto potter's tissue and then transfer it to the object. Then the image will face the same direction as the linoleum plate.

Another way to use linoleum prints is to color in the image and leave all the smooth surfaces of the sheet colorless. Then you will benefit from coloring it in with a brush with fairly stiff bristles. Distribute the paint as evenly as possible. Then roll the linoleum sheet onto the clay so that a relief is created from the pressure.

Transferring Images from Paper, Lithography

The basic principle of lithography, simply put, is that fat and water repel each other. You can use this

principle when you create prints with ceramic paints. Texts are easy to transfer to ceramics, and so are images. This method can also be used on bisque fired objects, but be aware that the paint contains oil that can repel the glaze.

You need access to a laser printer or a copy machine with carbon ink. Inkjet tends to dissolve in water and therefore can not be used. You also need gum arabic in solution, which can be bought in art supply stores, printing inks that are mixed with copper plate oil or linseed oil because it will not dissolve in water, a glass sheet, and a rubber roller.

If you are going to print text, it must be reversed. The image is printed onto plain printing paper. An easy way to create mirrored text is to first print it onto overhead film and then turn the film before you copy the image.

Apply a thin coat of gum arabic over the motif. Gum arabic will not stick to the print of the text/image because it contains fat, which repels water. Roll the ink onto the glass sheet with a roller. Once the roller is evenly covered with paint, roll the ink directly over the paper with gum arabic solution. The ink will now only stick to the text/image. If some of the color happens to spill outside of the image, wash it off with gum arabic solution. Press the image firmly against the object so that it attaches. Then, gently remove the paper.

Engobe Print

You can transfer animated images or texts to clay by using plain paper with this technique. The object should be leather dry. You need engobes, ink with glycerol as painting medium, plain paper or newspaper, and brushes.

Draw a design on paper and then paint the image with ink. Let the picture dry. When it is completely dry, dip the painted side of the sheet in engobe so that the engobe covers the entire image, and press it onto your object. The engobe should be quite thin; the consistency should be no thicker than that of soured milk. You can also silt some of the clay and dip the image in it. Either press the image on directly and make sure that it is in place by using a damp sponge, or let the engobe dry a moment before pressing the paper against the object. If you choose the latter, you must moisten the clay before the printing image is placed on it. Apply pressure to the paper with the backside of a spoon to work the image into the clay thoroughly. Leave the paper on until the engobe has dried. If the paper does not want to come off entirely, it will burn away during the bisque firing process and only the image will remain on the object.

Painting Engobes onto Fabric and Transfer

You will need clay, fabric and engobe for this technique. Paint a motif onto a piece of damp fabric. Paint a layer that is approximately 0.06-0.08 inch thick. When you transfer images this way, remember that the first layer that you paint onto the fabric, will be the top layer of the finished print. If a flower is the eye-catcher, it should be painted first, and then you color in the rest of the motif. Constantly moisten the cloth. Once the image is painted, press the fabric against the object; you can do this with the backside of a spoon or a polishing stone. Then, gently remove the cloth and make sure that the image has attached to the object.

Tips

- Roll the color onto a glass sheet or mirror so that the paint is evenly distributed over the roller. Then it will be easier to color the sheet evenly and the print will have a more even color distribution.
- When cleaning oil, you dissolve the color with cooking oil first and then wash with soap.
- Use glycerol for screen prints. Copper plate oil can clog the holes in the canvas and you will not be able to use the image for several prints.

DECORATING BISQUE FIRED AND UNFIRED GLAZED CLAY

There are many ways to decorate bisque fired or unfired, glazed goods. Here, some of the most common techniques are described. Based on those, you can try things out and experiment. You can also combine the different techniques with each other. Keep in mind that décor can enhance the result—but also worsen it.

Wax Resist and Latex

You can use wax or latex if you want parts of your objects to remain unglazed. You can also apply this technique to work with different glazes in several layers without having the different glazes affect each other.

If you paint wax onto a bisque fired item, the glaze will not stick to it because of the fat in the wax. This allows you to create different patterns that remain unglazed. It is best to paint wax onto bisque fired pottery while it is still hot. Then the brush will slide easily over the object. If the pottery is no longer hot, you can heat it up in a regular oven.

Wax emulsion is available at the ceramic supply store. Use a brush that you do not care so much about, because even when you clean it thoroughly with hot water and soap afterwards, it will never be truly clean again. You can also dilute the wax with water to make the solution more pliable. If you color the wax with stains or oxides, you will get additional effects in the form of colored wax resist. If you happen to get wax on an undesirable spot on the bisque fired object, you remove it with acetone.

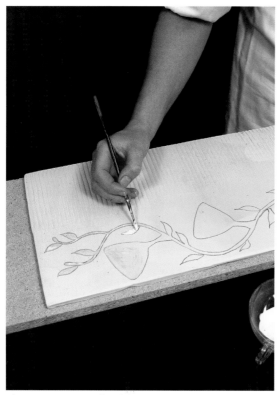

The pattern is covered with latex.

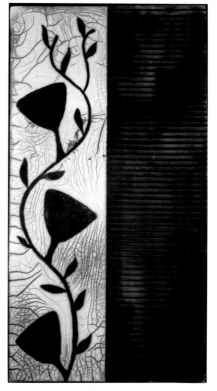

Stoneware clay, slab constructed, pattern painted with latex, raku fired.

After you have painted on the wax and glazed the object, small glaze drops may remain on the waxed surfaces. They are removed with a wet sponge or a ceramic knife before the object is glaze fired, because otherwise the glaze residue will remain on the object after the wax is burnt off.

You can also paint wax onto an already glazed surface. In this case you will benefit from using a wax/water mix. Then glaze with a different color. Then you will get wax resist in one color and the rest of the object in a different color. It is difficult to get a dark glaze to look visible on top of a lighter glaze.

Then you can mix wax and glaze and paint it onto the bisque fired or newly glazed pottery. If you use wax or a wax blend to paint glazed ceramics, you will not be able to remove any possible mistakes with acetone. You will simply have to rinse the glaze off with water and start over.

Instead of buying wax emulsion, you can melt beeswax, or use regular wax crayons, candles, or lip balm. All will produce the same results.

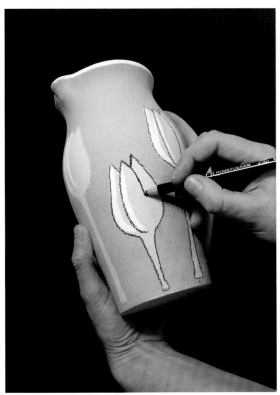

The outline is drawn with an oxide pen.

Another medium that works well is latex. Latex is a natural rubber and is used in a lot of different contexts, including with ceramics. You can buy liquid latex at the ceramic supply store. It has the same effect as wax, so the glaze will not stick to the spots where you apply latex. But unlike wax, you pull the latex layer off before firing the object. You can either use a brush or a ball syringe to paint the object with latex. Wait until the latex has dried thoroughly before you glaze the pottery.

Instead of the latex, you can use plain textile glue.

Oxide Pens and Crayons

Oxide pens are especially designed to paint ceramics. They work best on bisque fired pottery, but you can also paint newly glazed items with them. Oxide pens are available in different colors and made for earthenware or stoneware temperatures.

There are also oxide crayons, and you use these on bisque fired pottery. They will produce the same result as when you color paper with wax crayons. A tip is to sketch your design onto the bisque fired object with a pencil before you color it in with oxide crayons. Mistakes can be difficult to wash off and the graphite burns off during the firing process and will not be visible on the finished product

However, crayons have a tendency to flake, so when you dip the object in the glaze, half of the color may end up in the glaze bucket. It can ruin the glaze, and to avoid that you can after bisque fire the object one more time before you glaze it. Then the color will settle. Another way to avoid this is to spray the glaze on. Oxide crayons are suitable for earthenware and stoneware temperatures.

Oxide crayons consist of colored clay, and you can make them yourself. For this you need kaolin, stains or oxides, a tile or a glass sheet, a palette knife, water, and paper. If you choose a stain, make sure to check at what temperature it is able to keep the color. All oxides retain their color in stoneware temperatures. At least half of the color blend should consist of kaolin, the rest of oxide or stain. Oxides usually produce stronger colors than stains, cobalt in particular.

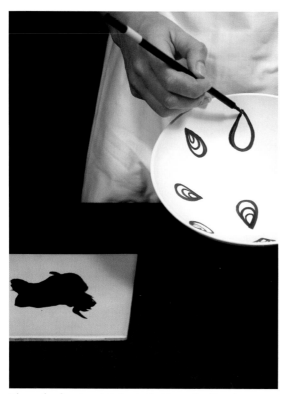

The underglaze is painted onto the bisque fired bowl.

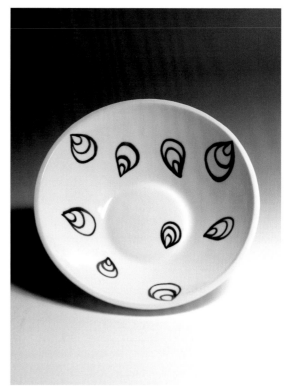

Porcelain clay, casted, underglaze decoration, transparent glaze, oxidation fired, cone 8.

Test your way to the right amount of oxide or stain to achieve your desired results.

Add a couple of tablespoons of kaolin and the desired amount of oxide or stain on top of the glass sheet. Add water and mix the substance with a palette knife well until all the lumps dissolve. The consistency should be like clay. Place the clay in a piece of paper and roll it into a crayon. Once the crayons have dried, bisque fire them and they will be ready to use.

Underglaze Colors

Underglaze colors are painted onto pottery before it is fired. For this you need good, soft brushes. You can paint unfired clay with underglaze, but it is more common to paint bisqueware with it. Bisqueware is another word for pottery that has been bisque fired. Underglaze colors are used to paint decorations and patterns before the pottery is glazed with a transparent glaze. There are several reasons why underglazes are a good choice when it comes to decorating your pottery. First off, it is easier to paint a bisque fired surface because it is hard so you will not deform the object, which can happen when you decorate a leather hard surface with engobe. It enables you to create very fine details anywhere on the object. An underglaze is colorful, and you can make the mixture covering at once so that you do not need to paint several layers. You can buy underglaze colors that are ready to use, or you can mix your own. If you buy pre-mixed underglazes, make sure to check the firing ranges. Earthenware colors have a lower firing range than stoneware colors.

To make your own underglaze you will need a plate, a palette knife, ball clay, glycerol, water, and stain or oxide. Begin by measuring the ball clay and stain, about 60/40 on the plate. If you use oxide, the ratio will be about 90/10, and even less if you are using copper oxide or cobalt oxide. The amount of stain or body paint will determine if you get a strong or weak color, and different colors react differently, so you have to try things out to determine how much powdered color to use. You do not need huge amounts—a

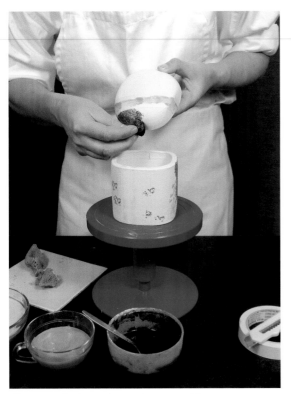

Glaze is applied onto the taped pattern with a sponge.

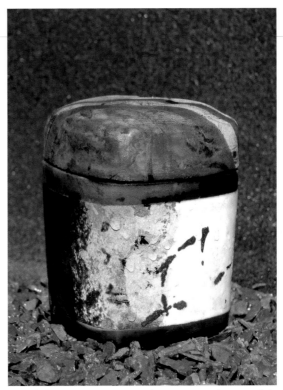

Wheel-thrown stoneware, patted into a square shape, cut lid, patterns with tape, raku fired.

teaspoon of each goes a long way. If you happen to mix too much color, you can store it in a sealed container until you use it again.

Then, you add a few drops of glycerol and a few drops of water. Mix the ingredients and shred the paint by pressing it with a palette knife so that all lumps disappear. Drizzle on more glycerol and water so that the mixture becomes a liquid paint. The paint should not be dripping from the brush, but also not be so viscous that you can only create brushstrokes. The paint should appear a bit oily and it should be easy to paint with it. Once you are finished painting the object, you can cover it with a transparent glaze. Just make sure to let it dry thoroughly first.

You can create several shades of the same color, based on your color mix. If you add more water, the color becomes weaker and will look more like water-color, and you can then play around with different shades when you paint your pottery. Try it on a water-color sheet first to see the different shades, but remember that the paper absorbs the paint differently

from the bisqueware. You can pencil in the outline onto the bisque fired object so that you know where and how to paint it.

Decorating with Tape and Clay

You can use tape to decorate your pottery. It will prevent the glaze from sticking to certain parts of the surface. Regular freezer tape or masking tape works very well in this context. This technique is performed on bisque fired pottery, and you attach the tape directly onto the bisqueware. Then you glaze it and finally, remove the tape. The spots where the tape was will remain unglazed. With this technique you are able to produce clear, straight lines. It can be difficult to tape rounded objects because the tape will wrinkle. To prevent this, you can use electrical tape instead. It has good elasticity.

If you want to create unglazed surfaces on an object with a rough structure, you will not be able to use tape; it will not stick. Even wax and latex can be diffi-cult to paint on a rough surface. Instead of tape, use

soft clay and press it onto the spots that you want to leave unglazed.

Overglaze and Faience

Before the powerful advance of porcelain in the beginning of the 1600s, most pottery was made out of earthenware. The red clay was abundant in Europe, and to make the objects more exclusive, they were glazed with a glossy, white, tin glaze. Mediterranean countries stood at the center of this exclusive manufacturing process, including Italy in the city of Faenza, and Spain with the small island of Majorca. When the objects were newly glazed, they were painted with beautiful patterns in strong colors, and that is how the concept of faience and majolica was born. The technique has survived until this day and is also used with porcelain and stoneware. The word "overglaze" is sort of a common name for the ceramic color mix that is used in the context. You can buy premixed overglaze, or you can make your own. The main characteristic of an overglaze is that it contains some form of flux substance, such as glaze, which makes the color completely merge with the underlying glaze, and together they form a smooth result.

If you want to apply this technique, you begin by glazing your pottery. If you do not have a white tin glaze, you can use any glaze as long as it is not too dark because then the decorative pattern will not be visible after the firing process. Let the glaze dry completely.

If you wish to mix your own overglaze, you need a transparent or white glaze, oxides or stains, glycerol and water. Measure up about 1/5 teaspoon of stain or oxide and place it on a plate, and add equal parts of glaze, water and glycerol, little by little. Shred the paint. The consistency should turn out like coffee creamer. The brush strokes should move freely over the dry glaze surface without any interruptions. You can add more glycerol in this case. You can also add more or less water depending on if you want to increase or decrease the color intensity.

Before you begin painting with this dye solution, sample paint the object with regular, light and thin watercolor to see where and how to paint it. Be gentle when handling the painted object. The paint will stick to the object once it is applied thoroughly, but if you are careless when grabbing the item, you might smudge the color with your hands. Once you are done painting the object, it is ready for the final glaze firing process.

Color wise, the end result will differ on earthenware compared to stoneware and porcelain. Since earthenware is fired at lower temperatures, you can use a broader color spectrum and therefore produce brighter colors. In addition, the lines will turn out sharper.

On stoneware and porcelain, which are fired at higher temperatures, the color mix tends to bleed, meaning that the lines get a little blurry at the edges, and some colors may seem a little insipid.

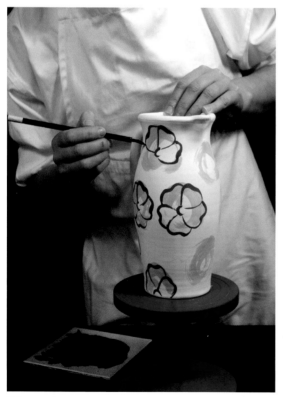

Faience on jug.

GLAZE

What Is Glaze?

Glaze is a thin layer of glass that is melted onto the clay surface. Depending on the glaze content, which can contain feldspar, kaolin, chalk and oxides, the glaze can be either matte or glossy, transparent or opaque, white or colored. The purpose behind the glaze may vary. It makes the object more durable, easier to keep clean and more practical because it becomes more dense, as earthenware itself does not sinter. However, most stoneware clay sinters at higher temperatures and becomes waterproof without any glaze. Another aim is to give the object character. Sort of like giving the object a means of communicating between the potter and the observer.

Earthenware glazes are burned at temperatures that range between 1,742 and 2,102°F, and stoneware glazes are fired at temperatures ranging between 2,192 and 2408°F.

The Glaze Composition

A glaze is composed of three main ingredients: silica, flux and aluminum.

Silica is the glass-forming agent in the glaze. The more silica you add to the glaze, the harder and stronger it becomes. However, silica has a very high melting point, about 3,092°F, so you will need to add other materials that will make the glaze melt.

Flux is a material that lowers the melting temperature. There is a variety of flux, and each has its own characteristics and impact, not only the melting point but also the quality of the surface and color. Some examples of flux in stoneware glazes are calcium oxide in the form of chalk, and magnesium oxide in the form of dolomite or talc. Small quantities produce a glossy surface, while large amounts will create a matte finish.

Aluminum is the last major component. It is added to the glaze in the form of kaolin or ball clay. These are stabilizers that allow the glaze to attach to the surface, as well as making it viscous enough not to leak off the object when it melts during the firing process.

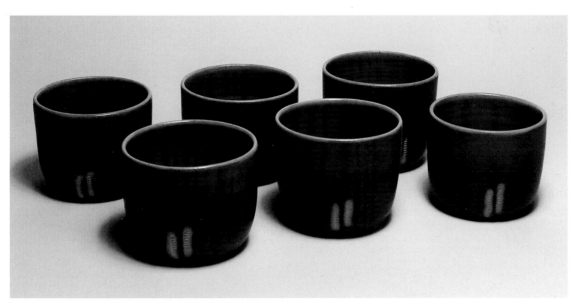

Stoneware, decorated with latex, glazed, oxidation fired, cone 8.

The constituents of glaze fall into three groups:

The Basic Group—contains substances that lower the melting point: barium, boron, potassium, calcium, lithium, magnesium, sodium and zinc.

The Acidic Group—contains substances that increase the melting temperature: silica, tin, titanium and zircon.

The Stabilization Group—stabilizes the glaze viscosity: aluminum.

The Basic Group

The basic group contains substances that lower the melting temperature of a glaze, and also give the glaze its character. Different substances have different properties and effects on the glaze, such as how the colors will appear and how the structure of the glaze will turn out. The basic group primarily consists of the following materials:

Barium Carbonate	Barium carbonate is toxic. It can produce beautiful blue nuances when combined with copper. Barium is also common in turquoise glazes. In combination with zinc, it can produce matte and silk-matte glazes. Barium can leak out of the glaze when it is fired, especially in combination with the acidity in overripe produce, if you use your creation later for carrying food. Therefore, keep the barium quantity low, under 20 percent, and wear a protective mask when you handle the chemical compound.
Boron	Boron is a glass builder and a flux substance, and it is used primarily in glazes with a low melting point. It also prevents crackles in the glaze. Boron tends to produce blue shades in combination with copper, and violet when mixed with manganese. Boron is added in the form of frit, colemanite, or primarily as ulexite.
Dolomite	Dolomite is a mineral that contains calcium and magnesium. It prevents crackles in glazes and it makes cobalt pull towards violet. Dolomite is used primarily to give the glaze a matte finish.
Chalk	Chalk is calcium carbonate. It is a cheap and good flux substance. The chalk works as a binding agent so that the glaze sticks to the object, but if you use huge quantities, it will produce pinholes.
Lithium Carbonate	Lithium carbonate has a favorable effect on coloring oxides, but it is hazardous. Always wear a protective mask when handling it. If you want to add lithium to the glaze, spodumene and petalite from the feldspathoid group are good options. These two minerals are cheaper and less toxic.
Magnesium Carbonate	**Magnesium carbonate is a flux. It can be used to make matte, but too much can cause pinholes. Cobalt will produce violet hues when combined with magnesium carbonate, and pink shades when combined with zinc.**
Talc	Talc contains magnesium and silicon and is capable of producing cobalt to violet. Talc glaze produces a nice matte finish.
Wollastonite	Wollastonite can partly replace chalk and may prevent the formation of pinholes.
Zinc Oxide	Zinc oxide impacts oxides positively and is often a component in crystal glazes. At high levels it produces a covering glaze and it prevents shrinkage and pinholes.

The Acidic Group

This group contains substances that have a high melting point, and therefore they raise the melting temperature. The acidic group is added through these materials:

Quartz	Quartz is a common glass-forming mineral. Use quartz in your glaze whenever you can. It produces a durable and shiny glaze. Silica dust is toxic to inhale and can cause silicosis. Wear a protective mask.

The Stabilizing Group

The last group has an important responsibility: to ensure that the consistency of the glaze does not become too runny so that it does not leak off of the object during the melting process. Aluminum is used to prevent this issue. Materials that add aluminum are:

Kaolin	Kaolin is a primary clay and is used as a binding agent in glazes. Kaolin also makes the glaze more fluid in the bucket.
Ball Clay	Ball clay is a secondary clay and fills the same function as kaolin but is not as pure. However, the particles are smaller.

A good glaze contains as much silica and clay as possible. Quartz makes the glaze hard and sustainable, and the clay makes the frosting attach to the pottery more easily.

Feldspar

Feldspar is the most important component in glaze production. It contains elements from the following three groups: quartz, flux and aluminun. Therefore, you can make a glaze out of feldspar alone. Feldspar is available in different compositions of minerals. The most common are potash feldspar, which contains high amounts of potassium, sodium feldspar containing high levels of sodium, and cornish stone and nepheline syenite which have high levels of both elements. Experiment to see how the glaze is affected when you add the coloring oxides.

Glaze Properties

The material in the glaze affects its characteristics, both in how it looks and how it feels when you touch it. A glaze can be anything from glossy to matte and rough. Various textures and structures are suitable for different objects. Here, the firing process plays an important role. It is important that the objects are fired at the right temperature in order for you to achieve the desired results. Test fire several objects to make sure that you will achieve satisfying results.

Transparent Glaze

A transparent glaze is clear and gives a smooth surface that allows for designs and patterns to remain visible. A good transparent glaze will not produce any cracks or crackles. If a transparent glaze turns out milky white or streaked, it may be because the glaze was too thick, or because it was not fired at a sufficiently high temperature.

Opaque Glaze

To make a glaze opaque, you add an opacifier. There are several materials that can be used for this purpose. If you add about 5 to 10 percent of tin oxide, zirconium oxide or titanium oxide, the glaze becomes opaque. Tin oxide covers better than the other two, but it is expensive and can be replaced with zirconium oxide or titanium dioxide, which are much cheaper.

Shiny and Matte Glazes

Glazes are basically blank, but, with the addition of different elements you can create surfaces that are pleasant to the touch and to the eye. One way to create a matte glaze is to increase the content of dolomite or talc. If you add magnesium carbonate the glaze acquires a silk-matte quality that feels like water-cut stone to the touch.

Coloring the Glaze

You can use metal oxides to give the glaze some color. But there are several factors that affect the final glaze color. The choice of clay, glaze composition, the oven condition and the firing temperature are all components that contribute to the tint. Several metal compounds can also be purchased in the form of carbonates. Oxides produce the strongest colors but are also more coarse-grained, resulting in a slightly dotted result. Carbonates are more finely ground and therefore they offer a more even color impression, but they require larger amounts to achieve the same color intensity as the oxides. It is fine to mix the oxides with each other in order to get different tones.

The most common oxides are:

Iron Oxide

Iron oxide is a very common naturally occuring oxide; therefore it is inexpensive. One to ten percent produces yellow to brown and brownish-red colors during oxidation firing. During reduction when used in low amounts, it turns green, while it produces black and brown colors at higher amounts.

Cobalt Oxide

Cobalt is a strong coloring metal oxide. It is also expensive. You only need a very small amount to produce a strong color. Addition of 0.1 to 3 percent oxide or carbonate is sufficient to obtain the entire color range from light blue to dark blue.

Copper Oxide

Between 0.2 and 4 percent oxide or carbonate produces a good color. During oxidation firing the hydroxide color spectrum ranges from pale green to dark and metal black. In alkaline glazes, that is, glazes that are high in potassium, sodium or lithium, the color turns turquoise blue to metallic turquoise. During reduction the copper turns red and pink, and copper oxide is used to create oxblood glazes.

Chromium Oxide

Adding 0.5 to 3 percent of chromium oxide gives the glaze a green color. Unlike copper, which produces a lively variety of colors, chrome gives a more uniform color. A glaze that contains chromium oxide can affect other glazes during the firing process, such as glazes containing tin. The objects with tin glaze can then turn pink instead of white.

Manganese Oxide

A percentage of 4 to 10 percent of manganese oxide in the glaze gives various shades of brown. In alkaline glazes, manganese turns violet. Manganese is a powerful flux, so if you add more than 10 percent to the glaze, it can become quite runny.

Nickel Oxide

If you add 1 to 2 percent nickel in a glaze, you get blue, gray, pink or green tones. Nickel is often used to tone down other strong colors.

Rutile

Rutile produces a beige color, but is also used to liven up a glaze. The addition of 2 to 10 percent of rutile in a glaze can make it speckled, mottled or spotted.

Tin Oxide

Inclusion of 7 to 12 percent of tin oxide in a glaze makes it white. The amount of oxidation determines how opaque the result will turn out.

Titanium Dioxide

Together with other coloring oxides, titanium oxide produces a speckled color effect. A rate of 8 percent and above makes the glaze white with warm yellow tones.

Zirconium Oxide

Zirconium oxide provides a warm white color. It can be added up to around 10 percent. If you use zirconium silicate, you can add up to 18 to 20 percent.

Stains

Stains are made from a mixture of metal oxides and compounds that are commonly used in glazes. The mix is melted and after it has cooled down, it is ground to a fine powder. The process yields a variety of colors in exact shades. The amount of stains in a glaze can vary up to 20 percent.

Some colors, like pink and bright yellow, cannot withstand the very high temperatures and burn off. You can get advice on what colors can handle certain temperatures when you go to the ceramic retailer.

Some Common Types of Glaze

Earthenware Glaze	Earthenware glazes have a lower melting point than stoneware glazes. Lead oxide was previously the most commonly used flux in earthenware glazes. Lead oxide has favorable effects on colors, but unfortunately lead is very toxic to handle. If you store sour produce, such as fruits, juice, or vinegar in vessels that have been glazed with a lead oxide glaze, the lead may leak into the produce. This is important to keep in mind when you are buying glazes, but also when you buy pottery. Does your ceramic retailer know what the glaze contains? Nowadays, it is more common to incorporate frit into earthenware to lower the melting point. Simply put, frit is a fired glaze-mix that melts at temperatures ranging from 1,292 to 1,832°F. It comes in various element compositions.
Ash Glaze	Glazes where ash is the biggest component.
Feldspar Glaze	This group is the most common glaze group. It is characterized by the fact that it is made out of elements from all three groups, with feldspar as the main component. The feldspar glaze has a tendency to crackle.
Transparent glaze	This includes glazes composed mainly of earthenware clay and is used to frost stoneware. Examples of such glazes are the classic temmoku, khaki, and tessha. Transparent glaze is also used in the so-called re-glazing, meaning the glaze is applied when the goods are hard and then glaze-burned directly, without having to burn raw materials beforehand. This saves time and energy.
Clay Glaze	These are glazes that primarily consist of earthenware clay and are used to glaze stoneware. Classical examples are tenmoku, kaki, and tessha. Clay glazes are also used during raw glazing. During this process, the glaze is applied onto leather hard clay, and is glaze fired right away, without being bisque fired first. This saves time and energy.
Crackling Glaze	This glaze shrinks more than the clay it is glazed on. Therefore, crackles are formed on the surface. This type of glaze always has a high content of feldspar. This effect is often seen during raku firing.

Oriental Glazes

These are classical glazes, and they require reduction firing to achieve their correct color and shade.

Oxblood	Red	Copper oxide produces the red color.
Shino	White to orange	The color will turn out white where the glaze is spread thickly, and range from orange to brown where it is spread in a thin layer.
Chün	Blue	The blue color comes from phosphorus, which leaves an optically light impression with small glass beads that do not dissolve in the glaze. Ash that contains phosphorus is used to produce this glaze.
Celadon	Green-gray Green-blue	The iron oxide in this glaze produces its pleasant green color, 1–3 percent iron.
Temmoku	Black/dark brown	Contains high amounts of iron oxide and becomes black with golden-brown to red-brown edges, 5–10 percent iron.
Kaki	Rusty red. The iron is collected on the surface as crystals.	Contains more than 10 percent of iron.

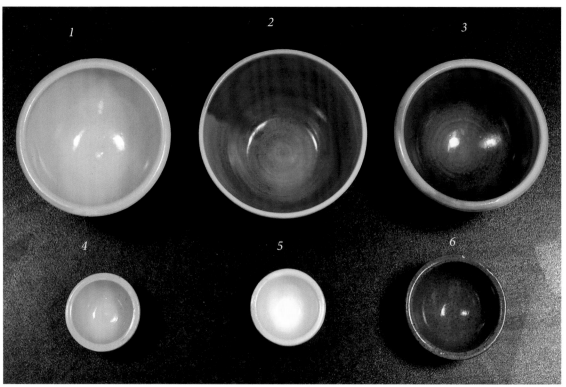

1) Transparent semi-gloss. 2) Transparent semi-gloss + 1.5% copper oxide. 3) Transparent semi-gloss + 1.5% copper oxide + 3% titanium dioxide. 4) Mita base. 5) Mita base + 10% zirconium silicate 6) Mita base + 10% zirconium silicate + 1% cobalt + 3% rutile + 1% manganese oxide.

Ash Glazes

Ash contains all necessary components needed for a glaze, and ash is also a common ingredient in glazes, and forms glaze on its own. You can use ash from any organic, combustible material, but wood ash is the most common choice. All ashes have different components and the elements are determined by wood type and its growing site. It is therefore very difficult to repeat the results gained from an ash glaze. Hower it is excellent to use if you want to create your very own authentic glaze.

To get the right composition of the glaze, several samples are needed. The first thing you could do to test it out is to burn only the ash to see how it behaves. Sprinkle dry, sifted and washed ashes in a bisque fired vessel, or mix the ashes with water and dip the object in the mixture. After you glaze fire the object, you will see the result. Some ashes contain high levels of flux, which makes the ashes runny. In those cases, you may add more clay in the form of kaolin.

The following is a simple, basic recipe for ash glaze: 1 part ash, 1 part feldspar and 1 part kaolin.

If you want to experiment further based on this basic recipe, you can reduce the amount of kaolin and increase the amount of feldspar with about 5 percent at a time. Be sure to label the samples correctly so that you use the correct ones when you want to experiment further.

You can also dye your basic ash glaze by adding oxides or stains, little by little. Begin, for example, with 0.5 percent of oxide and increase by 0.5 percent at a time until you achieve the shade you desire.

Mixing Glazes

You can buy glazes that are ready to use in all kinds of colors and shades. The majority of glazes are sold in powder form, but some are also available as liquids. If you follow the instructions and stick to the recommended firing interval you will achieve glazes with the promised color. Results may vary due to clay

Glaze Recipes

Transparent semi-gloss cone 8

Soda feldspar	61
Dolomite	9
Lithium carbonate	5
Kaolin	10
Quartz	15

Mita base cone 8
Transparent semi-gloss basic glaze

Sodium feldspar	72
Kaolin	4
Chalk	11
Quartz	13

Examples of blue colors based on mita base

Zirconium silicate	10
Cobalt oxide	0.5
Rutile	3
Manganese oxide	1

texture and color. Even the atmosphere in the furnace can affect the color.

Whether you choose to buy a glaze powder, or choose to mix a glaze from a recipe, the preparation is the same. You mix the dry powder with water. A good starting point is to count 3 2/5 cups of water per 2.2 lbs of dry matter. Some store-bought glazes come with instructions on how much water to use. But even when they do, you will benefit from trying out different thicknesses on the glaze to see which properties it has, and which one suits the pottery that you are working on.

Get all the ingredients in the recipe and weigh each one up carefully. Check off each ingredient that is measured and ready to use. Fill a bucket with the appropriate amount of water and gently add the the dry ingredients. Use a protective mask during the part of the work that creates a lot of dust. Then let the glaze stand for a few hours, preferably longer, as it will facilitate atomization, making the matter easier to stir. A dish brush or a toilet brush are excellent tools to use for stirring. Do not dip your hands into the glaze, and always make sure to wear rubber gloves.

When the glaze is well stirred, strain it through a sieve with a 80 and 120 mesh. The mesh number indicates the number of wires in the mesh per linear inch/ the density.

Even when you are working with a store-bought glaze, you will benefit from creating your own samples, and you can also mix in various oxides if you want to color the glaze. It may be practical to buy a good transparent glaze that is reliable and then dye it yourself with various oxides or stains. A simple and much cheaper way is to mix your own transparent glaze to use as a starting point. Here is a recipe:

Transparent glossy cone 8

Soda feldspar	40
Kaolin	10
Quartz	30
Chalk	20

To test the thickness of the glaze after it has been sieved, you can dip a piece of bisque fired pottery in it and see how much of the glaze sticks to it. A layer that is about 0.04 inch thick will give a good opaque layer. If the glaze seems too thick, to- add more water, little by little. If it becomes too thin, allow it to sit undisturbed for a day or two. The elements of the glaze are heavier than water and sink to the bottom. You can then easily scoop out any excess water.

It is good to make samples with the glaze in various thicknesses to see how it behaves during the firing process. You will then be able to determine if it is too runny, if it changes color, or if any other characteristics appear depending on the thickness.

If you have recipes that work well and that you can trust in the oven, you can look at what materials it contains. Then you can read about how the materials react to various oxides and how they affect the colors. Make little samples so that you learn how to produce fine colors in beautiful nuances that you want for your pottery.

When you have been working for a while with store-bought glazes and/or your own recipes, you

might want to give your object a special chracteristic through your very own glaze. It is possible to figure out how to get the glazes exactly as you want them. There is a lot of good literature that describes different approaches in a simple and pedagogical way.

Glaze Samples

Burn a number of test samples with the glaze before glaze your real work. This will save you time and agony. When you are satisfied with the samples you can move on to the real objects. A lot of people tend to add sample of some kind during the glaze firing process, and it is always exciting to take the glaze samples out of the oven and try to imagine them on the next set of pottery.

Small rolled sample plates are excellent to use for glaze samples. They do not take up too much space in in the oven and they are easy to store. Stamp or carve patterns into the plates if you want to. Then you will be able to see clearly how the glaze turns out when layered thin or thick. Another way to test the glaze is to either throw or pinch small bowls. This allows you to see how the glaze behaves on standing and lying surfaces. You can also see how the glaze works on edges, and observe if it is runny. Based on the samples you can pick your selection of glazes that you want to work with. Be sure to label your samples and write the results of your experiments.

Storing Glaze

A glaze is best stored in a bucket with a tight-fitting lid. Be sure to label both the bucket and the lid. When a glaze has been untouched in the bucket for some time, it tends to settle. Usually, you can stir it up again, but if there is a really hard sediment, you may need to use a powerful electric whisk to stir with, and the mass may also need to be sifted. To counteract the sedimentation, you can add 1 to 3 percent of bentonite to the glaze. Bentonite comes in powder form and should be added to dry materials, as it is nearly impossible to stir it into liquid. If you are going to add it to a glaze that is already mixed, you can do it the following way: Mix the bentonite in a glass with warm water. Let it stand until the next day. By then the bentonite will have swelled and acquired a gel-like consistency. Pour the mass into the glaze and whisk it until it is smooth.

Various Glazing Techniques

The various methods available to apply glaze are through dipping, pouring, spraying or brushing.

To know which method is the most appropriate, you should have a clear picture of the outcome before you get started. Should the glaze be layered on thin or thick? Are you going to cover an entire pot with it, or should you leave parts of it unexposed to the glaze? Perhaps you are going to use a different glaze for the interior surface, than the glaze used on the exterior of your object.

Usually, objects are glazed after they have been bisque fired. The pot surface is porous and absorbs water from the glaze, leaving a fine layer of powder on the surface. The thicker the surface is, the more water and glaze it will absorb. If the chipping is very thin, you have to work quickly or it will absorb so much water that it becomes saturated and then the glaze will not stick to it.

Sometimes raw glazing is used. Then you apply a clay based glaze onto leather hard pottery and fire the object only once.

Dipping

If you want a a smooth and fine glaze, you can dip the entire object in glaze. For this you need a large amount of glaze and large buckets or tubs. Glaze tongs will come in handy when you dip the object in glaze. Make sure that the pot will fit in the bucket and that there is room to place hands or glaze tongs around the pot. Dip the entire pot into the glaze and quickly lift it out. Turn it upside down so that any excess glaze leaks off the object. Set the object aside and let it stand until the glaze has dried completely, and you can lift it up without creating any fingerpritnts.

If you want to double glaze the object, or add several glazes on top of each other, it is best to start out with the lightest color and then dip the object in the darker color, or you will risk getting the darker glaze into the bucket with the light glaze, and by then it may be ruined.

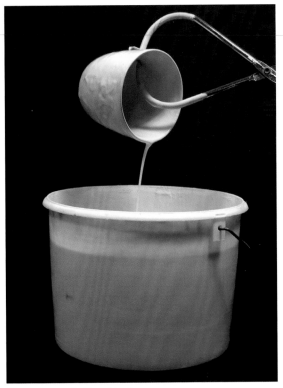

The entire cup is dipped in glaze.

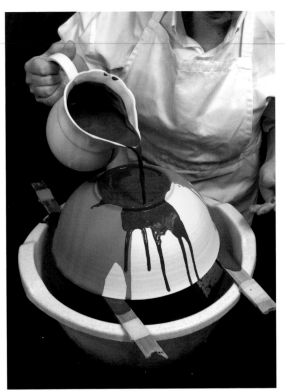

Glaze is poured over the bowl.

Pouring

Large plates, or tall pots can be difficult to dip in glaze because of their size. Pouring glaze over these object may be a better option. It occurs in two steps. With tall objects, the interior is glazed first, by pouring the glaze all the way up to the brim and then immediately pouring it out. Hold the object upside down until all the excess glaze has leaked out. If you happen to spill some of the glaze onto the exterior of the object, you can wipe it off with a sponge. Then let the object dry so that it is possible to touch it and so that it can absorb more water. When it is dry, place the object upside down on two thin wooden slats over a bucket or a tub. Keep as little as possible of the object's surface touching the wooden slats. Fill a vessel with glaze. Pour the glaze over the object. Pour it over the bottom and around in a stream so that the glaze is evenly distributed over the object. Then let the object stand until it is completely dry. A lot of glaze tends to collect around the edge, which rests on the wooden slats. You can even it out by using a finger to wipe away any excess glaze. If you are using the same glaze on the interior and the exterior surface, just even out the thickness of the glaze and remove any excess. However, if you are using a different colored glaze on the exterior of the object than on the interior surface, you will need to be more cautious. Then it can be better to leave the object's edge unglazed until you have poured glaze over the exterior surface and wiped the rim, and then you dip it gently in the desired color.

Pouring and dipping are the most common ways to glaze pottery. The advantage of these methods is that they require no additional equipment, and it is also an economical way because it leaves essentially no waste. The disadvantage is that it requires large amounts of glaze and big, bulky buckets.

Spraying

Spraying pottery with glaze opens up a plethora of possibilities, at least when it comes to creating nuances in color with one and the same glaze. It is also a good option when glazing large objects. It allows you to use small amounts of glaze that would not be enough for dipping or pouring. However, spraying

Spray glazing.

creates a mess as a lot of glaze is spilled all over the place.

It takes practice to being able to spray on an even coat of glaze, but many people strive for variations in the glaze thickness, which produce a shaded effect.

Spraying requires a compressor and a paint-sprayer. There should also be a fume cupboard with a good ventilation system. When spraying it is necessary to wear a protective mask. Otherwise you may breathe in the small particles that whirl around when you spray glaze, and they get stuck to the lungs. It is very important to be cautious and take the risk of injury seriously.

Set the object on a banding wheel and let it spin slowly so that the beam of glaze from the spray gun is as evenly distributed over the object as possible. It is important not to use too much pressure in the spray gun. The glaze should be a little thicker in consistency than when it is used for dipping or pouring. To find out if you have sprayed a sufficiently thick coat, use a pin tool to carve the glaze carefully. If you want an opaque glaze, a coat that is about 0.04–0.06 inch is sufficient, but it may vary depending on the glaze and your preference. As you use this method,

you will learn the effects of the glaze when it is thin or thick.

Bisque fired objects that have been decorated with underglaze colors will benefit from a spray glaze, since it may be difficult to dip them in glaze without ruining the decoration, by virtue of pieces of it falling into the bucket.

Brushing

At the retailer, there are special glazes developed specifically for brush painting. Other glazes may be difficult to brush on evenly. The surface quickly absorbs moisture, which shortens the brush strokes and makes them visible. This method is used primarily on small surfaces, which are easier to handle when you want a smooth and even finish. To facilitate the painting, you can add glycerol to the glaze, which will make the brush strokes more pliable.

It is also appropriate to apply the glaze with a brush if you want to paint decorations with different glazes on an already glazed object. A glaze with a higher melting temperature can produce great effects on an object that has already been glazed.

Wiping Off Glaze

Use a damp sponge to wipe off excess glaze whenever possible. Scraping off and blowing off the glaze will result in fine dust particles that are stirred up, and the risk of inhaling them is great. You need to take safety precautions to avoid this.

When you glaze stoneware, always wash off the glaze on the bottom of the object, otherwise it will stick to the oven during the firing process. The glaze melts and turns into glass that solidifies and the object will be stuck to the oven like glue. Earthenware is often fired on tripods; see glaze firing on page 121. Then you can let the glaze on the bottom remain.

When firing objects with a lid, it is best to leave the lid on. It is therefore important that the edges are thoroughly cleaned from any glaze and that you apply alumina hydrate on the seams; otherwise the lid will be glazed fixed to the object. Holes in strainers and teapots and such may also need to be looked over so that they do not get glazed shut.

If the glaze is freshly prepared and it does not turn out correctly during the firing process, it could be because not all materials were included or that they were not measured correctly. Meticulously check off all ingredients needed for the glaze and verify that they have been measured correctly. It may save you many troubles.

Glaze Issues and Prevention

Issue	Symptom	Cause	Prevention
Crackled Glazed	A network of fine cracks in the glaze.	The glaze shrinks quicker than the clay. Cracks are formed when the glaze is cooled off too quickly.	Add more materials that have a low expansion rate, i.e. quartz or kaolin.
The glaze acquires pinholes.	The glaze is full of pores, much like an orange.	Could be caused by gases in the bisque-ware or the glaze, or by air that is trapped inside the bisque fired object. Too much chalk in the glaze.	Raise the temperature when you bisque fire clays that contain manganese. Decrease the amount of clay. Spread a thinner coat of glaze.
The glaze shrinks.	The glaze shrinks and leaves patches of unglazed clay surface.	The most common cause is that the glaze has been applied too thickly.	Apply a thinner coat of glaze. Brush the bisque fired object clean before glazing it. Wear gloves during the glazing process.
The glaze is peeling off.	The glaze is peeling off, especially around the edges.	The clay is shrinking more than the glaze.	Increase the amount of feldspar, and decrease the amount of chalk.

1) *CD* 2) *Electrical resistance* 3) *Onion* 4) *Medicine* 5) *Copper nail and brass mat* 6) *Tourmaline and hematite* 7) *Cladonia stellaris*
8) *Human hair* 9) *Iron wire* 10) *Candy*

1) *CD* 2) *Electrical resistance* 3) *Onion* 4) *Medicine* 5) *Copper nail and brass mat* 6) *Tourmaline and hematite* 7) *Cladonia stellaris*
8) *Human hair* 9) *Iron wire* 10) *Candy*

Glaze Experiment

When you mix glazes, it is important to carefully weigh the different ingredients to get the effects and the color of the glaze that you desire, and to be able to repeat successful results. However, it is worth remembering that mistakes can sometimes lead to the most amazing results.

You can also add or attach other types of materials on the object that is to be glaze fired. This opens up a whole new world of possibilities. If you fire the object in earthenware temperatures, chances are that the second material appears more distinct. Many materials burn away completely, or leave small imprints in stoneware temperatures. It is important to have a good ventilation system if you are burning unknown material. Keep in mind that the new material can melt and leak or spatter inside the oven. Above you can see burning experiments of various materials that have been fired up to 2,300°F.

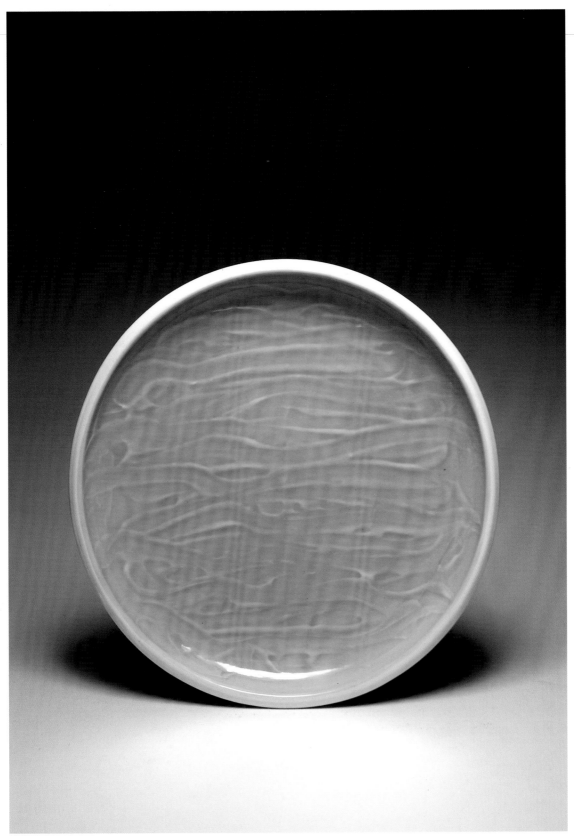

Porcelain, decorated with engobe, glazed, oxidation fired, cone 8.

KILNS

The kiln is one of the most important tools in a pottery workshop. There are many different types of kilns, and they can run on different kinds of energy—gas, wood or electricity. In our part of the world, electric kilns are the most common. An electric kiln is easy to manage. It is connected to an instrument that controls oven temperature automatically.

When you fill your kiln with objects it is referred to as setting the kiln. To set a kiln you need kiln shelves and kiln posts to build shelves. These are made out of sillimanite, which is an aluminum material that can handle temperatures up to 2,372°F.

To make the shelves last longer and to prevent any glaze that happens to spill onto them from sticking, treat them with kiln wash. It is an engobe that contains aluminum hydroxide. It is important to make sure that no glaze residue is stuck to them. Only small quantities are needed for the object to get stuck in the remains. If any glaze from a glazed object melts and fuses with the shelves, the object will stay fixed to it. Remove all glaze residue with a hammer and chisel. Use safety glasses! Then apply a new layer of kiln wash.

When you set a glaze kiln with pottery, place the objects on tripods. Tripods are made of the same material as the rest of the setting materials and have sharp points that can lift the pottery up without getting stuck in the glaze as they have a very small surface to stand on.

To ensure that the automatic temperature system is showing the correct temperature, there are cones you can place in the kiln. They are made out of compressed material similar to that used in glazes. They have a precise melting point and come in many different temperature ranges. The cones begin to bend when they start melting and when the tip is pointing towards 3 o'clock, the cone has reached its specified temperature. It is good to measure with three cones—one that has the desired final temperature, one with a

lower temperature and one with a higher. If you want to know the exact temperature distribution, place three cones in the kiln, one on each shelf, so that you can tell if the temperature varies in different places inside the oven. This way, you can control the actual temperature of the oven and set the automatic temperature according to that.

Stoneware, thrown, assembled, oxidation fired, cone 8.

What Happens to Clay During Firing

<230°F	Mechanically bound water disappears.
482–662°F	Chemically bound water begins to dissipate. Organic materials begin to burn.
752–1,112°F	Quartz Conversion at 1,063°F. Burn with care.
572–1,652°F	Organic impurities are burned away.
1,652–1,832°F	Reduction firing can begin.
2,012–2,192°F	Feldspar begins to melt. Shrinkage is evident.
> 2,192°F	The glass phase begins here. Further shrinkage of the clay.
Cooling	Cool the kiln slowly. Never open the kiln before the temperature is below 392°F to avoid cold cracks.

It is good to keep a firing journal. Use it to describe what you put in the kiln, track firing temperatures, and log any details about the clays you are using, or record if you are firing specifically sensitive objects. It is exciting and fun to track your firing progress. The journal becomes indispensible when it comes to repairing pottery in case of breakage. You can also track details about fun or difficult glaze samples and get a nice diary about the everyday life in a pottery workshop.

Stoneware, wheel-thrown, decorated with engobe prints, glazed, oxidation fired, cone 8.

BISQUE FIRING

Stoneware, slab constructed, colored with stains, unglazed, oxidation fired, cone 8.

Bisque firing is the very first firing process. It is done when the clay is completely dry and does not feel cold to the touch. At this stage, the objects are very frail. Use both hands when lifting the unfired objects. Do not lift any objects by their handles.

Until you bisque fire your creations, you can reshape the clay and start over again. Once the clay is bisque fired, you can no longer reshape it. The chemical changes that take place make all the water evaporate and the clay turns hard in structure, which facilitates the glazing process.

During bisque firing, you may place objects inside and on top of each other in the kiln. Rolled plates should stand up, leaning against each other. If they are stacked on top of each other lying down flat, the bottom plates tend to crack. It has to do with the fact that clay tends to expanded slightly before it begins to shrink. However, plates that stand on top of each other have enough room to expand.

Remember to fire the objects slowly in the beginning of the firing process. The temperature should not rise more than 212°F per hour up to 1,112°F. This is because there is water bound into the clay that can blow up the object if it is heated too quickly. During the firing process the clay goes through several chemical changes. When the bound water evaporates between 662 and 932°F, it is good to keep the kiln ventilators open to allow steam to escape. The quartz in the clay is also converted on two occasions, at 437°F and at 1,063.4°F during the heating and the cooling process. This leads the clay to expand about 1 percent. After 1,112°F, the temperature may rise quicker, until you reach the peak temperature of 1,760 to 1,796°F. You can use the same temperature when bisque firing earthenware and stoneware. No temperature stabilization is needed during bisque firing as the kiln will keep the final temperature consistent for some time. The kiln should remain closed until the temperature reaches below 392°F. The object can easily break even when it is bisque fired. Handle your pottery with great care.

GLAZE FIRING

Once the objects are glazed, they need to be glaze fired. During the glaze firing the glaze melts together with the clay and forms a homogenous surface. Earthenware is glaze fired at temperatures ranging between 1,742 and 2,102°F, stoneware and porcelain at temperatures ranging between 2,192 and 2,372°F. The firing temperature depends on the type of clay, and on the glaze composition.

Make sure to wipe off any glaze from the bottom and a bit up on the edge on stoneware objects before you glaze fire them so that no glaze gets stuck to the shelf. Earthenware objects that are glazed on the bottom are placed on tripods.

A glaze kiln will contain fewer objects than a bisque oven as the glazed objects need a lot of room so they do not rub against each other. Be sure to leave space around each object. It becomes a fine art to try to fit as much as possible into a glaze oven.

During glaze firing, the temperature may rise much faster than during bisque firing. Then, there is no bound water to worry about. The firing process will still take about the same time because the temperature has to rise higher. Once the final temperature is reached, keep it at that temperature for about 15 to 30 minutes. This stage is called smoothing, and this is when the glaze is molten, and matures to form a smooth finish. For some glazes, such as crystal glazes, the cooling off process of the kiln is important. That is when the crystals are formed.

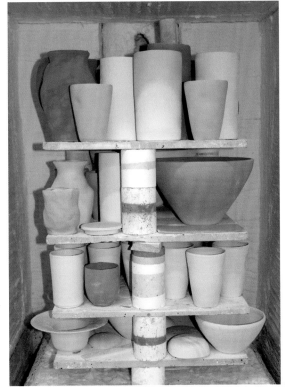

Unfired glaze kiln.

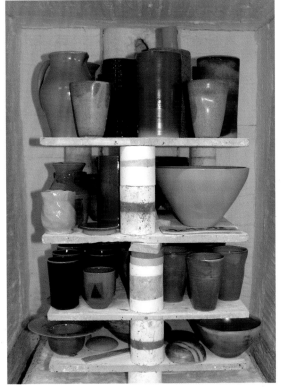

Fired glaze kiln.

OXIDATION FIRING AND REDUCTION FIRING

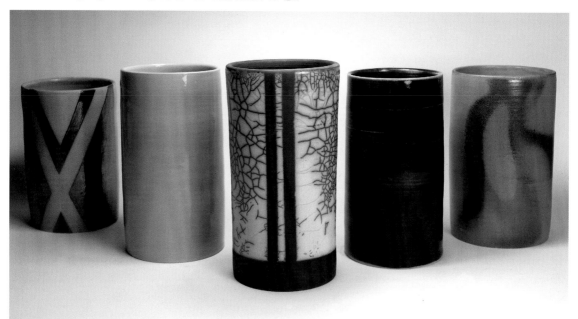

Cylinders thrown in stoneware clay. 1) Taped pattern, engobed, salt fired, cone 10. 2) Glazed with oxblood glaze, oxidation fired, cone 8. 3) Taped patterns, glazed with a transparent glaze, raku fired. 4) Glazed with oxblood glaze, reduction fired, cone 10. 5) Anagama fired, cone 10.

The atmosphere in the kiln is critical for the outcome. In an electric kiln, it is always oxidation firing. This means that during the entire firing process there is free access to oxygen in the furnace.

Reduction firing means that the oxygen is reduced during the firing, and for this process you need a wood- or gas-fired oven. There, you can control the flame by using a damper. In order to keep the firing process progressing, even after the oxygen supply is curtailed, the flame will absorb oxygen from anything it can find, even the oxygen bound in the glaze. This means that the glaze color will change: A copper glaze that usually turns green during oxidation firing will turn out red, and an iron glaze that turns yellow or reddish-brown during oxidation firing becomes green during the reduction firing process. Even the raw clay color will turn out differently in an oxidizing atmosphere.

An oxidation atmosphere is fired in a temperature up to about 1,652°F. Then the fuel is increased while the damper is clogged. That is how the reduction process begins, which continues up to the peak temperature. Flames find their way out through the chimney and someone that is experienced in the art of reduction firing can determine the degree of reduction just by observing the length and color of the flames. When the peak temperature is reached, the reduction process ends, to slowly transition into an oxidizing atmosphere again.

Tips

- Some glazes will stick to the bisque fired clay and not move during firing, while other glazes will start running violently. Be sure to wipe off the edge towards the bottom so that the glaze does not leak onto the kiln and fix the entire object to the kiln plate. Crystal glazes and ash glazes tend to be more runny than other glazes.

RAKU

Raku firing has been popular for a long time. Raku is a low-firing glaze firing technique that is performed outdoors and has a rapid progression. The whole process takes less than 1 hour and by then you have the finished objects in your hand. It results in colorful objects in combination with a dull blacks and vivid black crackles in the glaze. The procedure is a quick experience in strong contrast to the often slow manufacturing process.

Raku firing is rooted in Japan. There was a Korean man who lived there during the 1500s by the name of Chojiro. His pottery expressed a simplicity and became widely acclaimed. When he glaze fired his objects, he used a technique that was utilized by brick makers, namely by removing the objects from the oven with long pliers while the pottery was still very hot. Then the objects were left to cool off outside the kiln. This process eventually led to the approach and expression of raku firing. Raku means pleasure, happiness and joy.

What most of us today refer to as raku differs some from what the original technique used to be. Today raku is a fusion of a traditional Japanese technique and western exploration of it. The actual technique is as follows:

The glazed object is burned in a raku kiln at a temperature ranging between 1,652 and 1,832°F. When the glaze is molten, after about 15 to 20 minutes, the object is removed from the oven with long pliers. The hot object will immediately begin to cool. The rapid

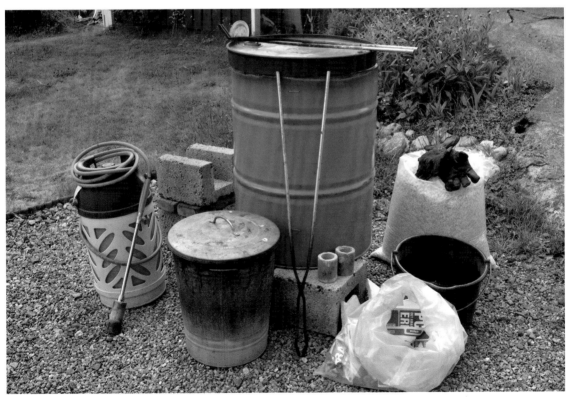

Preparations for raku firing.

Things Needed for Raku Firing

Oil Drum with Lid	The base for the oven.
Aluminum Oxide Mat	Isolating mat that can handle 2,282°F.
Kanthal Wire	Thread that handles very high temperatures.
Shelves and Kiln Posts	To place objects on top of in the kiln.
Gas Burner and Hose	
Gas Tube	
Long Tongs	To pick pottery in and out of the oven.
Barrel with a Lid to Use for Firing.	For local reduction.
Combustible Materials	Sawdust, paper, leaves and similar materials.
Sturdy Work Gloves	Must withstand high heat.
Protective Mask	That filters out dangerous substances in the smoke.
Bucket of Water	For cooling and cleaning.
Steel Wool	To wash away soot residue.
Raku Glaze	See recipe on page 131.
Tools for Glazing	Sponge and brushes.

Stoneware, slab constructed, raku fired, mounted on glass.

temperature changes causes the glaze to crack, hence the crackled design. Then the object is placed in a barrel and covered with combustible materials, such as sawdust, paper or leaves. The material will immediately set on fire. Cover the barrel with a lid to deprive the oxygen supply and still the fire. The fire will continue to burn until all oxygen runs out inside the barrel, even the oxygen in the glaze. Thus a local reduction occurs. This means that the glaze covered by the combustible material is reduced and the glaze changes in color. Glaze that remains uncovered will have the same color as before. The parts of the objects that are unglazed will turn black.

There are many different techniques when it comes to raku firing, but in this book, we only take on the basics.

The Kiln and Firing

You can perform a raku firing on your own, but it helps if you are two or more. To raku fire pottery, you will need the materials in the list above.

Simple Production and Raku Kiln

Making your own raku kiln is relatively easy and quick. If you want a more permanent furnace, you could build it out of brick. If you want a portable oven that you can move around and bring with you, an oil barrel or any other large metal barrel with lid works well.

If you use an oil drum, make sure that the barrel is thoroughly cleaned inside and contains no traces of flammable substances. Then drill a hole for the gas burning nozzle, about 4 inches in diameter, in the wall close to the bottom of the barrel. Then you dress the

barrel inside with insulation. An aluminium oxide mat provides insulation that can withstand high temperatures. Check with a ceramic supplier which mat is right for the temperatures you are going to use. To keep the insulation in place in the barrel, you can drill small holes straight through the barrel and and the mat and thread Kanthal wire through the holes. A few pairs of holes are enough to sew carpet into place. Isolate the barrel lid the same way as the barrel.

Make and Glaze Objects for Raku

Because of the large temperature differences that the pottery is exposed to during raku firing, it is advisable to choose a chamotte clay. The recommended amount of chamotte is 25 percent, but the roughness of the chamotte does not matter.

Traditional raku objects are not thrown; they are asymmetrical, individual and unpretentious. Today raku objects have all sorts of shapes and are made out of different techniques. Ensure that all parts are secure. Applied small parts are prone to loosening, and parts that are assembled with each other tend to crack. Try to have an even thickness on the objects if possible. This avoids tension in the material, which prevents cracks in the surface.

Once you have made your objects, you bisque fire them like you would normally do. Then you glaze them.

Glazes that are used for raku are typically composed of only a few ingredients and are easy to mix; see page 127. There are several ways to make a raku glaze, but a good method, and perhaps the simplest one, is to use glass frit. Simply put, frit is a homogenized glaze mixture that melts at a temperature between 1,292 and 1,832°F. Some recipes also contain kaolin or ball clay. These elements make the glaze mixture attach better to the bisque fired clay. Many frits sediment easily. To prevent this, add some bentonite. The bentonite gives the glaze a jelly-like character.

It is common to make the raku glaze slightly thicker than regular glazes, and the best way to apply them is by using a sponge or a brush. As a rule, glazes are not applied inside bottles, urns and the like. The surfaces that are left unglazed will turn black from the soot from the smoke in the reduction barrel. Here you can work with tape or wax, and thus create black surfaces with striking contrasts against the vibrant glaze.

It is very important to let the glaze dry fully before the object is placed in the raku kiln. If the glaze is the least wet, moisture will penetrate into the clay. Because of the very rapid firing process, the object cannot get rid of the water without cracking, and sometimes the moist parts even blow up.

The Firing Process

Tools that you use during firing, as well as the objects, become extremely hot, so be careful when you fire your creations. Preferably stand on gravel or asphalt. Use a pair of sturdy work gloves and put your hair up if it is long. The risk to burn off hair and eyelashes is great. The smoke formed in the reduction barrel can become thick and strong. It is wise to wear a mask. Whether you choose sawdust, paper or leaves to reduce with, you should be cautious, especially if it is windy. An ignited paper blows away easily and is a major fire hazard. Always have water handy.

Make sure to have all the tools in place when you begin the firing process—one or more barrels for the local reduction, a pair of long tongs, sawdust or paper, and a bucket of water.

When you set your oven, you need three kiln posts and an oven plate. The supporting aids need to be at least 4 inches high, so that the oven plate ends up above the firing nozzle. Then place the objects on the oven plate and put on the lid askew, so that ¼ of the barrel is uncovered at the top. Never put the lid on completely during any part of the firing process! A gap is needed to make oxygen available for combustion. If you put the lid on during the firing process, the flame will either get extinguished or find its way out through the gas burning nozzle, which can be very dangerous!

Place the gas burning nozzle so that it is firmly anchored in the hole at the bottom of the barrel and ignite it. During raku firing it is common to set the barrel up for several firings following each other because it is such a quick firing process, but the first firing may take a little longer so that supporting material can warm up slowly. Fire with great care the

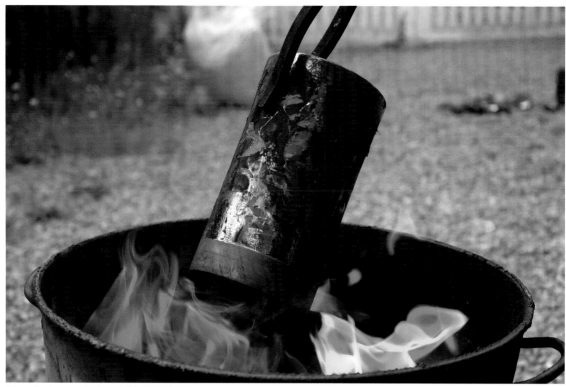

The cylinder is picked out of the barrel.

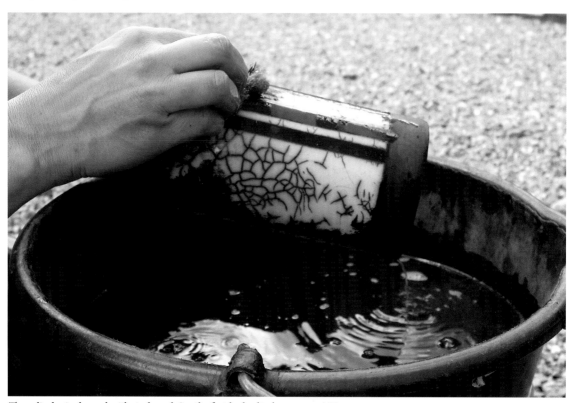

The cylinder is cleaned with steel wool. See the finished cylinder on page 126.

first 15 minutes and then gradually increase the flame for another 30 minutes, before finally turning on plenty of gas towards the end. If you have objects that are large or thick, it is wise to fire them in the first round, when the heat rises slower than the following rounds.

You can observe the progress of the objects in the gap between the barrel and the lip. You will see how the glaze gradually changes character from dry matte, to shiny and glossy without any pores. When the glaze looks shiny like a quiet lake, the firing process is finished.

Turn off the gas and prepare the barrel for reduction by adding some combustible material on the bottom. Lift the lid off and use the pliers to remove the first object. Once the item is out in the air, you can hear how its glaze cracks. Put it in the reduction barrel and cover with combustible material. A fire will begin in the the barrel. Cover it with the lid to choke the fire.

Then take the next object and repeat the process. Remember that heavy smoke will billow out of the barrel every time you lift the lid off. When all objects are taken out of the barrel, it can be loaded with new ones. This time the kiln is already heated, so the firing process will be shorter. Between 10 to 20 minutes is usually enough.

Then it is time to wash the objects that are lying in the barrel. You can either let them remain in the barrel until they have cooled, or you can lift them out and place them in a bucket of water. Hollow shapes with small openings should not be immersed completely in water, as incoming water will create steam inside the object that can cause it to burst. When the objects have cooled down enough for you to hold them, clean them with steel wool. Only then will they appear in their proper form.

An important fact about raku objects is that they are not appropriate for everyday use. The low firing temperature makes the objects porous. That in combination with the crackles contributes to the objects not being waterproof.

Raku Glaze Recipe

Transparent basic glaze

Borax frit	98
Bentonite	2

Turquoise / metallic

Copper oxide	2
Tin oxide	2

Blue

Cobalt oxide	1
Copper oxide	2

Troubleshooting and Potential Solutions

The objects burst during the firing process	The glaze was moist when the object was put into the kiln. Air cracks in the clay. Tensions in the clay because the object is uneven in thickness.
The objects burst while cooling in the reduction barrel, or in the bucket of water	The construction of the object should be reviewed. Make sure that the the object is even in thickness. Be meticulous when you assemble the object with slip.
The objects are not black enough	Make sure to get enough smoke in the reduction barrel and cover the objects generously with combustible material.
No crackles are formed	The coat of glaze is too thick.
There are too many crackles	Apply a thicker coat of glaze, or choose a different frit for your glaze recipe. Put the object into the reduction barrel quicker.
The soot is difficult to wash away completely from the glaze.	Try using a different type of combustible material.

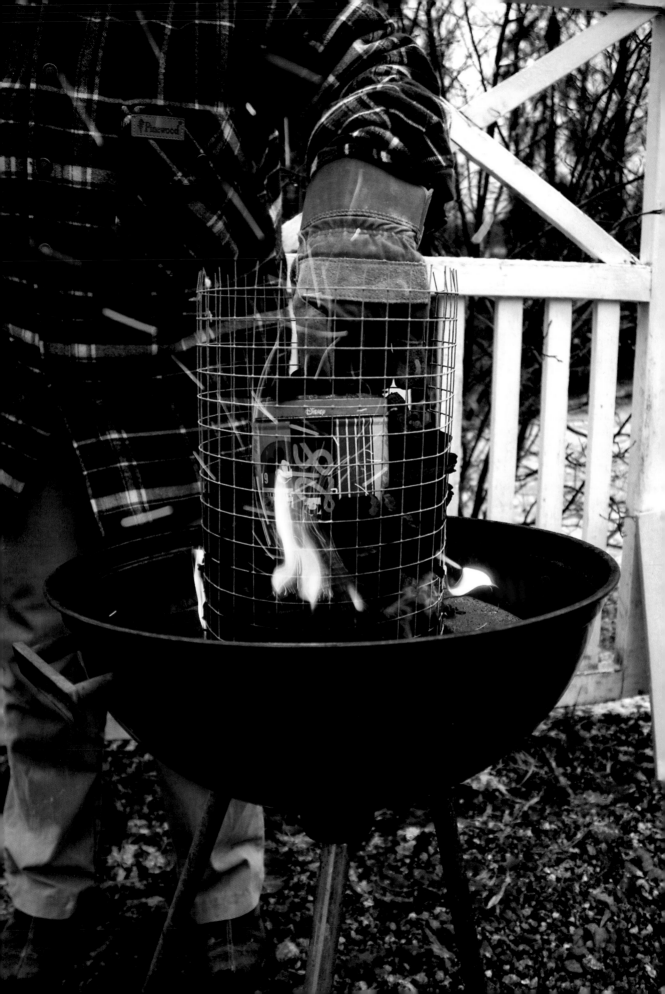

BLACK FIRING

Black firing is one of the oldest firing techniques, and it used to be performed in a pit. Back then, they did not have objects that were bisque fired. The objects were burnished and when they had dried, they were put in a pit lined with grass or straw. Then the objects were layered with grass or straw, and wood. All this was covered with peat and burned with a minimal supply of oxygen. A firing took about eight hours and resulted in pitch black objects good for everyday use. Since the temperature in such a firing only rises to between 1,112 to 1,472°F, the items were greased to make them more waterproof.

Today we use black firing for entirely different reasons—solely for the fact that it produces beautiful black pottery that is delightful to the eye, something that is quite important. Today, the cera-mics are usually bisque fired in an electric kiln before they are black fired. It minimizes the risk of the pottery cracking. On page 77, you can read about how to burnish the objects before bisque firing them. Black firing can easily be done in the garden; you can even use a typical charcoal grill. The process is a nice pastime and does not require a lot of prepa-ration, just a little bit of ingenuity. Since this firing process does not produce any dangerous emissions, you can even grill hot dogs simultaneously and use the grill maximally!

You will need a tin can with a lid for the black firing process on the grill. The size needed depends on how many objects you are going to fire. Other things needed are: charcoal, dry combustible materi-als, newspaper, and fine-mesh chicken wire.

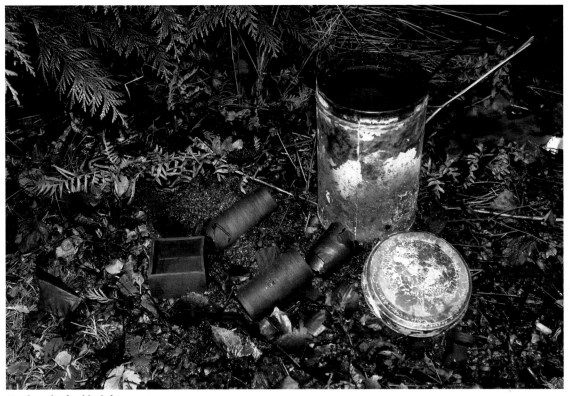

Final result after black firing.

Charcoal is filled around the tin can.

Tightly wrap all the pottery that is to be burned in newspaper. Pour sawdust into the bottom of the can and add the objects. Try to get a lot of space between them. Layer ceramics and sawdust. Pack the can full of sawdust. It is better to add fewer items than too many, so that there is enough combustible material to char and blacken all the ceramics. The sawdust will not burn during the firing process, despite the heat, due to the deficit of oxygen. However, it will get charred. The soot that is formed will color the bisque pottery black. Let the lid stay on the tin can to prevent too much oxygen from entering. However, you will need a few air vents. Use a nail to make 2 to 3 small holes on the bottom of the can.

Instead of sawdust, you can fill the can with any other combustible material, such as leaves and grass, but it must be fairly dry.

Light the grill and wait until the coal is glowing. Then set the packed can down. The entire can must be covered with charcoal to get good heat all around and to get everything in the can to turn black. Make a roll out of the chicken wire, about 4 inches wider than the can, and place it around the tin. Then fill the cavity between the tin and the wire with coal and allow the coal to cover the lid to get heat all around. Be prepared to continuously load more coal during the firing so that there is always an even heat around the jar. The whole firing process takes about 3 to 4 hours. Then you stop the firing and allow the tin to cool down before opening it.

If the firing process was successful, the newspaper around the object will have turned pitch black but the text will still be readable. Burnished bowls are excellent to use as fruit or salad bowls if you exclude vinegar.

Black fired objects do not withstand being outdoors very well because of the low firing temperature. They easily absorb moisture and crack over time, especially if they are exposed to cold and moisture.

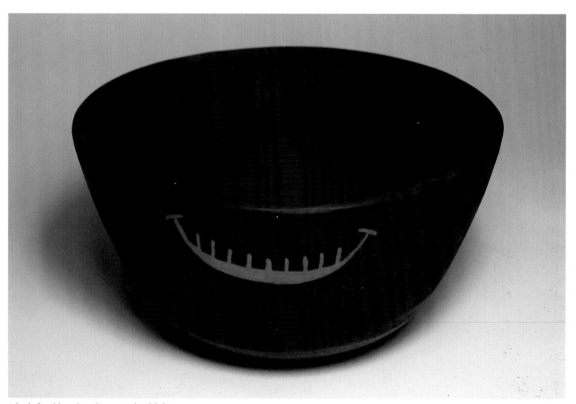

Black fired bowl with painted gold décor.

BARREL FIRING

This low-burning firing technique is performed outdoors. The results are lively with a wide color spectrum. There is a lot of room for experimentation based on the conditions that are described below.

To perform a barrel firing you will need: a barrel that is resistant to fire, firewood, sawdust, straw, grass, leaves or paper, charcoal lighter fluid, oxides, stains and salt.

Make sure that all combustible materials are thoroughly dry before you begin, or they will create a lot of smoke, and then the fire might suffocate.

Begin by adding a layer of sawdust on the bottom of the barrel and then add a first layer of ceramics on top. It is good to put the heaviest and largest objects on the bottom, otherwise they risk breaking the smaller and more fragile items. Place wood and straw between the objects and then cover them with a layer of straw. Sprinkle with 2/5 cup of one or more oxides. Add a new layer of ceramics, wood, straw and oxides. Do not add too many layers, or it will be too heavy for the objects on the bottom. Top everything off with a layer of wood. Pour charcoal lighter fluid on the firewood, and when it has absorbed the liquid, ignite it.

This firing process takes approximately 5 hours. If you notice that the firewood burns up quickly, you may need to add more. During the firing, the ceramics are in a reducing atmosphere because the fire absorbs the oxygen, but once all the combustible materials are burned, the objects come in contact with oxygen again and are reoxidized. The firing is complete when

Effect of barrel firing.

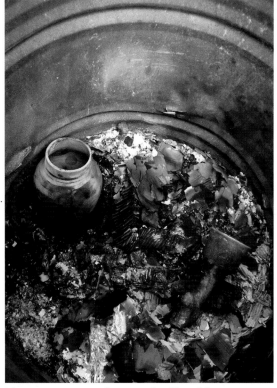

The ceramics appear after a completed barrel firing.

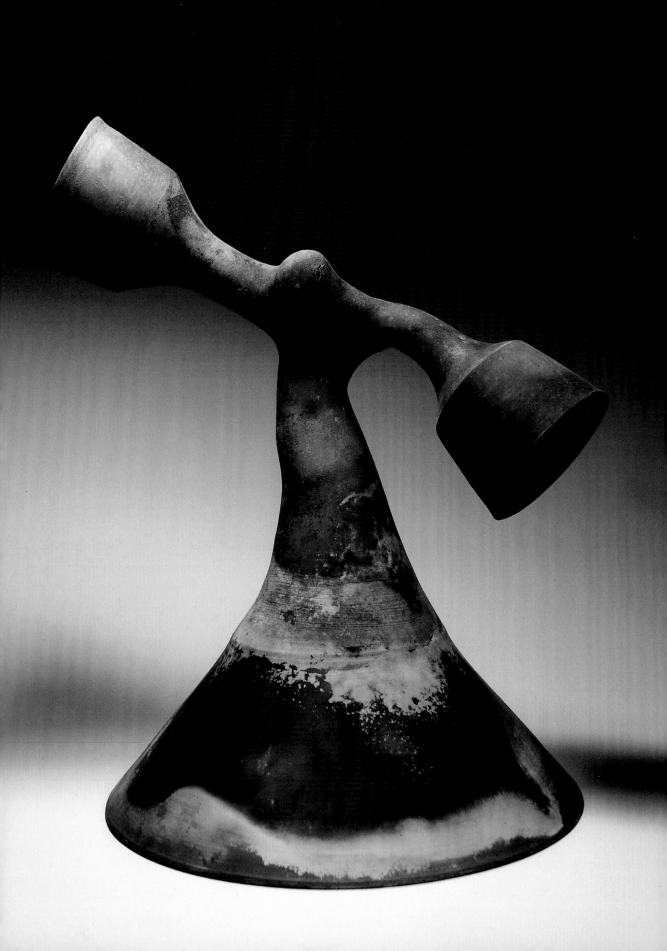

all the materials are burned, and only ash and ceramics remain in the barrel. Once the objects have cooled off a bit, you can lift them out of the barrel.

Several factors affect the result. First, it depends on how long you burned the objects and the temperature you reached. It also depends on the choice of firewood and other combustible materials, and which oxides you used and to what extent. If you are not satisfied you can fire the objects again.

You can also brush oxides or stains and salt solution onto the objects before the firing process. Then you get more colorful results. Another option is to wrap them in copper wire or copper mesh.

Let your curiosity inspire you to experiment with other materials that may produce exciting colors or imprints on the pottery.

Barrel fired urn.

Object ready to be lifted out of the barrel.

Stoneware clay, thrown and assembled parts, bisque fired, sponged with oxides and saline, barrel fired.

ANAGAMA

Anagama firing is a technique with its roots in East Asia. *Anagama* means "hole kiln" or "cave kiln" in Japanese. The pottery is fired unglazed and the kiln is fired with firewood. Ashes and flames, combined with a high temperature and long firing time, give anagama fired pottery a special character.

The kiln, which is usually built on a slope, looks like a long cocoon on the outside and like a tapered cave on the inside. These kilns are typically large and long and hold a considerable amount of pottery. The entrance is located at the front of the kiln, and the chimney sits in the back of the tunnel. The setting of this kiln is of great importance. It should be filled to capacity, so that the long flames need to find their way between the objects. A mixture of ball clay, kaolin, and aluminium hydroxide is rolled up into small balls that are attached to the underside of the objects to prevent them from getting stuck to the kiln surface during the firing process. When the kiln is filled with ceramics, the entrance is walled closed so that only a hole remains where you can set it on fire.

The lighting is done in the front of the kiln, but also in the holes on the sides of the kiln. The flames that are formed make it through the entire cavity and all the way out through the chimney. The flames bring ash that is formed during the firing with them, and the ash melts onto the objects and settles as a glaze. Different types of wood contain different elements, and the choice of wood affects the outcome.

The firing process takes between 1.5 to 12 days, depending on what kind of results you want, and the temperature is around 2,372°F.

Another crucial factor that affects the result is how much oxygen is released into the kiln. If you fire with a lot of firewood, the flames will devour the oxygen and there will be a heavy reduction. If you use firewood sparingly, it permits the oxygen to circulate in the kiln, and you will get an oxidizing effect instead. After completed firing, the ceramics are left to cool for several days before the kiln is opened.

It was not until the 1970s that this technology spread in the world, first to the U.S. and Australia, and eventually to Europe.

Stoneware, thrown, anagama fired, cone 10.

SALT FIRING

Salt firing began in the 1400s in Germany. In Sweden, the Höganäs company is famous for their salt fired ceramics, a practice they began in the 1800s. They mainly manufactured vessels for pharmacies and hospitals, and during the mid-1800s, pans and sanitary equipment used in many hospitals were manufactured there. The Höganäs company began producing brown salt glazed vessels in 1835, and these are perhaps the most famous pottery items in Sweden, and in many homes they still serve as jam pots.

During salt firing, salt is added during the firing process. You can either put the salt in small bowls that stand in the kiln during the entire firing, or you can spray or throw salt into the kiln during firing. The natrium in the salt combined with silica and alumi-num in the clay forms a hard and durable glaze that is called sodium aluminum silicate glass. The glaze itself is colorless, but you can color your pottery with engobes. The engobes are mixed from different types of clay and oxides or stains, which in turn add special surface textures and colors to the pottery. The firing temperature rises up to about 2,372°F, and you measure the temperature with cones.

As a rule, salt glaze kilns are large and can hold between 3.3 and 6.6 cubic feet of pottery. The kilns are fired with firewood or gas and the firing is done outdoors. The salt forms the glaze, which means that everything in the oven becomes glazed including the tiles and bricks in the kiln. That is why all the pottery needs to be placed on little balls made from kaolin

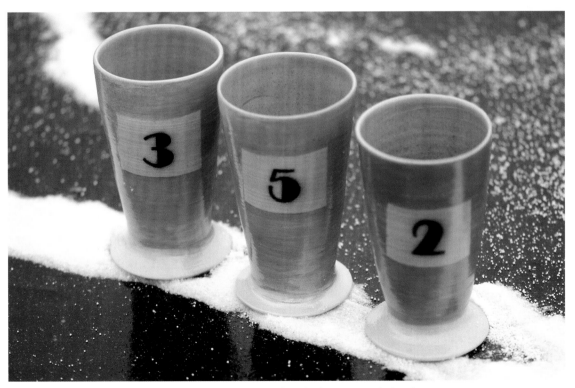

Stoneware, wheel-thrown, engobed with stencils, numbers with underglaze paint, salt glazed, cone 10.

and aluminum oxide. Aluminum and sodium will not form glass and therefore the objects will not get fixed to the tiles.

Place little sample rings of bisque fired clay in the kiln during the firing process to determine the effect of the salt on the clay. These sample rings can be taken out of the kiln with a metal rod during the firing process to determine if you need to add more salt for the glaze.

If you are firing the kiln with firewood, the atmosphere in the kiln will transition from oxidation to reduction each time you add more firewood. When the temperature reaches about 1,832°F, make sure to have a reduction atmosphere. If no salt was added to the kiln in the beginning, add it at cone 4. The salt is thrown or sprayed into special salt gates at intervals from about 2,192°F. Continue salting the kiln until a good glaze is formed. When you are done salting the kiln, raise the temperature a bit more so that the glaze melts onto the pottery thoroughly; this process is referred to as the glaze maturing.

When the cone for the final temperature falls, it is time to complete the firing process and clog all firing holes and salt holes and close the damper a fair amount. The kiln will cool slowly, and this has a beneficial effect on the colors.

Firing a salt kiln is an individual process, and each potter has his own way to fire salt and creating a reducing atmosphere. Each firing opportunity is unique. Weather conditions, wind and firewood will all affect the final outcome. Even the way the flames make their way out through the kiln and how the objects are placed inside the kiln will affect the final result.

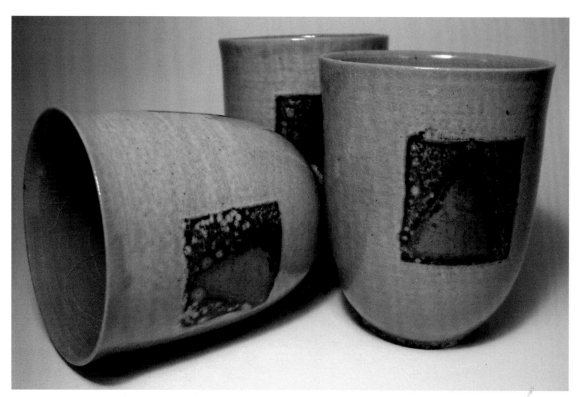

Salt fired mugs.

THE WORKSHOP

A pottery workshop can be set up in many different ways and the premises for this purpose vary accordingly. You may already have a place in mind for your workshop, or perhaps you are in search of one. Here are some things to consider:

Size of the Workshop	Think about what you are going to make in your workshop, what tools and machines you will need and how much space they require. You need room for a good work bench.
The Floor	It is best to have a floor with a floor drain, so that you easily can rinse it when it is time for a cleaning. The floor should be plain and dense, and from a material that can withstand being scrubbed every day.
Water and Sewage	Having water and a sewage system connected to the workshop is pretty much a necessity. A large sink will be of great help when you need to clean buckets and other larger items, and your pipes and drains should be connected to a septic tank and a sewage system to prevent the drains from getting clogged.
Electricity	You will need electricity in the workshop, and if you are going to get an electric kiln, you will need to get a three-phase.
Environment and Ventilation	If you are going to store all materials, such as clays and glazes, in the workshop, it should be heated, otherwise the material will freeze. However, if it is very hot in the workshop other problems may arise. Clay and engobes can dry out too quickly and will create problems during the production process. A good ventilation system is important.
The Kiln	If you are going to buy a kiln, you should have a good extractor fan as well, to get rid of different gases that are produced during firing. Preferably, you should keep the kiln in a different room than the one you stand and work in. Carefully read any safety manuals that come with the kiln, so that you do not place it in such a way that it becomes a hazard. It is always good to check the placement with the fire department.
Cabinet	It is good to store all glaze materials in labeled containers in a cabinet.
Shelves	You will need a lot of space where you can place your objects while you are working on them. Place the shelves a bit above the floor to facilitate cleaning.

Workshop Environment and Hygiene

Given that some of the materials used in ceramics are a health hazard, it is extremely important that you keep your workshop clean and make sure that the air is good. Mopping the floor regularly, cleaning the work surfaces, and having a good ventilation system are all requirements.

All dust and particles from the clay and the glaze are harmful if inhaled. Never vacuum in the ceramics workshop, because the little malicious particles will not stay inside the vacuum cleaner, but blow out of the filter and continue to swirl around the room. However, a central vacuum system is good. Wet mopping is by far the best method to clean the floor. A water vacuum cleaner is also a good alternative.

Always wear a protective mask on your face when mixing glazes or the like. The dry raw material dusts easily. Also wear gloves when you prepare glazes and when you work with oxides and stains.

Some glaze materials are toxic to handle and to inhale. Some materials, such as lead, are totally inappropriate to use in glazes that are going to be used on utility goods. It is not necessary to stop using these materials if you follow safety instructions and protect yourself and your surroundings. Always find out if the materials are toxic, and how they should be stored. Such information can be received from the supplier. It is best to store materials in plastic boxes with tight-fitting lids so that you do not need to be opening bags of various kinds each time a glaze or engobe needs to be mixed, as it tends to whirl up some dust in the process.

Wear work clothes when you work and put them on and take them off in your workshop so that no dust is spread around in other rooms. Wash them often.

Any ingestion of pottery particles should be avoided.

Here is an overview of materials that you should be particularly careful with when handling:

Hazardous Substances That Must Be Handled with Extreme Caution

lead

cadmium

nickel

Materials That Must Be Handled with Caution

barium

lithium

stains

frits

Cones

Cones are used as aids in firing to be able to control the oven temperature. With cones you can read the exact temperature of the oven and you can customize the oven automatically after that.

Orton Cones

Cone No	140°F/h	302°F/h
010	1,657.4°	1,679°
09	1,688°	1,706°
08a	1,727.6°	1,752.8°
07	1,788.8°	1,808.6°
06	1,828.4°	1,855.4°
05.5	1,859°	1,877°
05	1,887.8°	1,911.2°
04	1,945.4°	1,970.6°
03	1,986.8°	2,019.2°
02	2,015.6°	2,051.6°
01	2,046.2°	2,080.4°
A	2,078.6°	2,109.2°
2	2,087.6°	2,127.2°
3	2,105.6°	2,138°
4	2,123.6°	2,161.4°
5	2,166.8°	2,204.6°
6	2,231.6°	2,269.4°
7	2,262.2°	2,294.6°
8	2,280.2°	2,319.8°
9	2,300°	2,336°
10	2,345°	2,381°
11	2,361.2°	2,399°
12	2,382.8°	2,418.8°

INSPIRATION

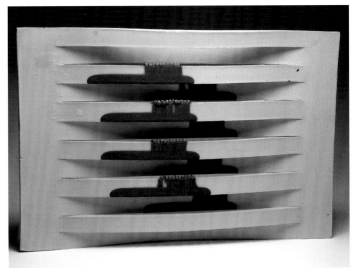

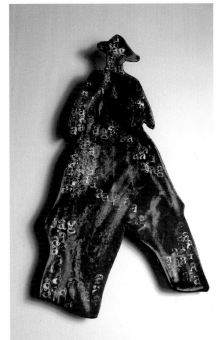

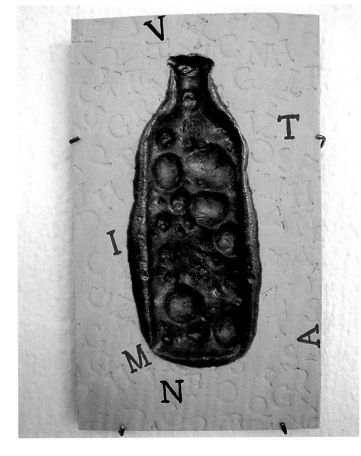

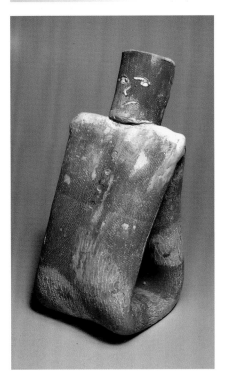

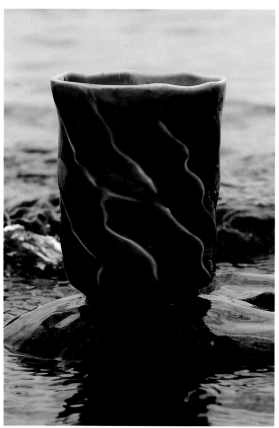

GLOSSARY

Ball of Clay	A kneaded piece of clay that is used primarily in hand worked to thrown pottery, see the picture on page 39.
Banding Wheel	Consists of a foot and a rotating work surface to place your objects on. Used primarily when sculpting and decorating ceramics. Available for table and floor.
Bisque Firing	The first firing process where the bound water is burned away in the pottery.
Bisqueware	Bisque fired clay.
Chamotte	Fireproof clay that has been fired and crushed.
Chuck	Form used as an aid during trimming.
Density	Measure of a material's density, mass per unit volume.
Engobe	Alluvial and colored clay, often used as decoration on leather hard clay.
Faience	Low fired earthenware clay glazed with a white tin glaze. Decorated with oxides that are painted onto the unfired glaze. Also called majolica and delftware.
Flux	Substances that lower the melting point of materials with a higher melting temperature.
Foot Ring	An edge that is thrown onto bowls, plates, and cups.
Handle Machine	Tool used to make handles.
Leather Hard	Clay that is dry enough to be handled and worked without getting deformed.
Lip	Edge that is thrown onto a jar or the lid so that the lid stays securely in place.
Majolica	See faience.
Mesh	The mesh size of a sieve.
Oxidation	Firing in an environment with unlimited oxygen supply.
Plasticity	The quality of how easily clay can be molded or shaped.
Potter's Tissue	Thin paper used to transfer prints from screenprints onto ceramics.
Reduction	Firing atmosphere where there is a limited supply of oxygen.
Sedimentation	Heavy particles that settle on the bottom and form a hard sediment.
Sintering	Clay that is fired until the more easily molten particles have melted without the shape getting deformed.
Slip	Clay mixed with water that is used as a type of glue.
Terra Cotta	Fired, unglazed earthenware clay with a high iron content that gives it a red to red-brown color. Used for pots.
Thickening Agent	Substance that is added to glaze to make it more fluid in the bucket and to prevent sedimentation.
Trimming	Trimming wheel-thrown objects up and down on the potter's wheel at a leather hard stage.

READ MORE

Impressed and Incised Ceramics, Coll Minogue, A & C Black Publishers, 2001

Ceramics and print, Paul Scott, A& C Black Publishers, 2002

Glasyr, Anders Fredholm, see www.fredholm.nu

Slipcasting, Sasha Wardell, A & C Black Publishers, 2007

The Potters Guide to Ceramic Surfaces, Jo Connell, Apple Press, 2007

Raku, John Mathieson, A & C Black Publishers, 2005

Lettering and Ceramics, Mary White, A & C Black Publishers, 2003

Vad är grafik? En handbok i grafisk konst, Philip von Schantz och Jordi Arkö, Bonnier Alba AB, 1996

Alternative Kilns & Firing Techniques, James C. Watkins & Paul Andrews Wandless, Lark Books, 2006

Handmade Tiles, Frank Giorgini, David & Charles, 1995

SUPPLIERS

Big Ceramics Store
http://www.bigceramicstore.com
543 Vista Boulevard
Sparks, NV 89434

Call: 888-513-5303
support@bigceramicstore.com

Mile Hi Ceramics
http://www.milehiceramics.com/
77 Lipan
Denver, CO 80223

Call: 303-825-4570
milehi@milehiceramics.com

Axner Pottery Supply
http://www.axner.com
490 Kane Court
Oviedo FL 32765

Call: 800-843-7057
axner@axner.com

Sheffield Pottery, Inc.
http://www.sheffield-pottery.com/
995 North Main St
P.O.Box 399

US Rt. 7
Sheffield, MA 01257

Call: 1.888.774-2529 or 1.888.
spi-clay
sales2@sheffield-pottery.com

American Ceramic Supply Company, Inc.
www.americanceramics.com
2442 Ludelle Street
Fort Worth, Texas 76105

Call: 817-535-2651
sales@AmericanCeramics.com

Flat Rock Clay Supplies
www.flatrockclay.com/supplies.
html
2002. S School Ave.
Fayetteville, AR 72701

Call: 479-521-3171
info@flatrockclay.com

Alligator Clay Company
(Southern Pottery Equipment
and Supplies)
http://alligatorclay.com

2721 W. Perdue Ave.
Baton Rouge, Louisiana 70814

Call: 225-932-9457

Clayworks Supplies, Inc
http://www.clayworkssupplies.
com
4625 Falls Road
Baltimore, Maryland 21209

Call: 410-235-5998

The Ceramic Shop
http://www.theceramicshop.com
3245 Amber St
1st Floor
Philadelphia, PA 19134

Call: 215-427-9665

Continental Clay Company
www.continentalclay.com
1101 Stinson Blvd. NE
Minneapolis, MN 55413

Call: 800-432-CLAY
sales @ continentalclay.com

INDEX